Constructing a sociology of the arts

Contemporary Sociology

Contemporary Sociology attempts to counteract the excessive fragmentation that has marked the development of sociology in recent years. Such fragmentation has often led to pluralistic ignorance on the part of many sociologists, both beginners and mature scholars, in regard to aspects of sociological theory and research that happen not to be a part of what they claim is their specialized competence.

The series attempts to acquaint its readers with ongoing thought on the frontiers of knowledge in branches of sociological inquiry with which they may be unfamiliar. It aims at developing a series of road maps of rapidly expanding areas of theory and research that merit the attention of general sociologists and of scholars specialized in other areas.

Each volume will acquaint the readers with the various strands of thought in the field under consideration and will be predicated on the notion that the clash of ideas, here as elsewhere, is not a drawback but an opportunity.

It is hoped that this series will contribute to reducing excessive fragmentation in the sociological enterprise and indicate to its readers that although the house of sociology has many mansions it is still built on common grounds and a common tradition.

Lewis A. Coser
Series Editor

Constructing a Sociology of the Arts

VERA L. ZOLBERG

Graduate Faculty of Political and Social Science
The New School for Social Research

CAMBRIDGE
UNIVERSITY PRESS

Published by the Press Syndicate of the University of Cambridge
The Pitt Building, Trumpington Street, Cambridge CB2 1RP
40 West 20th Street, New York, NY 10011, USA
10 Stamford Road, Oakleigh, Melbourne 3166, Australia

First published 1990
Reprinted 1991, 1993, 1997

Library of Congress Cataloging-in-Publication Data

Zolberg, Vera L.
Constructing a sociology of the arts / Vera L. Zolberg.
p. cm. – (Contemporary sociology)
Includes bibliographical references.
ISBN 0-521-35146-4. – ISBN 0-521-35959-7 (pbk.)
1. Art and society. I. Title. II. Series: Contemporary
sociology (Cambridge, England)
N72.S6Z65 1990
701'.03 – dc20 89-38446
 CIP

British Library Cataloguing in Publication Data

Zolberg, Vera L.
Constructing a sociology of the arts.
1. Arts – Sociological perspectives
I. Title
306'.47

ISBN 0-521-35146-4 hardback
ISBN 0-521-35959-7 paperback

Transferred to digital printing 1999

For my late parents, Gisa and David Lenchner

Contents

Preface

Reflexivity makes life hard. Once upon a time it was legitimate to study the arts in society as if the arts were a known quantity. Today this is no longer intellectually viable. Scholars have discovered the socially constructed nature of art, cultural institutions, artists, and publics. Rather than assume that these complex phenomena are explained by simple causes, we find it necessary to incorporate heterogeneity, processes of discovery, evaluation, history, and the creation of traditions in the very categories that once were taken for granted.

The theoretical underpinnings of this perspective have been derived from both literary and sociological disciplines. Because I believe that the sociology of art needs to keep the arts themselves at the center of its concern, as much as possible I focus on the arts in their social and historical context, in a manner informed by theory, rather than on metatheoretical elaboration and analysis. Instead of taking art as a convenient device around which to drape existing theories, I propose a sociology of the arts that continues and elaborates the work in which art forms, styles, objects, and ideas are integrated with theoretical formulations and methodological orientations in such a way as to enhance the strengths of aesthetic, humanistic, and social scientific fields. Accordingly, these are the ideas that constitute the guiding themes of this book.

Beyond conventional fine arts, we are surrounded by popular, commercial, non-Western, and "primitive" art forms that many of us have learned to appreciate almost as much, if not more, than the Western high arts. The fact of a plethora of art forms and styles, representing societies, states, and peoples of the world with few or no barriers of space and time has struck many thinkers as a new phenomenon, sometimes referred to as postmodernism. Viewed as the end of history, indicative either of the breakdown of standards of quality or as a promise of pluralism and equality, postmodernism is treated as the outcome of economic and political forces that have come to dominate cultural developments more generally. Indeed, the breadth and quantity of art forms has never been matched.

Yet the coexistence of styles, the radical diminution of distance, and the hungry acceptance by many of new vision and sound have a long history. Elsewhere I have argued that postmodernism can be said to have been previewed as precocious premodernism in an eclecticism of forms and styles of art, perceptible as early as the late Middle Ages, common to the culture of the Enlightenment, concretized in the curiosity cabinets of proponents and supporters of the new learning, and reaching an apogee in the nineteenth-century museums (Zolberg 1988). But can postmodernism be interpreted, paradoxically, as part of an historical process, recurrent and cyclical, rather than as a new phenomenon of the twentieth-century that represents the end of history? Is it a case of history repeating itself? If so, should we consider it as did Marx, the first time as tragedy, the second as farce (Marx [1869] 1968, 15)? The answer to whether repetition should be characterized as tragic or farcical needs to take into account the interests and biases of those who make such judgments. More generally, rather than being taken for granted, the "discovery" of postmodernism itself needs to be analyzed and periodized in the context of academic and intellectual life.

A second consideration raised by the postmodernism debate is how the arts themselves are to be defined, what the boundaries of the subject should be, how their form and content should be formulated. The view that aestheticians and humanist scholars have tended to support is that they be defined narrowly, with emphasis on the fine arts, and studied from an internalist perspective. When sociologists choose to study the arts, however, they take on a broader gamut of art forms and examine them from an externalist view, as proxies for societal processes and conditions. My position is that although each of these approaches has its importance, as many of the studies I cite (Chapters 3 and 4) clearly indicate, understanding is better served when scholars take cognizance of one another's domains. What is certain is that shrinking the arts to the subset known as fine art is of doubtful validity, whether done by scholars in the arts or the social sciences.

My concern with a much broader conception of the arts than the fine arts alone should not be taken as my total acceptance of their equality or interchangeability. Although social scientists have in recent times tended to favor a tolerant or relativistic outlook

and have rejected as elitist the critiques of artistic production by humanistically oriented sociologists, I believe that open-mindedness on both sides is needed. Integral to the worlds of the arts themselves are evaluation and criticism. Among the contributions sociology may make to their analysis is to focus on the manner in which rankings of art forms are arrived at, and how and why they change. At its best, this approach incorporates a critique of the content, form, and successive meanings (intended and unintended) of the art works themselves. This is one way by which social science may rise above being only a method, a set of techniques applicable to any subject, in which mindless value-neutrality displaces the ends of scholarship with the means used to advance knowledge.

My reasons for striving to build bridges among the arts, the humanities, and the social sciences have their general origin in my past and present. I was born in a Viennese milieu where, aside from family matters and politics, conversation was dominated by music and operatic gossip; began my university studies in Romance languages and literature; took as my social club New York's Museum of Modern Art; lived in cities such as New York, Boston, Chicago, and Paris, and in Africa, where arts of the most varying kind are omnipresent; teach in the Graduate Faculty of the New School for Social Research, where the importance of culture is never under-estimated: Together these have provided a fertile setting for my interest in the arts. Respecting the arts for their own sake has always seemed as natural and good as the ideals of Enlightenment modernity, sustained in spite of the need to contest a place for their study in the social scientific disciplines. From the standpoint of the arts themselves there is the additional confrontation between the canon of the fine arts and what have been considered the popular arts – jazz, folk music, movies, and commercial design and music. Rather than accept a sharply drawn boundary between them, I believe that understanding is enhanced by expanding the canon and incorporating them into a sociology of the arts.

Pursuing these questions has placed me in debt to numerous colleagues, either for specific help, or for general understanding, advice, and example. I wish to thank Mihaly Csikszentmihalyi, who kindly permitted me to use the manuscript report and data from his longitudinal research on artistic creativity and careers. My thanks

also to Robin Wagner-Pacifici for permission to cite her study of the Vietnam War Memorial, also in manuscript. I am grateful to Wendy Griswold of the University of Chicago for the opportunity to discuss the work-in-progress in her graduate workshop. An informal network of interested scholars, many of them connected with the Culture Section of the American Sociological Assocation, have provided intellectual and moral support in the development of this discipline. They include Judith H. Balfe, Judith R. Blau, Paul DiMaggio, Arnold Foster, and Richard A. Peterson.

Over the years I have benefited considerably from the intellectual stimulation of Pierre Bourdieu and his seminar at the Centre de Sociologie Européenne, Raymonde Moulin and her seminar at the Centre de Sociologie des Arts, Howard Becker and the inter-university culture workshop in Chicago. I have profited as well from contact with my colleague Jeffrey Goldfarb, whose serious commitment to the goals of cultural excellence and democracy have stimulated me to probe more deeply the implications for sociology of the disciplinary cleavages in academic life. Lewis Coser, whose sociological contributions have been an intellectual inspiration, has been an encouraging and supportive series editor. I greatly appreciate the helpful comments from my production editor, Melinda Mousouris, whose eagle eyes have saved me from many a slip. The person to whom I owe the greatest debt is my husband and colleague, Aristide R. Zolberg, who has always been a source of ideas, a goad to work harder, and the single individual whose encouragement and approbation mean the most to me. Although the stamp of their inspiration is visible in the book, my interpretations and the implications I draw from them are, of course, my own responsibility.

1. What is art? What is the sociology of art?

> I want to talk about the arts in relation to the mystery that
> surrounds them, not as a problem to be cleared up but as the
> very condition in which they appear at all. In that sense, mystery
> is to be acknowledged, not resolved or dispelled.
> Denis Donoghue, *The Arts Without
> Mystery* (1983): 11

> What I have said about art worlds can be said about any kind of
> social world, when put more generally; ways of talking about
> art, generalized, are ways of talking about society and social
> process generally.
> Howard S. Becker, *Art Worlds* (1982):
> 368

> Sociology and art make an odd couple.
> Pierre Bourdieu, *Questions de
> Sociologie* (1980): 207[1]

ASKING WHAT ART IS may seem at first sight disin-
genuous, since its meaning is usually taken for granted. But
modern Western societies have been witnessing such radical
changes in the forms and content of art, and questions about what
to include or exclude from the category of art arise so frequently,
that they obtrude in any sociological analysis of art. Moreover,
even when there seems to be consensus about art forms, new
claims for inclusion are made that seem designed to shake the
confidence of even seasoned observers. Instead of oils on canvas,
or marble sculptures in museums, they are now treated to piles

1 "La sociologie et l'art ne font pas bon ménage." Bourdieu goes on to point
out that this is due to the the conflict between the conception of art and artists
who see their world as one of belief in their gift, in the uniqueness of the
original creator, and see the sociologist as one who breaks into this universe
with the aim of understanding, explaining, and thereby causing a scandal.
The vexed relationship between creative artists and social scientists and its
counterpart in the no-more-peaceful coexistence of humanistic and scientific
scholarship are principal themes of this book.

1

of bricks (Carl André); instead of melodies created in traditional modes and harmonies, performed in ornate auditoriums by musicians whose efforts are coordinated by conductors according to prescribed scored notations, they get beachside "concerts" to which, as audience members, they are invited to bring their own portable radios and told to turn them on full blast at the station of their choice (John Cage); instead of dances performed by women on tiptoe in tulle gowns, or, regardless of sex, in an unnatural, turned-out stance, they see performers in nondescript rehearsal clothes, slouching about or breakdancing like street urchins (Twyla Tharp).[2] Clearly, the question is neither frivolous nor is there much agreement as to how to go about answering it.[3]

The problematic nature of art affects how it is studied as well. Depending upon whether scholars are allied to humanistic disciplines such as art history, aesthetics, or criticism, they start from different premises than those whose fields are part of the social sciences. The contrast between them is exemplified by the statements cited by Denis Donoghue and Howard S. Becker. For Donoghue the arts are miraculous revelations, not objects for naturalistic analysis. He implies that the mystery central to the art work is best left unresolved, because without it art might lose what, in another context, Walter Benjamin termed its power to radiate "aura" (Benjamin 1969, 223). Donoghue's view is basically at odds with the project of social science as exemplified by Howard S. Becker, for whom art holds little mystery indeed, and to the extent that any remains, it needs to be stripped away.

This is not to say that all sociologists approach the analysis of the arts as does Becker, or that all humanistic scholars agree with

2 As an example, the following dance review was printed in the *New York Times:* "There was wonderful junk on stage Monday night at the Joyce Theater. . . . Because Murray Stern's setting depicts a trash-filled alley and much of the action involves the acquisition of objects, "Junk Dances" can be interpreted as a comment on how we litter our lives with junk in this consumer society. But such a statement conveys no sense of the choreography's charm." (Dec. 30, 1987, C8).

3 B. R. Tilghman succinctly summarizes this matter (1984, 4), pointing out the changing definitions of aesthetics since Plato. In his classic articles on "The Modern System of the Arts" (1951 and 1952) P. O. Kristeller traces the emergence of the modern definition of the fine arts, leading to its crystallization in the eighteenth century.

Donoghue. Nevertheless, the understandings that sociology supplies and the ways in which sociologists formulate questions related to art are different from the way humanist scholars dealing with art look at it. On the whole, even if they have individual preferences sociologists avoid the implicit or explicit evaluative posture associated with humanistic disciplines. Social scientists are expected to strive for objectivity in their research, making a sharp distinction between personal preferences and the work they do. As scholars they are obliged to overcome individual tastes that may bias them, or run the risk of tainting their work.[4]

The arts present more than the usual difficulties in that regard, but in addition, social scientists who turn their attention to the arts in society are treading on dangerous terrain in another way. They earn resentment from specialists in the arts who question the legitimacy of their endeavor. No wonder Pierre Bourdieu, whose words complete this book's epigraph, finds their relationship quarrelsome.

Aside from cross-disciplinary conflict, sociologists differ among themselves in the ways they view society, social actors, and social processes. There is no need to restate or analyze here the many disagreements that divide schools of sociological thought (I examine that subject in detail in Chapter 2), except insofar as it helps to clarify why the sociology of art has until recently found no comfortable niche either in the social sciences or the humanistic disciplines. I leave for a later chapter (Chapter 5) the even more problematic status of creative artists, who frequently find themselves at odds with both social scientific and humanistic scholarship.

The lack of consensus about art may impede the sociological study of the arts, but it has at the same time provided opportunities for developing an intellectual field. It has forced humanists and

4 Naturally this is a point of contention among scholars. Its most influential articulation is found in the seminal essays of Max Weber, "Politics as a Vocation" and "Science as a Vocation" (Gerth and Mills 1946, 77–156). Since then the possibility of value-free research has been discussed and debated in any number of articles and books, of which Merton's (1972) and Gouldner's works (1970) are only some examples. What is at stake here is the model on which social studies are based, whether that of positivistic science, some other concept of science, or some other model altogether. This is a subject to which I return below and in Chapter 2.

social scientists to reexamine their ideas about aesthetics, which at its best results in innovative theoretical formulations. These disciplines are separated by both intellectual and institutional barriers that impede understanding. Whereas critics like Donoghue defend the mystery of art, sociologists like Bourdieu (1975) and Howard Becker (1982) analyze the social construction of aesthetic ideas and values. Working in different ways to provide insights into how art comes about, they focus on processes of creation or production, institutions, and organizations. Ideally, bearers of sociological ideas enrich and complement those of aesthetician's and humanist scholars. But they cannot achieve this enrichment without making changes in their theory and practice, notably by moving the subject of study, art, to a more prominent position. This is a matter of intellectual choice, since it can be argued that aesthetics should be left to "competent" specialists.

The term "aesthetician" usually refers to the philosophical discipline dealing with concepts rather than actual art. Unless otherwise noted, I use it flexibly, including art historians, theorists, and critics (Barasch 1985, *xiii*). Though at times I refer to art in general, because it is impossible to encompass adequately all art forms, I focus primarily on music and the plastic or visual arts of painting and sculpture in modern societies, especially in the capitalist democracies of Western Europe and North America. My approach is historical and comparative, whether explicitly stated or implicit in the syntheses and synoptic overviews of my own research and that of other students of cultural sociology. On the whole, except for purposes of comparison, I leave the analysis of literature and the arts associated with the mass media to specialists directly concerned with those domains. This is not because I consider those works or the arts of other epochs or of non-Western societies unworthy of consideration as art. Rather, it is that the various art forms have become so differentiated in the ways in which they are made, their creators recognized, educated, and rewarded, that for some purposes they are best examined in specialized studies.[5]

5 Mass media studies consist of a number of subfields centered on various kinds of communication vehicles and their content (news), and their role in the formation of public opinion; culture industries (popular music, movies, romance novels, television sitcoms, etc.); commercial art forms (advertising art, muzak). As a sampling of older references to these rich fields of study, the collection

Because the subject of study itself is a matter of debate between competing intellectual orientations, I examine, first, the complex relations between humanistic, or "insider-based," treatments of the art and sociological, or "outsider," approaches to their study. Sociologists and humanists choose to consider works for different reasons, emphasize different aspects of art, and bring strengths and weaknesses characteristic of their intellectual fields to their understanding of the arts in society. Since the interest of sociologists in humanist subjects is as disturbing for humanists as for certain other sociologists, it is likely that the differences are not purely intellectual, but indicate institutional conflicts as well. The second principal theme of this book centers on why the arts give rise to debate in society, making consensus about "what is art" less and less likely.

Humanists and the arts: the view from inside

When humanists deplore the free-for-all pervading contemporary art, they are comparing it implicitly to an earlier consensus now overthrown. To a degree their perception is accurate, since in recent times the very nature of the disputes has changed. Previously, they revolved about aesthetic quality or ethical or moral correctness. Nevertheless, it was taken for granted as self-evident or natural that certain things were art, whereas others were not. Beside this fundamental principle, humanists assume a stable consensus as to what constitutes "great" art. If certain works considered great today were not always so acknowledged in the past, because the qualities of greatness are immanent in a work, humanists generally blame factors external to art, such as an obtuse public or rigid institutional authorities. What was and largely continues to be central to their concerns is the *work of art*, interpreted from an

by Bernard Rosenberg and David Manning White is a fine resource (1957). Beyond classic studies such as those by Theodor Adorno of radio music in the early 1940s (1976) or opinion formation by Elihu Katz and Paul Lazarsfeld (1955), more recent research on news has been carried out by Michael Schudson (1978) and Gaye Tuchman (1978); on the movie industry by Emanuel Levy (1987) and Robert Faulkner (1971); on television by Muriel Cantor (1980) and Todd Gitlin (1983); on advertising by Michael Schudson (1984); on literature by Wendy Griswold (1986).

"internalist" perspective. By this is meant that they analyze its formal elements: techniques and media used, content of imagery or language, aesthetic influences from works created in the same or similar tradition. They regard each great work as a unique, meaningful expression of its creator's being.

In looking at the creator, these scholars imply that the personality and psychology of individual artists are intrinsic to their works or styles, considered as spontaneous expressions of individual genius. According to this view, it is these geniuses who are responsible for masterpieces that partake of universally conceded greatness. This structure of thinking is evident from references to a painting as "a Rembrandt" or "a Van Gogh," an opera as "a Mozart opera," or when an artist's name is adjectivized and applied to a characteristic style, as in "Wagnerian motifs" or "Joycean epiphanies."

Since humanists pay serious attention only to those works that can be fitted into a category that may be denoted as a "unique case" in the aesthetic realm, they encounter empirical difficulties when they have to reconcile the criterion of uniqueness with certain common professional practices. When artists create several works of the same sort (Monet's *Haystacks,* for example), aestheticians are obliged to find rationales to justify these repetitive creations, other than that the artists are simply practicing (which might devalue works not yet "perfect"), or producing in a popular genre to fill market demand. This is as important for critics as for dealers, who try to control their exhibition and sale. After all, both scholars and dealers benefit from the rarity of an artist's works and have much to lose if they become commonplace.

Even more problematic are commercially produced near-replicas of art. The inclusion of film genres (photographically produced objects, either stills or film) as art is a case in point. Whereas humanists study great art, art that exists for its own sake, disinterested and divorced from commercial goals, these qualities are quite foreign to film, and to still photography, as the study by Barbara Rosenblum of different types of photographic work indicates (1978). Since the movie medium violates many of the rules of internalism associated with humanist scholarship, it may be surprising that certain academic critics take it seriously as art. However, this is understandable from a sociological perspective that focuses on the process of recognition of the medium. Starting with attention accorded to cinema

in the 1920s by avant-garde theater people as well as writers and, especially since the post–World War II period, by (mostly) European critics in magazines like *Cahiers du Cinéma,* serious writing, not only about art films, but even commercial movies, gained authority. The writers created a discourse congruent with, and inspired by, that used for the fine arts (Boltanski 1975), whose lynchpin is the *auteur* theory. What this signifies is that, congruent with paintings and classical music, they assigned responsibility for creating a film to a single individual, usually the director, thereby giving him an identity as the "artist." This is somewhat ironic, in a medium that is intrinsically the product of collective action (Becker 1982). Nevertheless, the result is that, just as a painting may be referred to as "a Renoir," it is now acceptable to speak of "a Hitchcock film," or for that matter, "a Renoir film!" That they came to be defined as art films is extraordinary because many of the movies these critics wrote about had been considered mediocre, unpretentious "properties." As I show later, this process is repeated in the case of other forms of marginal art.

These examples would seem to refute the idea that for an art work to be considered great it must be imbued with the quasi-sacred aura of uniqueness, something denied to the products of the age of mechanical reproduction. They suggest instead that it is equally likely for the aura of which Benjamin writes to inhere, not only in certain works, but to be constructed on the basis of quasi-sacral meanings – intellectual or philosophical ideas conveying value, such as beauty, perfection, or genuineness.

Both "beauty" and "perfection" are difficult to define because, as is the case for many terms of this kind, they lack referents that transcend their social location. "Beauty" may connote austere simplicity at one time and place, and ornate elaboration at another. "Perfection," an attribute not necessarily related to beauty, encompasses opposing tendencies as well; mimetic fidelity to nature on the one hand, and artificiality on the other. Though separate from either perfection or beauty, the characterisic of "genuineness" of art works cuts across most of these discourses, subsuming originality and uniqueness, as well as rarity (Moulin 1978; Alsop 1982). Implicit in the idea of genuineness is the assumption that the work was actually created by a specific artist. Its value is based on the fact that the artist is, in some way, indivisible from the art object

created, and artist and art object are complementary features of genius.

Beside these value terms, especially since the nineteenth-century burgeoning of new styles, critics have created a plethora of terms, some of them more descriptive, and at times, even intentionally disparaging, such as the well-known ones of impressionism, expressionism, cubism, surrealism. In order to encompass works of these styles that transcend the academic canon of figurative realism, color tone, subject matter, physiognomic expression, and perspective, art historians and critics have introduced concepts such as "significant form" or "tactile values" that they could apply to art styles as divergent from the academic canon as abstract or primitive art, as well as to the canonical works themselves. What these terms share with the earlier abstract terms, such as beauty or perfection, is their vagueness and dependence upon the observer's "sensitivity," a quality almost always defined by interested parties.

Despite the imaginativeness and aesthetic plausibility of many of their assertions about art, aestheticians' internalist orientation leaves gaps in understanding. Even though many of their ideas tacitly point to a societal basis for understanding how art comes about, they have until recently avoided deliberately incorporating such notions. To fill gaps in understanding, it would make sense to introduce the externalist view that sociological study of the arts provides. But as I show next, it is not surprising to find it at odds with many aesthetic assumptions.

Sociology and art: the view from outside

In contrast to aesthetic specialists, social scientists start from the premise that art should be contextualized, in terms of place and time in a general sense, as well as more specifically, of institutional structures, recruitment norms, professional training, reward, and patronage or other support. Sociologists direct attention to the relation of the artist and art work to political institutions, ideologies, and other extraaesthetic considerations (Peterson 1976).

As opposed to the idealist tendencies embedded in internalist analysis, the externalist approaches are more likely to be explicitly materialist, calling into question the special qualities imputed to

art by aestheticians, artists, critics, dealers, and connoisseurs. Whereas aestheticians think of art as subsuming the unique, sociologists assume regularity and typicality of their objects of study. They are not perturbed to learn what many aestheticians find difficult to accept and seem to need to explain and justify: that notwithstanding the conventional image of the solitary creator, certain artists and writers have made works with the help of editors, mentors, colleagues; or that they have remade the same work many times in order to benefit from its sale to a larger clientele (Hauser, 1951; Becker 1982; Wolff 1984, 1–4). From a sociological standpoint, a work of art is a moment in a process involving the collaboration of more than one actor, working through certain social institutions, and following historically observable trends. Because they assume that, like other social phenomena, art cannot be fully understood divorced from its social context, and because whatever else it is, an art work has monetary value, they accept the fact that the value attached to it derives, not solely from aesthetic qualities intrinsic to the work, but from external conditions as well. Clearly, these ideas are unacceptable to traditional humanistic scholars.

Although sociologists vary as to how much attention they pay to particular aspects of society, some preferring to cast their analytic net only a short distance, to take in small group interactions, whereas others try to encompass broad social structural patterns and historical tendencies, on the whole, the art object itself serves them as no more than an indicator or springboard for understanding extraaesthetic aspects of society. Whereas humanist scholars and critics accept a conventional definition of art, many sociologists do not, because they have become aware of its socially constructed nature. The analysis of this construction is itself part of the sociological project, as is evident in the recent transformations that I have cited. As social historians know, less sweeping but cognate changes have occurred many times in the past. For example, throughout most of world history, the arts and crafts were regarded as a unity and little analyzed by intellectuals. This was generally the case in the West, whose most valued cultural source was for centuries rooted in classical Greece. Except briefly, mainly during the Periclean Age, when art came to be considered a value in its own right, on the whole, art was not distinguished from craft,

nor artists from artisans (Hauser 1951; Wittkower and Wittkower [1963] 1969).

The plastic arts and musical forms developed along parallel lines, but they differed in certain significant respects. In Western societies the trajectory of music was bifurcated, one side in a highly esteemed association with the mathematical and philosophical speculation of classical Greek philosophers, and the other as either sacred or secular demotic forms. As opposed to the plastic arts, still largely undistinguished during the Middle Ages from artisanship, this Greek heritage provided justification for including music in the quadrivium, one of the components of what became the curriculum of the medieval university.

In order to achieve similar prestige, plastic artists needed a theoretical or philosophical foundation (Winter 1985, 123–6). By throwing off the constraints of medieval guild organization, they liberated themselves from the craft identity that had previously dominated and limited their careers. Particularly in Italy and in parts of northern Europe they retrieved and refurbished Platonism and neo-Platonism, among other ideas (Wittkower and Wittkower 1969; Alsop 1982). Renaissance and, later, Enlightenment artists, in collaboration with philosophers, scientists, and scholars, used the past as a springboard mediated by local intellectual traditions for innovations wherever social structural and political conditions permitted. Among other things, by working out rationales for distinguishing fine art from other production, certain artists helped to construct and conquer a place for themselves in the academy.

Beside philosophy, the discipline most prominent as a source of intellectual study was philology, a unified field of analysis of language and discourse applicable to a variety of aesthetic and broadly intellectual questions. By the eighteenth century, however, it had begun to split into three disciplines: art theory, literary theory, and criticism, each developing its own traditions (Barasch 1985). Regardless of differences in orientation or emphasis, intellectuals grounded in that tradition share a commitment to the study of art and literature. This does not mean that they employ exactly the same categories, always agree on what is worthy of study, share opinions on quality, or ask the same questions. On the contrary, they engage in polemics and follow intellectual fashion

in art scholarship, just as do artists and collectors (Alsop 1982).[6] The institutional development and strategic behavior I have described are a sampling of the understandings that sociology and social history can supply. They make an issue of matters that are considered transitory by humanist scholars, for whom intellectual content is what counts.

When it comes to choosing from the universe of art works and artists, humanistically oriented scholars or aestheticians much prefer major artists, although they occasionally also try to revalorize forgotten masters. Since social scientists see their disciplinary project centered on the social context rather than on the works themselves, they are more likely to choose works and artists less because of their aesthetic worth then for extrinsic qualities. They may study popular art (Peterson 1973), careers of artists in production industries (Faulkner 1971), or any type of art work without regard to its quality. They may disaggregate the components of art in order to understand its place in society (Bourdieu 1984). Unhampered by thoughts of the sacred nature of art, they are skeptical of such clichés as the exaggeratedly romanticized conception of artists and their creations.

Common in fiction, and underlying the ideas of humanists themselves, these beliefs are congruent with the notion that art is the spontaneous expression of its creator, that it should eschew playing any social role, or fulfilling any social function, and exist for its own sake alone. This is an idea that most educated people in the West have come to accept so unquestioningly that it is important to remind ourselves not to take it for granted as "natural."

Assets and liabilities of these opposing conceptions

Considering the work of art in terms of its social situation tends to reveal processes that shed light on the mystery of art: expressive strategies and career choices of the creator, social institutions, and

6 Among the phases and fads of scholarship are types of discourse or subjects of study. Although the term "fad" contains the imputation of irrational choice, it might be more correct to speak in terms of networks of relationships among mentors and pupils, in the context of a process of professionalization of aesthetic activities.

economic constraints. But what sociologists gain in understanding is at some cost. As Jean-Claude Chamboredon suggests, when sociologists short-circuit a complex process, they tend to reduce art works to mere outcomes of social processes and interactions, leaving moot the analysis of works as specific entities (1986, 309–11).

Whereas humanist scholars try to avoid the Scylla of reducing art to its social function, social scientists dread the Charybdis of a purified, defunctionalized, formalistic conception of art. In fact, however, both humanists and sociologists run the risk of piling up on these rocks because, as the overview of their intellectual background shows, their two camps have more in common than many let on. Taken together, if properly used, their approaches are capable of complementarity.

My own view is that an externalist orientation is essential, not only to clarify the social interconnectedness of art and society, but also to highlight aspects of art works neglected by aesthetic specialists. As with all intellectual strategies, however, despite certain gains, this also poses risks. From a certain standpoint it may be a positive contribution for scholars to treat the arts as social phenomena, the process of whose creation and dissemination is capable of being analyzed by established methodologies. This removes them from the realm of the inexplicable, the ineffable, from being, in effect, quasi-religions. But not all scholars, in particular humanists, share this view, at least not with respect to all art forms. Treating art as the result of a social process[7] is acceptable to most scholars when it comes to works created or produced for didactic, decorative, entertainment or commercial ends. In any case, on the whole many do not dignify the arts of the mass media as art (Arendt 1965, 43; Shils 1965). When it comes to acknowledged masterpieces, however, they reproach social scientists with reducing art (meaning "fine art") to nothing more than the outcome of social processes, having little to do with aesthetic quality.

Many aestheticians and humanists blame such sociological reductionism on the influence of Marxism which, among the soci-

7 Art viewed as a social process has a long tradition, which has been forcefully adumbrated in recent years by H. D. Duncan in his sociology of literature (1953), among many others.

ological traditions inimical to the idea of the sacred nature of art, they think is the most powerful.[8] In these terms, art is merely a reflection of, or epiphenomenal, to the relations of production, a commodity as any other product of the capitalist economy. Although it is unlikely that Marx himself took such a stand, certain others speaking in his name have argued that culture, including art, is an aspect of society's superstructure, dependent upon its base.[9]

These ideas are dismaying to non-Marxian and even to many scholars sympathetic to Marxian analysis. As highly educated individuals, they share a high regard for great art that conflicts with their commitment to demystifying it. They realize that pushed to extremes, frameworks of analysis based on such premises reduce art itself to pure material object at best or, at worst, to a tool for maintaining powerful groups in their advantaged position.

Perplexity with the problem of "greatness" in art pervades debates about art even among scholars claiming to be social scientists. They have addressed themselves in different ways to reconciling the externalist materialist approach with an aestheticist one.[10] In fact, Marx's own writings show that by no stretch of the imagination does he assume that the relationship between the arts and society is at all simple, or that art has no particular significance outside

8 This is the gist of the attack by E. H. Gombrich on the *Social History of Art* by Arnold Hauser. Among other things, Gombrich points out regretfully that Hauser warns against methodological oversimplification, but then goes on to ignore his own advice. "The more one reads these wholesome methodological reminders the more one wonders why the author does not simply give up his initial assumption instead of twisting and bending it to accommodate the facts. And then one realizes that this is the one thing he cannot do. For he has caught himself in the intellectual mousetrap of 'dialectical materialism,' which not only tolerates but even postulates the presence of 'inner contradictions' in history." (Gombrich 1963, 88).

9 As Louis Dupré points out, this is a gross simplification rejected by Engels and many other collaborators or followers of Marxian thinking. He writes that "Marx's sporadic observations do not amount to a theory of aesthetics; nevertheless, they reveal a keen awareness of the complexity of the aesthetic process. Most revealing in his early writings is his view of the aesthetic as a universal quality of conscious life" (Dupré 1983, 230–1).

10 Among the scholars who have confronted these or related questions are Raymond Williams, Georg Lukács, Walter Benjamin, Theodor Adorno, and Lucien Goldmann. My analysis calls upon some of the insights that these scholars have provided, but will criticize some of their failings.

of its social location. As he put it, "[T]he difficulty lies not in understanding that the Greek arts and epics are bound up with certain forms of social development . . . [but] that they still afford us artistic pleasure . . ." (Marx [1939] 1974, *iii*). Whereas some sociologists find this statement to be little better than a cliché,[11] I believe that the implication of his observation which needs to be considered more seriously by sociologists, whether Marxian or not, is that if they do not incorporate the existence of masterpieces that have, indeed, transcended time and place into their frameworks of analysis, they risk confining their disciplines to a concern with the trivial or evanescent.

In this regard, however, just as sociologists have at times dealt unconvincingly with questions of aesthetics, in fairness, it is necessary to point out that aestheticians who ignore the relations of their subject to its social context have done little better. Aestheticians claim that great art speaks for all time and to all humanity. It is for this reason that they criticize social analysis which, they say, reduces art to mere reflections of social, political, or economic processes (Gombrich 1963, 86). But a purely aesthetic analysis by itself is no less potentially reductionist than the reductionism imputed to many sociologists. When aestheticians treat art as a specialized activity of little import to anyone but restricted groups with specialized interests and knowledge, thereby confining art to a coterie, they make a shambles of their claim to universalism.

Underlying this attitude toward art and to art forms that they exclude from consideration is an elitist premise. Art professionals often give little credit to the lay public's ability to judge artistic value. Yet at the same time it has become a virtual truism that aestheticians themselves often disagree among themselves. And for all their certainty, their judgments about artistic value are only rarely uncontested in the long term, sometimes changing as rapidly and totally as fads and fashions of less exalted art domains (Meyer 1967; Harold Rosenberg, 1970, 389). Sometimes even works that

11 Janet Wolff, for example, seems to brush this aside by referring to the passage as "the well-known problem (perhaps first raised by Marx in his unsatisfactory reflections on why Greek art still appealed to nineteenth-century audiences) of the persistence of some works beyond the operation of their own social and ideological structures" (Wolff 1983, 23).

are renowned as great art find themselves downgraded (Alsop 1982, Chapter 1).[12] It follows that whatever else it contains, "greatness" stems at least in part from the changing opinions of a changing cast of experts, within a social world of changing sensibilities, and the degree of interest that certain works arouse among nonspecialists. While this idea may be disturbing to certain artists and art professionals, it has served to open up new avenues of understanding for others who have come to view art as a part of a society's culture, rather than as a world apart.

The intellectual barrier between humanistic study of aesthetic objects on the one hand and social scientific study of art on the other has stultifying effects on understanding that need to be mitigated. These are increasingly being felt and combatted, both by social scientists *and* humanists, the former by breaking away from an overly scientistic conception of sociology, the latter by recasting their scholarly work in a more sophisticated view of the social embeddedness of art. Another approach is to bring to bear ideas from fields of study that span the gap between these approaches. Cultural anthropology, with its dual tradition of humanism and science, offers promise for bridging it because it may be seen as recognizing universality, variety, and integration of the arts in the conception of culture.

Art considered as a part of culture

Art and culture are virtually synonymous as far as the lay public is concerned. Anthropologists, however, treat culture much more expansively than art alone. Accordingly, they see culture as a

12 Alsop cites the case of the Apollo Belvedere, a work long viewed as one of the greatest examples of classical sculpture. Among its many admirers were Goethe and, of course, all the popes, in whose collection it remains since its acquisition, as well as curators, art historians, and critics. Yet as Alsop shows, albeit well supported by some of the highest aesthetic authorities, its reputation has suffered a serious decline. Many more examples of this sort exist. Although there has been no major change in knowledge about the Apollo Belvedere, reputational changes are especially likely to occur when it turns out that a work has been *incorrectly* attributed to a major artist. But even without changes in attribution, certain styles or works rise or fall in public estimation. The case of the Beaune altarpiece (Chapter 4) is an example of the process.

whole, consisting of symbolic meanings or structures of thought, which in turn structure ideas and ways of thinking, including religious beliefs, ethical values, and symbol systems including language, as well as aesthetics and the arts. Because in one way or another all of these aspects of culture are found wherever human societies exist, they are considered "cultural universals" (Herskovits 1948). The awesomeness of this universality brings home the realization that viewing art as the sort of luxury good it has come to constitute in modern society is tantamount to viewing the cooking of food as no more than "gourmet cuisine."[13]

Whereas for many anthropologists to include the arts in one way or another in their studies is taken for granted as legitimate, for most sociologists it usually involves a specialized interest. This does not mean that, regardless of what else they do, that anthropologists invariably pay attention to the arts, whereas sociologists do not. The anthropological discipline is at least as varied in approaches as those of sociologists.

Certain anthropologists have tried to understand the functions of the arts in fulfilling human needs, religious or magical ends, or cementing alliances among widely separated groups (Malinowski 1922.). Some focus on the position of artists in their society, seeking to know and understand how they are supported, whether by patrons or other structures of support, such as selling their work to a market of one sort or another. They compare the relative standing of artists with other occupations or professions, whether they are permitted or encouraged to be innovative or nor (Firth 1982, 58). Still others analyze symbols and rituals, which have at least in part an aesthetic aspect, to grasp the structures of thought

13 Acknowledgment of the universal prevalence of art in all societies thus far studied does not, of course, explain *why* art exists, or why among specific groups we find certain forms of art and not others. Some scholars argue that art is a necessary feature of human biology that is a positive factor in the evolutionary success of the species and therefore a human universal (Dissanayake 1982). Others, rejecting the idea that biological adaptiveness explains culture, acknowledge the importance of art because it is inextricably intertwined with cognitive structures of thought, cultural values, symbolic representations, and when correctly decoded, helps reveal features of religion, economics, politics, symbolic status, or several of these realms combined, thus unveiling the cultural totality (Malinowski 1922). Clifford Geertz discusses this in an essay (1973, Chapter 2, 40).

and world views of their subjects, and the cultural structure of the society itself (Turner 1967; Douglas 1973; Geertz 1973).

Although these approaches may converge with the interests of certain sociologists, their goals and the constraints under which they work diverge, in part because of the conventional division of labor between the disciplines. Whereas anthropologists usually put their questions to small, homogeneous, kinship-based societies, sociologists direct their attention to large, heterogeneous societies, composed of peoples of different traditions, occupations, social statuses and world views.[14] Whereas anthropologists aspire to a holistic understanding of a culture, it would be far more difficult and perhaps impossible in large, complex, modern societies to aspire to the same goal.

As a rule, in societies of the sort that anthropologists have traditionally examined, the institutions and connecting links typical of complex societies are less overt. What this means is that these societies tend to have relatively unspecialized institutions ecompassing a number of functions, whereas institutions in modern societies generally deal with more clearly demarcated matters. Thus in relatively simple societies, religion and political governance, religion and health care, economic activities and familial obligations, to mention only a few, are likely to be carried out by the same individuals, legitimately playing clustered social roles, all of which may involve art in one way or another. In contrast, the societies which sociologists are likely to study present greater separation among these institutional arenas and more internal specialization within them.

It is evident that institutions associated with art vary considerably one from the other, as do the art forms and styles associated with

14 This is, of course, simplifying considerably. Anthropologists no longer are as apt to study "simple" societies if, indeed, they could agree as to what such a society is. As Geertz wrote recently, "It can't be that we study 'tribal' or 'primitive' peoples, because by now probably the majority of us don't, and anyway we're not so sure anymore what, if anything, a 'tribe' or a 'primitive' is. It can't be that we study 'other societies,' because more and more of us study our own, including the increasing proportion of us – Sri Lankans, Nigerians, Japanese – who belong to such 'other societies.' It can't be that we study 'culture,' 'forms of life,' or the 'native's point of view,' because, in these hermeneutical-semiotical days, who doesn't?" (Geertz 1985, 623–4).

them. Modern societies display a level of artistic heterogeneity and simultaneity of styles heretofore unimagined. These result both from the creative process itself and also from the appropriation of finished works, such as art from "primitive" societies, now in private and public collections, the "booty" of expanding modern states. Unlike large complex societies in which a broad range of "art worlds," each connected to related institutional spheres or subcultures, social classes, or status groups coexist, simple societies consist of only one or a few art worlds (Becker 1982) involving a distinction between, perhaps, the world of the "sacred" and the world of the "profane." Moreover, in complex societies a number of institutions specialize in creating art, along with vocabularies and discourses germane to each of these worlds.

The variety of forms and types provides a pool of resources for the production of increasingly fine distinctions among the arts. These include distinctions between the arts and crafts, fine art and popular art, and numerous differentiated genres. Under certain conditions, the distinctions are made to serve as gradations of value (Becker 1982; Bourdieu 1984). But despite distinctions, the arts are no respecters of conceptual boundaries created by analysts or artists.

Implications of the differences

The differences among the arts of technologically primitive and of technologically advanced societies are such that they require and permit of different modes of analysis. In advanced societies art is likely to be more heterogeneous, and groups more segregated than in the simpler, smaller cultures that anthropologists usually consider. Whereas the microscopic ethnographic studies that anthropologists have pioneered are appropriate and efficacious in small societies, it is taken for granted that when similar methods are used in larger societies, they can only be of limited value unless supplemented by other methods, depending upon the nature of the problem under consideration. Macrosociological data analysis is an important option as well (Blau and Hall 1988), as are social historical (Hauser 1951, 1982) and interview-based studies (Rosenberg and Fliegl 1965).

While most of the methods used by sociologists are predicated on the availability of data sources unavailable to anthropologists,

this does not mean that anthropological field methods cannot be, or have not been, part of the sociologist's toolkit since the early days of the discipline (Clifford 1983; Bulmer 1984). From the now classic studies of subcultural groups (Whyte 1943; Liebow 1967; Gans 1975), and even though eclipsed by a different orientation (as I show in Chapter 2), ethnographic approaches have been important parts of methodologies in the study of artistic subcultures as well (Adler 1979; Becker 1982). In fact, far from rejecting anthropological approaches as irrelevant to understanding the arts in modern society, in recent years anthropology has had an important impact on sociologists, either directly or in conjunction with related influences derived from literary criticism or structural linguistics. Both sociologists and anthropologists are reorienting their approaches, in line with ideas derived from literary sources on the one hand, as in the dialogic form of discourse analysis (Lukács 1963; Bakhtin 1968; Clifford 1983), through symbolic analysis based on a rereading of pragmatist philosophy (Rochberg-Halton 1986), as well as through the "thick description" of Clifford Geertz (1973 Chapter 1). In so doing they surmount rigid empiricism by incorporating imaginative if risky methods of interpretation to explicate aspects of art objects themselves in relation to other cultural structures of society (Geertz 1980; Sahlins 1985). They treat art objects as texts to be read, in order to tease out meanings from them that are not immediately evident when using more direct means.

Certain art forms lend themselves to being read more easily and clearly than others (Meyer 1967, 16–18), although each specialist in an art form seems to think that his own subject is more difficult to grasp in this way than others. It may seem obvious that literary works are "read," but it is challenging to try to "read" music; paintings and sculpture; commercial art or design (Francastel 1961; Berger 1981; Mukerji 1983). As the music critic Wilfrid Mellers has written, "The book is esoteric and hermetic only in so far as music, of its nature, is more abstract than the other arts: for whereas painting and sculpture, even when belonging to the genres described as abstract, to a degree imitate reality, and whereas literature affects communication by way of signs similar to those we employ in normal speech, music is a semiological language – if language it be – that functions on its own terms. Its meanings are more basic than other arts. Its imitative properties, to the extent that they

exist in (say) the henniness of Rameau's *poule* or the cuckoldry of Beethoven's cuckoo, are superficial, even trivial; its essence lies in its relation to the science of number. This is why our progressive Western world, though it has tended to forget that all art is revelation as well as incarnation, has never totally denied the religious implications of music, an ultimate repository of truth" (1987, 813).[15]

Music is, no doubt, more opaque than other art forms, though how much more than some forms of plastic art is difficult to measure. Clement Greenberg, an expert in visual art, considers the readability of images, their translation into literary language, as no less difficult. "It is easier to write plausible literary criticism than plausible art criticism. You can write at length about the questions raised by the kind of life depicted in an indifferent novel or even poem, and whether or not you make a contribution to general wisdom, the chances are that your failure to deal with the novel or poem as art won't be noticed." (1984, 8).

Beyond these developments, and congruent with a pervasive characteristic of much Western anthropology in the past half century, anthropology has championed a point of view that enables it to encompass many aspects of the arts of both primitive and advanced industrial societies. This is based on the attitude of respect for human diversity that may help social scientists resist quick judgments about art and instead, devote serious and sympathetic attention to artistic production regardless of the valuation, devalorization, or even stigmatization it may be subjected to. This orientation is founded on cultural relativism, itself analogous to trends in contemporary modern art, for which the nearly total lack of institutional criteria of quality tests the limits of art itself.

15 Although Mellers may exaggerate the conventional association of music with mathematics, to which I alluded earlier, there is some evidence that musical ability is related both to mathematical and other abilities. It is worth noting that the cognitive psychologist Howard Gardner suggests that mathematical intelligence is only one of the different kinds to which musical intelligence may be related. "As an aesthetic form, music lends itself especially well to playful exploration with other modes of intelligence and symbolization, particularly in the hands (or ears) of highly creative individuals. . . . In my own view, the task in which musicians are engaged differs fundamentally from that which preoccupies the pure mathematician" (Gardner 1985, 126).

Debating art

The problem I evoked at the start of this chapter centered on the lack of consensus as to *what* art is. This uncertainty may be treated as a minor matter, having to do with individual taste or, to the contrary, as an issue with important social consequences. But more is at stake than idiosyncratic taste. As I show in succeeding chapters, artists and their supporters fight for recognition; debate endlessly and with passion about aesthetic quality or concerning what kinds of works to include in the category of art. Aesthetic judgments are embedded in institutions that both maintain existing canons and serve as loci of their creation. Their officials or agents apply themselves to establishing and prescribing what those judgments should be, thereby helping to enforce a consensus. Rather than assume that there is no consensus about art at all, it is more accurate to seek a plurality of shared conceptions.

Cultural institutions, though more or less specialized, share the characteristics of many other social institutions. They are not fixed and static but change from the time they are established, as generations of members succeed one another, and in the context of external conditions. No matter how authoritarian and rigid, they never achieve total consensus because, as conflict analysis suggests, in situations of scarcity, competition is likely to be endemic. For the arts in particular, competition for patronage, market position, or access to honored standing is far from new, but gained prominence in the nineteenth century, a period of major institutional transformations.

It is worth considering briefly the most celebrated example of these processes in France, where competition became especially marked among artists who opposed academic strictures defining quality of execution and hierarchies of artistic value (Boime 1976). For artists who refused to bow to established canons of technique, content, and deference to tradition, as interpreted by official juries, life was difficult indeed (White and White 1965). They were not permitted to benefit from winning prizes from the prestigious artistic institutions of their nation, receive commissions for public art from their government, or easily find patrons.

The story, told and retold, is that if in the face of rejection and ridicule artists maintain their integrity, eventually they win fame.

This trajectory encompasses the elements of an honorable history, though frequently only after the artist's death. In recent years, the most spectacular example of this pattern is Van Gogh who, as constantly reiterated by the media, had succeeded in finding a buyer for only one work during his life. After his death, not only did his works become valuable properties, but by comparison with most other paintings, including the old masters of the distant past, Van Gogh's *Irises* fetched the highest prices for an art work sold at auction, fifty-four million dollars!

Although this is a particularly extraordinary example, it follows a pattern by now well established, but distorted by the mythologizing of the social role of the romantic artist as hero. To maintain sociological perspective, it is important to remember that although Van Gogh was committed to creating innovatively, by comparison with later artists, he was not extremely unconventional. He painted or drew with conventional materials and lived in hope of selling his pictures to ordinary, though discerning, collectors.

More striking since his time is the growth of interest in, and prices for, works by creators who deliberately challenge the notion of the art work altogether. Some of these artists do not merely paint in styles opposed to some canon, they work in media totally unlike those associated with conventional art works. Some avoid oil paint and canvas (or associated materials), choosing instead to manipulate found objects, ready-mades, junk. They may reject making saleable works in any form, preferring to create landscape or environmental art *in situ,* or ephemeral objects, concepts rather than solid things, music that cannot be played on conventional instruments; working not individually, but as collectives. Activities such as these flowered during the late 1960s and 1970s, and were found suitably shocking, as avant-garde activities by *tradition* should be. It is important to bear in mind that to a great extent marginal artists now follow the example of their precursors, as if they had learned their social and aesthetic role.

Among the most influential creators of these traditions was Marcel Duchamp (1887–1968), who made a profession of twitting the respectable art world in ever more disrespectful ways. Having started as a painter dabbling in various advanced styles, he gained notoriety by presenting a cubo-futurist-inspired work entitled *Nude Descending a Staircase* at the Armory Show of 1913 in New York. The painting created a major scandal, providing material for sen-

sational copy in newspapers because it rejected conventional figurative realism (Goodrich 1963). Even as provocative as he had made it, however, Duchamp eventually surpassed himself by assaulting the very idea of what art is. Rather than confine himself to oil and canvas, Duchamp attacked the best known and arguably most sacred work of art, Leonardo's *Mona Lisa*. On its reproduction he painted a mustache and appended an off-color pun as its title.[16] This behavior earned him the execration of the respectable art world of established collections and museums.

Duchamp did not confine his mischief only to the old establishment but outraged the modern art world as well. For while it is not surprising that the world of the antimodern Metropolitan Museum of Art dismissed him scornfully, the *respectable* avant-garde art world, the very source of his patronage, was also appalled – or at least titillated – by his behavior. This occurred when he ostentatiously submitted to a modernist art show (with whose jury he was himself connected) a piece of ordinary porcelain plumbing, a urinal, which he entitled *Fountain* and signed with the amusing signature, "R. Mutt." Although the object was rejected for display at the exhibition, the furor which it aroused has become, just as Duchamp seems to have intended, part of the work's definition as an art object.[17]

16 It is not clear that non-French speakers who saw the work were aware of the smutty character of the title; the letters, *L H O O Q*. They were to be read slowly in the accent of the French alphabet. Done that way, they say *"Elle a chaud au cul,"* meaning in a loose translation, "She's got the hots."

17 It is difficult to know just what Duchamp had intended. In an interview shortly before his death, he gave interpretations of the work, the title, choice of the signature, that conflicted with earlier statements and interpretations. Given the nearly half century that separated him from the event, and the high regard in which he had come to be held, it is not clear what he had in mind, if that matters. Bourdieu notes that the critic Rosalind Krauss believes it is a pun on the German word *Armut,* or poverty. But Duchamp denied that with the claim that it comes from the name of a firm making sanitary equipment, called Mott Works. Spelling it "Mutt" is a nod to the popular comic strip, *Mutt and Jef* [sic]. The reason for preceding it with the letter *R.* is that it stood for "Richard," because it struck him "as a good name for a loo!" (Bourdieu 1986). Without wishing to embellish these interpretations further, I should add that there may be more to Rosalind Krauss's insight than even Duchamp could fathom, since a popular work in French ideas about America is Benjamin Franklin's *Poor Richard's Almanac.* Thus, *Armut* may be correct after all.

The result of incessant attacks upon the meanings of art has, for the time being at least, opened the way to the possibility that almost anything might be put forth with the claim that it is a work of art (Bourdieu and Delsaut 1975). We have become accustomed to considering something a work of art if it has recognizable features, such as a signature, or if it has passed through a certain "career." In the past the career consisted of being made by an artist who had received an education in some sort of institution; won prizes and other recognition, exhibited work in juried shows; sold works to collectors, preferably through a dealer. The crowning achievement was exhibition in and eventually entry into the permanent collection of a museum. Nowadays even career stages for marginal art are discernible. They generally incorporate aspects of the traditional career, but with outrageous variations.

A recent case may serve as an example of the process. It concerns an individual who, having bought the house and grounds previously inhabited by a well-known abstract expressionist, discovered a "painting" that had been left behind. The new owner was able to have certified as genuine the seat of a disused outhouse which had been decorated as a joke by the artist. Subsequently, clearly inspired by Duchamp, he put it up for auction (Danto 1985, 282–3).

If "art" has become a term of uncertainty, it is hardly surprising to find that it has also become difficult to designate certain works "fine art" as opposed to other kinds of art, for example craft, commercial art, popular or naïf art (Becker 1982). Criteria demarcating the boundary between the fine arts and the popular arts used to be fairly clear. By definition fine art was "certified" through official acclaim, acceptance by museums; high price enhanced by scarcity or uniqueness of the works (Moulin 1978), attractiveness to a limited and exclusive public, the disinterestedness of the creators (the art work as an end in itself) (Bourdieu 1984), and complexity of content or texture (Gans 1975). Put simply, fine art is for elites of wealth or of knowledge rather than for the public at large, except insofar as its members are similarly gifted or have acquired the requisite intellectual framework. These attributes are extrinsic to the work itself and stem from cultural institutions or the economy of the art market.

Aesthetic value or quality has undergone so many challenges that except for the most dedicated formalists, sociologists and

certain art professionals try to disregard it altogether. They confine themselves to other matters, such as history of provenance, that sidestep issues of quality. This strategy implicitly supports the view that the arts are socially constructed entities, with symbolic meanings that are not immanent in the works themselves but change under different social conditions (Wolff 1983). The relativism underlying these sociological formulations troubles some sociologists, who contend that this conformity to the ideal of value-free social science presents an intellectual and ethical dead end (Goldfarb 1982; Balfe 1985). They deplore the refusal of most sociologists to consider value in a domain so laden with value, citing various reasons that, together, add up to the fear that sociologists trivialize a potentially important scientific endeavor, leaving to the humanists and critics what should be the task of all scholars. Their intellectual stance is made more difficult by the lack of criteria of value for modern art, which I have discussed in this chapter. It becomes even more problematic, however, in light of the extreme heterogeneity of the arts in modern societies. Debates about art go beyond deciding what is suitable to be included in the category of fine art to deal with commercialized forms as well.

Considered in terms of its anthropological universality, it is clear that art has many social functions, varying in different kinds of societies, but usually related to religion, social control, and commerce. The most salient feature of the arts in modern societies is their infinite variety and the opposing perspectives on them that coexist. Art may be considered lofty or trivial; dispensable or vital; innocuous or dangerous enough to be regulated and even censored. The rarest is what has come to be called fine art, conceived as existing for its own sake, the expression of spontaneous individual creativity, transcending its time and place. Sociologists of art try to encompass these conceptions of the arts in coherent frameworks. In the chapters that follow, I show how well some of them succeed and suggest ways that might take them farther.

Plan of the book

I have made the case in Chapter 1 for a sociology of the arts that keeps the arts themselves at the center of theoretical concern. Intellectually this involves overcoming the narrow perspectives of

both social scientific and humanistic aesthetic disciplines. This does not mean, of course, that there is no place for the narrow-gauge approaches of specialized study. But those who undertake studies of that kind should be aware of the limitations under which they operate.

Until recently, American sociologists, who came to dominate the social sciences, at least since the end of the World War II, had devoted little attention to the arts. In light of their influence, it is important to consider the reasons for their intellectual choices. In explaining American sociology of the arts, I follow my own strictures, by attributing importance to the context within which sociology developed. Setting my analysis in the framework of developments in American social and political conditions and beliefs, I argue in Chapter 2 that while the orientations of American sociologists depend strongly on these patterns, they are intertwined with institutional and disciplinary aspirations of sociologists as academic actors. The increasing interest in cultural and artistic study by sociologists today stems from changes in the social context of the university, interacting with changes in the nature of art itself.

As case studies illustrating the diverse approaches created by and available to scholars, in Chapter 3 I analyze research, bringing to bear humanistic and social scientific outlooks and methods on the relations of art and music and its performance to different kinds of societies; primitive or industrialized, high art and music or popular. Continuing the perusal of different approaches to other forms of art, in Chapter 4 I look at the collective and historical processes whereby art works are created, and come to be "re-created" at different times for new social purposes.

The case studies that I consider in Chapters 3 and 4 may be taken as evidence for the reputation sociologists have earned for not being concerned with the creative process itself. They tend not to consider specific artists, but rather construct "the artist" as a social type. In Chapter 5, therefore, by reviewing theories about the making of the artist, I show how the disciplinary orientation of sociologists tends to direct attention away from highly individualized social roles. Even when acknowledging that artists of different ability levels, art styles, and art forms are not interchangeable, sociologists are more likely to explain them in general terms than as unique individuals, especially not as geniuses, a view

at odds with that of aestheticians and critics. In looking at how artists are made, I address three levels of analysis: the individual, the production matrix, and the overall social structural configuration. This framework includes processes of discovery, recruitment, and socialization of artists, and raises the question as to how important is the psychological makeup of the individual involved in light of the institutional structures in which artists function.

Just as art is not created in a vacuum, once created, it does not exist in a vacuum. Since art has no existence without an audience, in Chapter 6 I consider the interrelationship of art and its public. Rather than accept the common sense notion of the audience as a permanent feature of society, a pleasure-seeking entity, I argue that the audience is a social construction, as are the art forms to which its members are oriented; that their relationship to the arts, far from simple pleasure seeking, is a complex social process involving the development of different ways of receiving and using symbolic culture with consequences for social reproduction of status groups.

Artistic change or innovation has attained such high esteem in modern times that it is difficult to imagine a different state of affairs. In Chapter 7 I argue that change was not always and everywhere highly valued, either from the standpoint of artists or their publics. Yet because of recent developments, attention is more likely to be directed to accounting for change than to explaining stability. From an internalist perspective, change is the result of the exhaustion of style, whereas externalist observations see the causes in political, economic, social, or cultural terms.

Finally, in Chapter 8 I take stock of the sociology of art as a field of study. In recent years it has benefited from promising theoretical advances, as well as enhanced research possibilities stemming from the availability of new data on the arts, audiences, cultural institutions, and art professions. They help to verify or refute speculative theories concerning the role of culture in either reproducing existing social inequality or undermining it. Rather than look only at the social concomitants of art, however, I show how the incorporation of previously excluded art forms and groups associated with them are intertwined.

The goal I set myself in this book is to suggest ways by which the approaches of sociologists and those of art professionals or humanists may be brought into congruity. I do this not for the

sake of a factitious harmony, since each set of disciplines has its own goals, and methods for arriving at them. Rather than maintain barriers between them, however, I argue that their proponents should learn from each other, not merely for the sake of creating a unified view of the arts in society, but by maintaining the creative tension which exists between sociology and the arts to achieve greater social understanding.

2. Why sociologists have neglected the arts and why this is changing

CONSIDERING THE UBIQUITY and omnipresence of the arts in all known human societies and the varied individual and social functions they seem to serve, it is strange that until relatively recently sociologists, and American ones in particular, have not incorporated them into the center of their intellectual concerns. The reasons for this gap have a great deal to do with the development of sociology in the United States because for various reasons, some circumstantial, others arguably systemic, American sociology came to dominate sociology as a whole for several decades. Examining the scholarly foundations on which sociology came to be modeled reveals how the arts ended up being virtually excluded from its purview. In this chapter I present reasons for this apparent avoidance of the arts, a situation that had come almost to be taken for granted.

Just as an internalist analysis of the arts provides only a limited understanding of the aesthetic realm, analysis of a discipline divorced from its social context is equally flawed because sociologists tend to be drawn to the study of subjects recognized as important by the society and the nation state in which they function. Sociology, no differently from other social sciences, virtually all of which are nineteenth-century constructions, is best considered even today as a discipline and profession in process of formation. Sharing the assessment of many Americans, sociologists judged the arts as being of far less importance than other issues for their professional concerns and consequently allocated them little space in sociology. It is useful to consider how and why the fine arts came to be viewed as a dilettantish pastime for leisured ladies and effete men, particularly foreigners, and thus marginalized.

Part of the answer is that the arts have been victims or beneficiaries of the marketplace. When a painting by Van Gogh changes hands for fifty-four million dollars, art becomes a serious business. The arts are now recognized, subsidized, and honored to an unprec-

edented degree by the state. Related to this recognition are changes in form and content of the arts themselves, a blurring of the lines between categories such as "fine art" and "popular art"; and mainstream recognition of art previously marginalized, such as the arts of women, "amateurs", and minorities, to mention only three overlapping cases. These are among the reasons why sociology has begun to make the arts more welcome than before.

American society and the arts: an ambivalent relationship

> I must study politics and war, that my sons may have the liberty
> to study mathematics and philosophy, geography, natural history
> and naval architecture, navigation, commerce, and agriculture,
> in order to give their children a right to study painting, poetry,
> music, architecture, statuary, tapestry, and porcelain.
>
> John Adams[1]

It may seem that the arts have always been highly esteemed in American society, central to its system of values. Why think differently before the enormous crowds filling museums, attending orchestral performances in every major and even middle-sized city, contributing gifts of money or art objects, volunteering their time to cultural institutions, applauding presentations of medals and awards, grants and fellowships, to artists of all kinds by the nation's most prestigious institutions? On top of sheer quantity of plastic and visual art works, music, dance, and theatrical works, the generally high quality of performances available to so many people, makes it difficult to believe that America was not always a haven for artistic creation, exhibition, and performance. Yet becoming a world artistic leader was by no means a clear outcome only a century and a half ago. As Daniel Boorstin has noted, "Today the United States is one of the world's great centers for the fine arts. Yet only a century and a half ago a snide English critic could indict this country by the mere question, 'Who looks at an American picture or statue?'" (Taylor 1979, *vii*).[2]

1 Letters of John Adams to his wife, ed. by Charles Francis Adams [1841], vol. II letter 78 [1780].
2 Boorstin, editor of the Chicago History of American Civilization and former Librarian of Congress, is only one of the many commentators who have noted how far America has come. The English critic was referring to painting and sculpture made in America by American artists, rather than art collections,

Whether assailed by aristocratic critics of democracy who assumed that Americans could never be anything but uncouth, or even by relatively sympathetic observers, the United States did not seem to comprise a soil fertile for the arts. For one thing, to many Americans the fine arts were associated with an elitism incompatible with democratic aspirations and ideologies, while the popular arts were tainted by an equally suspect commercialism. These ideas form the basis of many analytic assessments of the United States in the past, and for some sectors of opinion, remain a durable myth.

Myths often contain a core of truth, and this one is no exception, as numerous foreign as well as American intellectuals have argued. Of the visitors to the United States in the early decades of its existence as a Republic, Alexis de Tocqueville was trying to understand the way in which democracy functioned in a system that had abolished distinctions of status or condition to a degree foreign to then existing European states (Tocqueville 1955, 36–56). Although Tocqueville did not concentrate specifically on art, the breadth and depth of his vision and the power of his analysis permit extension of his insights to the arts in American society. Specifically, he broached the problem of whether democracy and excellence could coexist, a question that continues to trouble sociologists today (Goldfarb 1982; Balfe 1985), and is worthy of analysis in its own right (Chapter 8). Enthusiastic about many aspects of political structures and life in the democratic nation, he nevertheless expressed reservations about certain institutions and trends. Among the most dismaying was the fate he foresaw with respect to the arts and crafts. It seemed to him most unlikely that democracy in America was compatible with high aesthetic quality. His reasoning derives from his preconceptions about the nature of art on the one hand and his perception of a complex set of social structural, political, and cultural values on the other, and the relationship between the two.

Tocqueville started with the assumption that the arts (in which he included crafts), are capable of achieving high quality only when three conditions are met: They must be created and produced

museums, and other cultural institutions. In fact, of course, a century and a half ago very few of the latter existed either.

within corporate or guildlike structures; they must have as their principal clientele a discerning aristocracy; in addition, the cultural traditions of the country must be hospitable to the arts. As far as he could see, in America none of these institutions or traditions existed, with serious implications.

First, the apparent absence of an occupational structure to see to the training and control of craftsmen meant that there would be no quality control over works at the source. Secondly, equality of social condition (at least with respect to white men), while congruent with democratic goals, meant that no aristocracy would arise. The two factors combined served as the basis of his prediction that standards were likely to deteriorate. How could one insure the proper training of craftsmen under the authority of masters without, on the one hand, a well-structured organization of work, and on the other, a demanding clientele that would reject products of poor quality?

In the same vein, the absence of social distinctions, which made possible upward mobility unhampered by differences in condition, could not be an unmitigated benefit for artistic and cultural growth more generally. On the one hand, if upward mobility were un-checked, the market of buyers for artistic (as well as other) products, composed of untutored consumers, would surely encourage high production, but at the cost of quality. On the other hand, since there seemed to be nothing to stop it, downward mobility was just as likely a possibility in this open society. Thus, just as a public of parvenus would try, as did Molière's *bourgeois gentilhomme,* to adopt a life style for which they were totally unprepared, a public of déclassés, though perhaps the bearers of good taste, would lack the means to maintain a life style in which owning high quality art works and furnishings was possible. To conceal their déclassement, they would be tempted to preserve surface appearances of gentility by acquiring ostensibly artistic but cheaply contrived products, thus contributing even more to decline in the quality of crafts and, consequently, of life.

Finally, he took as the cultural orientation of the country the Puritanism that he believed to be dominant. Although it impressed him as partly responsible for certain American achievements, he feared it would present a barrier to the development of the arts since, because of its austerity, Puritanism was basically incompatible

with the worldliness and sensuous values intrinsic to the arts. It would cause Americans to reject decoration for its own sake in favor of practicality. Although each of these institutional arrangements and traditions by themselves would not by themselves have such negative effects, taken together, he saw them raising barriers to cultural eminence.

Tocqueville's generally pessimistic view should not be taken as a rejection of democracy or of Puritanism. Despite his own aristocratic origins, he was critical of the failure of ancien régime aristocracy to create a responsible role for itself (Tocqueville [1856] 1955a.[3] But for so wise and reliable an observer, Tocqueville reveals himself to have had only limited opportunities to see the America of 1831. Though prominent, Puritanism was by no means the only religious ethos extant in America, nor did it entirely reject sensuous pleasure. Beyond that, his apparent unwillingness or lack of concern to acknowledge an aesthetic canon different from that derived from his own upbringing is understandable. More troubling is his seeming inability to imagine that common people might either produce fine art or become a discerning public. Yet despite these failures of imagination, his observations highlight the question of why the arts did not immediately burgeon in the United States. With some caution, therefore, we may take his assertions as a framework for understanding the development of the arts in nineteenth-century America.

Tocqueville was struck by what seemed a preference for plainness rather than decoration, something he attributed to American practicality. This is indeed a stylistic characteristic often noted in nations or governments seeking symbols representative of democracy. In the United States in particular simplicity was clearly a criterion stipulated in commissioning art work for government buildings. In cases where artists incorporated rococo elements (cupids and curlicues) into decoration, American observers derided these images

3 "When we remember that it was in France that the feudal system, while retaining the characteristics which made it so irksome to, and so much resented by, the masses, had most completely discarded all that could benefit or protect them, we may feel less surprise at the fact that France was the place of origin of the revolt, destined so violently to sweep away the last vestiges of that ancient European institution" (Tocqueville [1856] 1955a, 204).

for their inappropriateness to a society based on freedom and equality (Miller 1966, 76–8).[4]

Tocqueville's observation suggests that, on the whole, opinions concerning the appropriateness and quality of public art are often divided. All states, whether repressive or liberal, including post-monarchical modern states, promote aesthetic representations of their nation through styles symbolic of guiding ideas and ideologies. But unlike autocratic regimes in which differences of aesthetic judgment are likely to be repressed, in democratic societies they are permitted to surface because like many other types of political decisions, they are open to negotiation and to criticism. Tocqueville's impression notwithstanding, in fact, the Puritanism of American communities was not confined to the sects descended from the original Puritans. Instead, attempts to censor the arts were likely to emanate from a number of moralistic religious forces in a variety of sects or churches. They include small town fundamentalist Protestants and, what Tocqueville might not have predicted, with their arrival from the second third of the century on, big city Roman Catholics, clergy and laity, who directed much of their effort against the popular arts, as they would later against the mass media (Lynes 1985).[5] Nevertheless, it is important to recognize that regulations attempting to control or impose certain sorts of morality existed and continue to exist with various degrees of vigor. While much local repression has been directed at the popular arts, even

4 Actually, it should be noted that a certain simplicity was frequently preferred in art and architecture even in France under certain monarchs, but more often in times of democratic revolutions (T. J. Clark 1973). If in America the aesthetic quality of simplicity in the art works, buildings, and related symbolic artifacts of the nation were later less well regarded, however, it is not because their "form followed function," an aesthetic tenet that did not become an important stylistic canon until more recently.

5 Overt censorship of art works in established institutions such as museums and opera houses has become a rare occurrence today. In the past, however, when Mary Garden, for example, ran the Chicago Opera Company, she scandalized conservative opinion by appearing in such shocking works as Massenet's Thaïs because, despite its moralistic ending, it gave her the opportunity to play the temptress in flimsy garments. Earlier, apparently, the Milwaukee Opera tried to put on Richard Strauss's Salomé, to much the same scandalized reaction as in Europe. The production and reception of such features in works as nudity and other forms of "immorality" deserve careful analysis.

cultural institutions, such as museums or opera companies, which address themselves to "respectable" citizens, sometimes find themselves involved in disputes, directly or indirectly, over religious issues, such as the content of art works displayed, performed, or published or rules concerning the observance of the Sabbath.[6]

Beside the effects of the Puritan ethos, as I indicated, Tocqueville also feared that rapid social mobility would cause aesthetic decline. It is important to note that he was extrapolating from the legal constitution to its presumed consequences. While it is true that status barriers of "condition" were absent, there is some doubt that social mobility was much more prevalent in the United States than in other nineteenth-century industrializing societies (Lipset and Bendix 1959). Secondly, the question of whether expanded or mass production necessarily leads to a decline in quality of the product has been and continues to be debated (Benjamin 1969, 217–51; Scitovsky 1977). Most reasoned discourse does not assume that large quantity necessarily degrades quality in and of itself. It is unlikely that quality, whether of manufactured goods or of the arts, has declined as their quantity and the breadth of access to them have expanded.

In Tocqueville's time, in France and a number of European countries, the arts were officially constituted into two categories, one intended for an elite, and the rest excluded from official honor. In the United States only late in the century did the modern barrier between elite and mass art become concrete. Despite the fact that the processes whereby this happened were unfolding at approximately the same time that sociology was becoming a profession, sociology paid surprisingly little attention to the arts, a subject that I consider next.

Sociologists against the arts?

It is usually taken for granted that, in contrast to the concerns of sociology's European founding fathers (Weber, Durkheim, and Simmel), American sociologists had little interest in the fine arts

6 Censorship may take the form of official acts or unofficial community-based protest over certain kinds of visual or aural entertainment. At the level of national government until only a few decades ago, certain literary works, such as novels by James Joyce or D. H. Lawrence, were barred from publication, access to the postal service, and importation into the United States.

or in the arts in general. Whereas, because of their cultural so-
phistication and classical education, Europeans incorporated the
arts and literature within the core of their scholarship, American
sociologists are stereotyped as overly specialized, fine technicians,
but not scholarly gentlemen. In fact matters are much less clear
than this cliché suggests, since European sociologists who actually
devoted considerable time to understanding the relationship of the
arts and society are relatively rare as well. It is essential for un-
derstanding the character of intellectual life to avoid stereotyping
American sociology and sociologists as has sometimes been done
by European sociologists (Morrison 1978), and by American so-
ciologists critical of their intellectual roots. The discipline has not
remained stationary but has developed within and in relation to
its social context; nor has it been unitary in character (Rochberg-
Halton, 1986).[7] Among leading intellectuals identified as sociologists
and whose university careers attest to their scholarly credentials,
Weber stands out, with his work, *The Rational and Social Foundations
of Music* (1958). For although this was Weber's only work dealing
directly with an art form per se, in the tradition of Kant and, to
a degree, Nietzsche, aesthetics for Weber was a cultural structure
parallel to and competitive with religion and its moral concerns.[8]

7 My argument concerning the relative neglect of the arts by the founding
fathers of sociology is the opposite of the recent view by French sociologists
(Chamboredon and Menger 1986, 363; Moulin 1987). Perhaps our divergent
readings of the past represent the phenomenon sometimes referred to as seeing
the glass half empty or half full. While my French colleagues point to Marx's
statements about and (perhaps) intention to go more deeply into Balzac's
novels, and Durkheim's placement of aesthetic sociology into the matrix of
sociology as he created it as signs of its centrality, I argue that these represent
either afterthoughts or, at most, the general intellectual concerns of well-
educated people. Neither Comte nor Marx, despite the breadth of their phil-
osophical and scientific intentions, wrote systematically about the arts (Solomon
1979, 4).

8 Acknowledging that religion and aesthetic creation have operated in tandem,
he noted that the logic of aesthetics is such that art tends to become a "cosmos
of more and more consciously grasped independent values which exist in
their own right" (Gerth and Mills 1946, 340–2). Consequently, art begins to
compete directly with religion, especially during eras characterized by high
levels of rationalization. Under these conditions, aesthetic judgment (taste)
becomes an alternative to moral judgment. In his analysis of the aesthetic
realm, however, he did not sort out the implications of this insight for art
and society.

Of the founders, only Georg Simmel was unambiguously devoted to the analysis of the arts in society (Wolff 1950; Coser 1965; Etzkorn 1968; Frisby 1986).[9] He wrote extensively on aesthetic subjects, including about such artists as Rodin, Rembrandt, Goethe, and styles or movements, including *Jugendstil,* expressionism, as well as on culture more generally. Indeed he was much more identified in his lifetime as a general intellectual than an academic scholar; and many of these writings were published in reviews and newspapers for a public either of laymen or of humanists, rather than for sociologists.[10] In fact, as I show here, American sociology tended to ignore or relegate to the realm of philosophy, literary criticism, or political ideology much of the work of Central Europeans such as Simmel, Lukács, Benjamin, Adorno, and others (Fleming and Bailyn 1969; Coser 1984).

9 Coser's assessment of Simmel's sociological influence by the mid-1960s correctly stresses his impact on small group theory, the formalism of von Wiese and the Cologne school in the interwar years, as well as the concepts of social distance, social roles, and Coser's own studies of social conflict. American urban sociology and reference group theory were indebted to him (Coser 1965, 23 ff.). In fact, Simmel's writings on aesthetics were customarily excluded from consideration by sociologists, as evidenced in Donald Levine's contribution to the same collection (p. 97). Etzkorn's translation of certain of Simmel's cultural and aesthetic essays suggests that American sociologists' propensity to relegate Simmel's approach to the sidelines had to do with their search for single causes, foreign to German theorizing style (Etzkorn 1968, 8). Etzkorn predicted, correctly, that Simmelian ideas would come to be taken more seriously.

10 Although Simmel made important contributions to formal theory and viewed sociology at one level as a science, most of his essays on the arts are in the realm of art theory, criticism, and aesthetics rather than social science. It is striking that for American sociologists his major contribution until recently was his scientist formalism rather than the cultural analysis now being stressed. This is not to be taken as an absolute, since the sociology of knowledge of sociology, as is true of many intellectual analyses, tends to be responsive to contemporary debates. For example, when Morris Janowitz wrote the introduction to the 1969 re-edition, or replica of the 1921 standard University of Chicago sociology textbook, he took the opportunity of responding to critics of mainstream sociology, which it had come to exemplify. Arguing that the book proved the critics wrong who accused it of having neglected the study of conflict and symbolic analysis, he showed that the organization of topics and their treatment are strongly indebted to Simmel's analysis of the processes of conflict, competition, and cooperation.

Although many of the contemporary innovations in sociology of art come from France, they do not derive from an unbroken tradition. The work of Emile Durkheim, the most important figure in the establishment of sociology as an academic discipline, is strikingly bereft of studies directly related to the arts. The strongest indication of how peripheral the arts were to his programme is revealed in the journal that he founded, *L'Année Sociologique,* as an important part of his strategy for institutionalizing the discipline. A journal of review essays, it was intended to disseminate to the nascent profession analyses of studies done by sociologists and scholars from other disciplines. But finding the arts in it is nearly a vain pursuit because by its third year (1898–9), when Durkheim set up the main categories of sociological subfields, space given to the arts is conspicuously modest. Whereas he assigned full rubrics to the topics of general sociology, economic sociology, religious sociology, moral and juridical sociology, criminal sociology, and social morphology, only under the seventh rubric, a residual category entitled *divers* (miscellaneous), is listed the minor subheading, *Sociologie esthétique* (Zolberg 1980).

In light of France's long humanistic tradition of interest in the relations of society and the arts, including writings (still cited) of the historian Taine, and the leading intellectual Madame de Staël, among many others, the reasons for this apparent relegation are not altogether clear.[11] For whatever combination of reasons, as far as the Durkheimians were concerned, the arts remained marginal

11 Perhaps Durkheim identified the arts with play and could therefore not bring himself to view them as worthy of serious attention; or he was trying to place some distance between the new discipline of sociology and the humanities (*lettres*), as he was doing in relation to other disciplines, in order to legitimate its autonomy as an academic field. An increasingly large body of literature exists on the nineteenth-century reorganization of the French university and the place of sociology in its curriculum (Karady 1976; Lemert 1981). In 1935 Célestin Bouglé drew up an accounting of contemporary French sociology, mentioning only in his conclusions the subject of the arts and society. The context refers to the deaths during World War I of Durkheim's son and other young scholars whose investigations of the relationship of linguistics and sociology were thus aborted. Had they lived, suggests Bouglé, they might have pursued the sociological bases of and connections among science, religion, and art (Zolberg 1980).

to their activities, just as, conversely, sociology remained marginal to the concerns of most art historians and theorists.

Given the dearth of active scholarly involvement in the arts by the European sociologists who had the greatest impact on American (and British) sociology, and the selective manner in which their works were incorporated into American frameworks, the contrast with American sociology seems less startling. Just as Tocqueville might have predicted, with few exceptions, to the extent that any American sociologists displayed interest in the arts, it was more as an "extracurricular" activity. Although for long stretches of time American Sociologists concentrated on other matters, scholars in other disciplines, and intellectuals generally, were not hermetically sealed off from one another.[12]

It was chiefly with the arrival of certain European emigré scholars during the 1930s, in particular, members of the Frankfurt school, for whom literature and the arts, both fine and commercial, were central concerns, that new problematics were introduced (Fleming and Bailyn 1969; Coser 1984). Although many resided for a time in a virtual intellectual ghetto, they attracted a number of American scholars after World War II, who came to share their interests. Together they straddled the ground between the humanities and social science (Wilson 1964, *v*), but remained marginal to what became the mainstream concerns of sociology. Like many scholarly disciplines, American sociology has gone through swings from one orientation to another. As studies of science and literary disciplines reveal, from causes internal to their subject matter or from social pressures of their organization, they change in sometimes extreme ways (Kuhn 1970; Amsterdamska 1985). Sociology is no

12 Veblen's name comes most readily to mind, but some of the pragmatist philosophers either directly or indirectly, as in the case of Peirce (Rochberg-Halton, 1986), laid a foundation of thought which could incorporate the arts. This was the case in particular, of John Dewey ([1934] 1958), who became the friend of the leading American collector of modern art, Dr. Albert Barnes. Barnes had formed a major collection of postimpressionist art after World War I, largely on the advice of Gertrude Stein. Interestingly, Gertrude Stein had studied with William James, another pragmatist. What is particularly important is that in spite of university disciplinary development, intellectual life was far from fragmented into rigid departments, whether inside the university world or outside.

exception, as attested to by recurrent debates in the pages of professional publications about what should be its concerns.[13] Looking at how it was changed helps us understand why in the past the arts were rejected and indicates why at the present time sociologists are more willing to consider their study legitimate.

Like the other social sciences, sociology followed a pattern of change from being part of a relatively open field of intellectual discourse in which men and some women, of varied higher educational backgrounds, explored social, political, ethical, scientific, and artistic subjects, to becoming a discipline almost completely embedded in university departments. This did not happen suddenly but was part of a trend whereby the relatively unspecialized intellectual life in nineteenth-century America, often organized in clubs and associations, gradually split into a domain for laymen, while those seeking intellectual depth, not to speak of full-time careers, created a niche in the increasing numbers of institutions of higher education. Not only did possibilities of college teaching increase in the last third of the century, but graduate education, with its emphasis on research, began modestly to develop, and burgeoned from about the last decade on (C. W. Mills 1964; Jencks and Riesman 1968, 77–80, 237).

Whereas like other professions sociology has developed a theoretical basis that raised it above the status of an ordinary occupation, it differs from most because, unlike the ministry, medicine, law, and engineering, it does not provide a service, or care directly for the public.[14] This may seem surprising since, along with many

13 One sociologist has called it a "multiple paradigm science" (Ritzer 1975); others have questioned whether the study of society should aspire to being a science at all (Denzin 1987, 175–9); still others consider sociology to be in the doldrums (Collins 1986, 1336–55), wondering if it is still alive (Denzin 1987, 175–9); and so it goes, and has gone for the century and a half since the word, *sociology*, was coined. Currently it seems to exist as a heterogeneous set of subdisciplines rather than a unitary one (Warshay 1975).

14 Until the early 1980s there had been little incentive for sociologists in professional associations to promote a career line outside of the university world. Except in rare cases, for example, when some worked in the industrial relations field, or during World War II, when sociologists did research for the military (Coser 1984), to the extent that sociologists actually worked in applied fields, they were regarded as, and came to regard themselves as, marginal to the institutionalized discipline, whose proper locus was considered to be in the university

other American intellectuals, sociologists around the turn of the century were deeply involved with social reform movements, some of which became institutionalized in the field of social work or government. Sociology as a discipline, however, soon became distantiated from both the movements and what were to become the applied fields, a transformation that appears to be part of a process of profession creation or building.

Profession building, as analyzed by Magali Sarfatti-Larson, typically involves an occupation in a process of upgrading itself. In order to achieve respectability and autonomy, participants are obliged to organize themselves in particular ways; within the opportunity structures available to them in their society, generally in competition with other groups seeking legitimacy (Sarfatti-Larson 1977). As her analysis shows, competition is not a frivolous game because, not only does upgrading provide jobs and career possibilities, but it serves as a means of gaining control over access by new members, thus avoiding overcrowding of the field and consequently obtaining greater control over material advantages, such as fee setting. If it has previously been allied with marginal fields, an occupation usually tries to distinguish itself from them. The doctors distanced themselves from barber-surgeons; dentists from itinerant carnival tooth pullers. Sociologists followed a similar logic, drawing a line between themselves and certain former allies. Instead of reinforcing their connection with social reform movements, including settlement house activities of women such as Jane Addams, and forming an alliance with the social work profession, for practical purposes they participated in making social work an applied profession with a largely feminine makeup – a semiprofession – while sociology became a largely masculine academic discipline. This does not imply that sociologists renounced all applied research, but the tie

or at least in associated institutes. As Derek J. de Solla Price shows, in the mid-1960s it was much more common for Ph.D. graduates to be employed outside the University in the hard sciences than in the humanities and social sciences. Although sociology was not the most academic bound (political science had 94 percent in university positions), it was above the most "exact" of the social sciences, economics. Thus 75 percent of economics Ph.D.'s and 83 percent of sociology Ph.D.'s held university positions. In contrast, in chemistry and psychology the corresponding figures are 24 and 27 percent (Price, 1986, 158).

between application and subfield expertise on the one hand and theoretically oriented research on the other, was broken (Bulmer 1984, 37).

Sociologists, like certain medical practitioners, created and controlled the course of studies in higher education, rejected traditions and competitors with whom it had previously been allied. Whereas doctors chose the scientific model, rejecting homeopathy, herbal medicine and midwives, sociologists chose a scientific model to unite its members in a community of scholarship distinct from that of philosophers, anthropologists, or psychologists (Mills 1964), as well as ministers and female social workers.[15] This seems to have been the case principally for scholars involved with graduate education, who worked toward achieving autonomy from what had been broader, unspecialized intellectual concerns, by establishing boundaries around its theoretical orientations, methodological approaches, questions for study, recruitment and socialization of personnel, and criteria of evaluation.[16] By the turn of the century their efforts to gain academic respectability were increasingly successful. Sociologists founded serious scholarly journals and created associations that set criteria for membership and gave recognition to particular kinds of works, implying the exclusion of others (Bulmer 1984).

Although there is no inherent necessity for the arts to be excluded from a scientifically oriented discipline, sociological practice in the United States, which had included a variety of approaches before World War II, increasingly came to reject qualitative methods and

15 Despite previous connections with social reform, through the religious commitments of several of its American founders, many of them either themselves Protestant ministers or the sons of ministers (Vidich and Lyman 1986), they confined those activities largely to their private pursuits.

16 In his study, *The Emergence of Professional Social Science,* Thomas L. Haskell traces the history of the American Social Science Association from 1865 on, when it began as a combined abolitionist, social work, and social scientific organization of college-educated gentry. Its members made little distinction between investigation and agitation, a stance that led to their being rebuffed by the new Johns Hopkins University headed by Daniel Gilman, their founder and still active member. Gilman had come to believe that the university should avoid involvement in political action, that research and reform should be separated, and that while research could be professionalized, reform could not (Haskell 1976).

humanistic subjects unless they were amenable to being operationalized in ways that conformed to scientific manipulation.[17] A scientific orientation is strikingly evident in the kinds of data sought, methodology, modes of analysis, and theoretical orientation (Turner 1978), so that by the end of World War II it had come to define the discipline's central focus (Bulmer, 1984). Subjects like history were excluded, because of the nomothetic view of science to which history was inimical. Its ideographic character, which assumed unique events understood largely by chronological sequencing was sharply differentiated from a sociology based on regularly occurring processes, amenable to finding lawlike patterns (Park and Burgess [1921] 1969).

Beyond intellectual goals, as with other university and professional schools, sociology students, no doubt warned by the example of overcrowded humanistic fields such as literature and philosophy, adjusted their career aspirations to the possibilities at hand. Whereas before World War II the humanities, especially the classics, had the highest prestige, in association with private liberal arts colleges, during and after the war the exact sciences attained the higher standing in the hierarchy of intellectual achievement (Zolberg and Zolberg 1971). This trend, common in virtually all modern countries, was especially prominent in the United States, which had come to political dominance in the West, and dominance in higher education as well. Even before the war education was increasing both in length and breadth, and its end saw expanded educational opportunities and curricular change at every level. For fear of lagging scientifically behind the Soviet Union, the federal gov-

17 The many ethnographic or qualitative descriptive studies done by such sociologists as W. I. Thomas and Florian Znaniecki (*The Polish Peasant in Europe and America*), William F. Whyte's *Streetcorner Society*, or Louis Wirth's *The Ghetto*, not to speak of the many studies of social roles, neighborhoods, communities, and other aspects of life in modern society are only a tiny sample of the research carried out. It is by no means less important than the statistical works which also came to prominence (Bulmer 1984; Winkin 1984). Aside from the pragmatism of John Dewey who, himself, did not hesitate to analyze the arts, among other cultural forms, and whose influence is present among most of the few sociologists who studied various aspects of art and literature concretely, many sociologists are more eclectic than they admit, using whatever methodologies or data appropriate to analyze their subject.

ernment was able to inject funding into scientific fields at a level hitherto unknown and supported state universities that had frequently started with a scientific emphasis at their very origins. Larger budgets had direct impact on science. It's effects even spilled over into other fields, such as the social sciences, whose faculty members created an ambiance into which students would be socialized through learning the theory and practice of the discipline, and being made aware of the marketability of certain specialties as opposed to others. In the process, they developed an esprit de corps favorable to the spread of scientific or positivist sociology, orienting their research in directions attractive to science funding disbursers.[18]

Resting on a value-free, empirical basis, the culture of science encouraged the use of as much scientific technology as feasible to quantify aspects of the subjects it embraced. Sociologists proved their bona fides by donning labcoats, and carrying Hollerith or McBee key punch cards prominently displayed in their pockets, as symbols of the then-latest technological advances in data retrieval and analysis. In this way they were attesting to the fact that they had taken the pledge of allegiance to survey research or aggregate data study. Not only did they wear the uniform, but they adapted statistical methods to analyze the mountainous piles of data that their methodological orientation was generating.[19]

Although the precise lineaments of scientism or positivism varied, sometimes involving a formalist, sometimes a functionalist framework, it came to mean relying on quantitative data gathering and analysis modeled on what had become the conventional meth-

18 It is true that the United States had become the undisputed leader of the West while Europe was still reeling from the effects of the war. But even without this, in Europe most states had educational systems that were smaller, less open to students of modest social origins, and more traditional in content. Nevertheless, all were obliged to open up some kind of postsecondary education to students who sought entry (Zolberg and Zolberg 1971).

19 Aside from those sociologists who gave themselves over to empiricism, even "grand" theorists such as Talcott Parsons extolled the basic reasoning employed by exact scientists in their formulations. Many wrote in terms of hypothesis formation, rules of logic for proving or disproving ideas. Empirically-oriented theorists such as Paul Lazarsfeld strove to provide as exact explanations of social action as the slippery behaviors of humans allowed (Coser 1984).

odological approaches of the exact sciences. Its logic of causality, based on a Newtonian and Baconian foundation, viewed science as a universal set of operations applicable to virtually any idea about human beings and about reality in general. It is equally compatible with Marxian and anti-Marxian orientations, but in the decades of the 1950s and early 1960s when it was most prominent, it made concern with qualitative or humanistic subjects and methods problematic.[20] By accepting a rather limited and, in fact, increasingly old-fashioned version of the meaning of "scientific," sociologists excluded conceptualizations that might require evaluative stands, not only with respect to the arts, but often other aspects of culture as well. They focused on subjects suitable for their techniques and paid relatively little attention to religion, symbols, language, and other aspects of culture content, except insofar as these topics could be retranslated into units amenable to manipulation in the positivist tradition. On the whole they relegated the cultural subjects either to the purview of anthropologists, to literary specialists, or to scholars on the margins of the field, such as European emigrés and women. The result was that until the late 1960s sociology had become a discipline perceived as biased against the very approaches that understanding of human society seems to require, and, in particular, any behavior of an artistic sort. Theoretically, the biases were expressed as psychologism and as materialism of both Marxian and anti-Marxist varieties.[21]

20 Proponents of value-free approaches had used them to claim legitimacy for studying sensitive subjects, arguing that even if their personal opinions were liberal or progressive, the methodologies they adopted protected their findings from being marred by bias. In the late 1960s their stance came under attack because, according to radical critique, it enabled sociologists to exclude from their analyses an examination of their own assumptions, including their acceptance of the nature of social structure as fixed and natural, including patterns that favored certain powerful groups to the detriment of the less powerful (Pollak 1979). Whether or not there is some truth in this critique of self-serving hypocrisy, it has been argued that the alternatives are hardly better since they simply reject even the possibility of a bad conscience (Macintire 1970).

21 Psychologism does not refer simply to the tendency to reduce art to the individual acts of the artist, though this is often an outcome of psychological analysis of artists, a subject I deal with later (Chapter 5).

Psychologism is reflected in two notions that have affected the sociological study of the arts. First, rather than consider art works directly, sociologists often frame their studies in terms of attitudes *about* the arts. This has the convenience of providing data manipulable in the positivist mode of operationalizing concepts in order to fit them to quantitative collection and analysis. At the same time, however, it elides the autonomous connotations of values as structures of belief or orientations which exist, in the Durkheimian sense, external to individuals (Durkheim 1951).[22] The other aspect of psychologism comes from the influential Parsonian structural-functional framework. By formulating the systemic goal that he defined as "pattern maintenance" so that it overlaps considerably with that of integration of social system members, he effectively conflates culture and psychology (Parsons 1961). Beyond that, Parsons did not develop the aesthetic realm to any degree, but assigned the arts to other aspects of culture where they are swamped by religious or ideological values. Although this may be a plausible approach for understanding some aspects of psychology and culture, on the whole, structural-functionalism in the Parsonian sense takes little account of complex modern societies in which the arts have become specialized and, for some purposes, may be understood better in terms of other system goals, such as those of economics and politics.[23]

Sociological materialism takes two principal forms: one clustered around ideas derived from the writings of Karl Marx; the other connected with the uses of the arts quasi-symbolically as insignia

22 In line with Sanford Dornbusch's proposal that sociology of the arts should conform to current sociological practice of ongoing research methodologies (1964, 365–7), it implies that it is sufficient, in spite of virtually disregarding art objects, to study instead opinions or tastes, as an elaboration or scientific form of market research.

23 As an aside, it should be said that the Parsonian framework is flawed in a manner similar to that of his leading rival at Harvard University, Pitirim Sorokin, who attempted to develop a grand theory of his own (Sorokin 1937). Far from being a structural-functionalist with an evolutionist conception of social change as was Parsons, Sorokin envisioned society as moving through a cyclical pattern of change characterized by transformations in all realms of culture, including the arts and ideas. Despite the great differences between the two scholars, in both cases, in their eagerness to create grand theories capable of encompassing all social phenomena, they assumed that complex societies are capable of being viewed as holistically integrated units. I return to Sorokin's approach in Chapter 7.

of status, a conception with some relation to the Marxist notion, but having a somewhat different intellectual history. Placing Marxian types of analysis into the category of materialism is virtually a convention, as are the status-connected uses of the arts in the sense employed by Thorstein Veblen. Since Veblen emphasized the symbolic nature of social behavior, it may be said that his assumptions are more compatible with those of Durkheim and Weber. Both sources of ideas about the arts have been criticized as inadequate or reductionist, but they have nevertheless been incorporated into newer frameworks. Yet whether centered on economic bases or symbolic status, they tend to exclude the arts from sociological legitimacy. The importance of their influence makes it necessary to understand how the priorities of Marx and Veblen worked against serious concern with the arts. From an orthodox Marxist point of view the arts (among other aspects of culture) are epiphenomenal to an underlying set of economic forces and relationships of certain groups to the means of production in society. As a component of society's superstructure they are, in the last instance, merely reflections, determined by its economic base (6–8; Marx [1939] 1974, 110–11; Laing 1978). As with many statements of this level of generality, it explains either too much or too little: It conceals ambiguity, assumes too much apparent passivity on the part of social actors, and does not deal effectively with processes of social and cultural change. Recent scholars such as Adorno, Hauser, Williams, and Bourdieu, though starting from different standpoints, have been more cognizant of the dangers of oversimplifying the inherently complex nature of social structural and cultural relations prevalent in modern societies, as I indicate later.[24]

Changes in sociology; changes in the art world

The fate of the sociology of art is still closely linked to the standing of the arts in society more generally, on the one hand, and to the

24 This orientation predominates, though with different implications in the works of Marxian scholars such as Hoggart (1957), Benjamin (1969), Raymond Williams (1976), and in modified forms in neo-Marxian or Marxist-oriented thought (Adorno 1976; Hauser 1982), much of which has to do with clarification and specification of the meaning of "reflection," a term notable for its vagueness. The idea that art reflects its society is common to philosophers, literary intellectuals, and social observers or critics, such as Madame de Staël, Stendhal, Marx, Tocqueville, to name only a few.

material sources of support which make the discipline of sociology possible on the other. In recent years, as a result of developments that stem from external influences, as well as internally generated change, American sociology has moved away to some degree from reliance on the scientific paradigm. Sociologists now pay greater attention to humanistic approaches, such as historical, ethnographic, and other qualitative methodologies. Although this trend may simply be ascribed to an expansion of the social area over which the sociological net is cast, or a reconceptualization of certain methodologies in forms compatible with the scientific model (as is the case for historical analysis using cliometric methods), in most cases the substantive expansion into new subfields indicates a questioning, for better or worse, of the traditional scientific paradigm as applied to the study of society.

The causes for this expansion are found, not in intellectual content of the field alone, but in the material state of the sociological profession and the academic discipline, and within changes in Western society as a whole. It would be oversimplifying considerably to claim that the era of the 1960s was entirely responsible for these changes, but it would be equally obtuse to neglect it. Without reanalyzing an epoch that shook the world inside and outside of the academy, it is important to note that from the early 1960s, particularly in the United States but in a large number of western European countries as well, the demographic phenomenon of a youthful cohort appeared on the scene roughly simultaneously; with access to higher education considerably increased, many were brought together into new or expanded universities. Revealed to them were issues in which young people had a stake, and in a large number of cases provoked them to organize against and contest them.[25] During the several years of student protest against the Vietnam War and against violations of civil rights, what had emerged as subsidiary issues in the course of contesting the larger political questions gained a perhaps unintended degree of centrality.

25 Although these included colonial wars in some countries, in which students ran the risk of fighting and dying for the iniquity they abhorred (France); reactionary resistance to implementation of rules of social justice in regions of one's own country (civil rights of minorities in the United States); and most important, America's involvement in the Vietnam War, in most cases students turned against their universities as agents of the "system."

Regardless of whether they sided with or against students, faculty members' attention came to be directed as well at the content and form of academic disciplines, toward which many became more skeptical.

Since students and, often, junior faculty members in sociology were among the most active in virtually every country, it is not surprising to find that they called for changes in content and curriculum in that discipline (Zolberg and Zolberg 1969). In the United States, where sociology had attained a high level of institutionalization as compared to other countries, and where the scientific paradigm had become most prominent, the "discovery" of how narrowly the discipline was conceived elicited the greatest demands for change. Among them were a call for recognition of new fields of study by the professional associations, the opening of access to different approaches and subjects in existing professional journals, and the launching of specialized new ones. Although many of these demands were resisted, by-passed, or in certain universities, ghettoized by establishing marginal programs in women's or black studies that obviated major refurbishing of the existing academic departments, in fact, over the past two decades many of them have been accepted and institutionalized. Despite the problems created by a shrinking rate of growth in academic institutions and enrollments, and the niggardliness of the governmental funding available for the social sciences in recent years, in the United States as well as in other countries, these contentious and often humanistically oriented subfields have become more or less established.[26]

The arts as a subject of sociological study have benefited from all of these trends, seemingly changing from a marginal field and

26 Furthermore, while in the past the ideological stance of established sociology may be described as liberal-reformist, and tended to be closely associated to a consensually-based assumption of political pluralism, in recent years sociologists adhering to more critical or radical positions have been achieving respectability. It is no longer surprising to find subfields in Marxist or feminist or other forms of sociology in which scholars are clearly making plain a political position. This is not to say that only one political position is implied for any one of these subfields but, rather, that sociologists who work in them no longer pretend they are totally disinterested. At their best, they import as much as possible the value-free methods and ideals of the discipline into their research, but only *after* they have chosen their subject, formulated their questions, and forthrightly exposed their own stance.

attracting the mainstream. "Marginality" is a term that has been little respecified in recent times (Coser 1965, 21). It may be used to characterize a sociologist in one or more of the following ways: having a primary professional identity in a nonsociological field, whether by choice or by necessity; working in universities distant from the mainstream of the discipline, and/or lacking in prestige; teaching in departments of other disciplines; being an emigré scholar; being a woman. With respect to the arts, some of these conceptions turn out on examination to be exaggerated.

Looking at the two leading collections of readings in the sociology of the arts, Robert N. Wilson's *The Arts in Society* (1964) and *The Sociology of Art and Literature* (1970) by M. C. Albrecht, J. H. Barnett and M. Griff makes it possible to put the purported marginality into perspective. For example, although the arts are considered a stereotypically feminine subject, little of the sociological writing published in the field until recently has been by women. Of Wilson's eleven authors, two are women; in the much larger Albrecht et al. collection, there are only four. Following the empirical style of data analysis, this would indicate a decline in feminine participation from 18 to 8 percent in less than a decade. Of all the essays over one-quarter are by foreign scholars, but it does not follow that they are otherwise marginal, since at the time of publication nearly all were teaching in leading institutions, either American or European. However, if marginality is taken to encompass having a major professional commitment to some discipline or field *outside* of sociology, then the label of marginality fits, though not uniformly. Only two of the contributors in the Wilson collection are prominent in fields other than sociology (18 percent); but in the Albrecht collection the proportions are virtually reversed. Only one-quarter are sociologists, whereas the other contributors are identified with a variety of other fields including anthropology, comparative literature, history, art history, and many are art professionals (curators, artists, dancers, professional writers). Rather than consider them marginal to sociology, however, it seems more reasonable to concede that the editors have imported contributions from fields outside of sociology to enlighten sociologists on the relations of the arts to society. The fact is that if Albrecht had set out his "institutional sociology of art" without three-quarters of the essays from adjacent or even distant fields, there would be *no*

institutional sociology of the arts at all (pp. 1–28). Indeed, by compiling the collection as they did, the editors helped to create the field in America, inclusive of European and American contributions with a strongly cross-disciplinary character, various methodologies and viewpoints, writings by art professionals and artists, ranging over fine art, folk art, music, dance, and literature.[27] Involvement with other disciplines is central to what the sociology of art is about. This is recognized, not only by sociologists, but by humanists and creative artists as they become more aware of social constraints under which creation takes place. Rather than confine their analysis and scholarship strictly to connoisseurship and traditional conceptions of creativity, many are adopting sociological outlooks, an important development that I take up in the concluding chapter.

I began this section by asserting that sociology as a discipline has undergone major changes since the late 1960s, so that the excluded subject of the arts (among others) has been brought to greater prominence than before. Until then, while it is not clearly the case that individual scholars who published on the arts were marginal in one way or the other, on the whole, few scholars in this field were likely to be published in prominent, mainstream journals. Just as the arts had tended to be viewed by many as the private pleasure of the rich or as a commercial product subject to the laws of the economic market place, most sociologists were likely to assume that everything worth saying about art had already been said by Thorstein Veblen. In fact, most scholars who deal with the arts were for a long time viewed as intellectuals in a broad sense or as radicals, but not *really proper* sociologists (Coser 1984; Wollheim 1970, 574 ff.).

Achieving respectability as a subject of sociological scholarship had something to do, as I have suggested, with the effects of events and social and political trends outside of academe. As part of the "greening of America" and the emergence of a counterculture (Reich 1971), interest in the popular arts had begun to find a niche in the field of mass media studies (Rosenberg and White 1957), which often took the form of a critique of commercialized society

27 The breadth encompassed makes the collection perennially useful though, sadly, currently out of print.

and culture. But in the sixties the division between fine art and popular or mass art began to fray as the traditional distinctions between these categories were increasingly challenged, in part by the emergence of pop art. It threw into question the categories which had become conventional among critics and artists, and among sociologists as well. Instead of assuming that art forms were to be taken for granted as fixed "high" or "low" forms, their study revealed the socially constructed nature of these categories (Becker 1982; Wolff 1984). Eventually sociologists had to take account of the opposition between art as mystery and art as social construct. In Chapter 3, I consider how they deal with art objects, and in Chapter 4, how some sociologists make the process itself the object of study.

3. Studying the art object sociologically

S OCIAL SCIENTISTS CONCERNED with aesthetics differ in orientation from scholars more clearly associated with aesthetic or humanist fields. Because until recently few American sociologists have studied the arts at all, the work of those who do so is exceptional to, rather than typical of, mainstream sociology. At their best both sociologists and aestheticians cast new light on the arts by bringing to bear externalist analyses, simultaneously highlighting aspects of society. Nevertheless, although no longer as controversial as in the past, straddling the humanistic and scientific fields continues to be rather unusual.

Even when they accept the art world's definitions of what art is, sociologists usually question its traditional assumptions about art. Principally, these assumptions consist of three interrelated components: that a work of art is a unique object; that it is conceived and made by a single creator; and that it is in these works that the artist spontaneously expresses his genius. Together, they represent a conception of art that is at odds with facts well-known not only to sociologists (Becker 1982) but to other scholars as well. Frequently the implications of these assumptions are unexamined, but as I show in the following cases, even if sociologists are committed to them on a personal basis, they find them in conflict with the social scientific ethos and use various strategies, intellectual and professional, to surmount the disjunctions.

Comprising the central themes of this chapter are the differences in their orientations as shown in how scholars choose what kinds of art works to consider, how their analyses of the art works differ from those of aestheticians or from a more ordinary social scientific point of view, and the limits of their respective intellectual contributions.

Art object as an object of study

Both aesthetic and social scientific scholars have dealt with similar art forms in the past and continue to do so to some degree today.

53

Like Georg Lukács they have analyzed genres such as the historical novel (Lukács 1963); like Theodor Adorno, the opera or symphony (Adorno 1976); like the art historian Leo Steinberg, who analyzed depictions of the sexuality of Christ, they have traced themes, through a large body of art works (Steinberg 1983). Although these studies could have been done either by humanists or by social scientists, their approaches differ.

Sociologists study group processes of decision making, and institutional constraints in the selection of works for cultural production (Hirsch 1972; Peterson and Berger 1975); institutional change and its effect on style, as in the emergence of impressionism (White and White 1965); structural constraints and opportunities in the modern painting world (Rosenberg and Fliegel 1965). As these examples indicate, they are more likely to focus on aspects of organization and process affecting how artists work and how their creations or output are disseminated or marketed in relation to the broader socio-political-economic context of the production of the art. In many cases, however, because of sociologists' concern with the social, the art works themselves become lost in the search for understanding society, ending up as virtual byproducts.

For humanistically oriented scholars the reverse is more likely, for even when they look at social concomitants of art similar to those addressed by social scientists, humanistic scholarship is not supposed to lose track of the work itself. Expected to emphasize aesthetic structure, they are prone to consider the social structure as a residual category. But as Svetlana Alpers, one of the "new" art historians contends, traditional art history had become overly narrow in its formulation. It assumed the unique role of the individual creator; focused on the uniqueness of the individual work; and took for granted the centrality of the institution of painting. Left aside were collaborative works, workshops, multiples, paintings in series, and serious attention to media other than oils (Alpers 1977, 1–13).

This characterization is unfair to a number of important theorists and art historians. Erwin Panofsky analyzed the Basilica of Saint-Denis in the context of theological thinking, historical, political processes, and a social psychological account of the life of its principal artistic creator, Abbot Suger (1957); Millard Meiss studied the

effects of the Black Death and its use by politico-religious reactionaries against humanized art in Florence and Siena (1951); Arnold Hauser wrote a major social history of art (1951). On the whole, however, socially contextualized art history continues to be controversial. The most acceptable art historical study remains the *catalogue raisonné,* the massive work tracing styles in chronological order according to national origins, or surveying the total *oeuvre* of a major artist. Despite pressure to conform to the older tradition, however, art historians have moved into social study in a variety of ways. Svetlana Alpers herself has related the scientific conceptions of "visualizing" to the works of Netherlandisch artists such as Vermeer (1983); Michael Baxandall has analyzed the manner of "seeing" by contemporaries in fifteenth century Italian art (1972). But in these cases the art (or architectural) works under consideration remain central.

In practical or professional terms, when social scientists de-emphasize the arts, their disciplinary peers are generally unconcerned unless their methodology is faulty; but when art historians or aestheticians do so, their colleagues quickly call them to account.[1] For example, in his article on classification or categorization in art, Paul DiMaggio theorizes about the manner in and processes by which categories and classifications of the arts are created. Even though his theoretical formulation is based in part on his earlier empirical study of the categorization and reclassification of content in nineteenth-century Boston (DiMaggio 1982), in the later article he explicitly excludes from consideration references to content and style of the works (DiMaggio 1987, 442). This may imply that the specifics of content are secondary, perhaps arbitrary. For sociologists, more important than *art creation* is the social process of *status creation,* to whose end certain art works are selected for

1 In his devastating critique of Arnold Hauser's *The Social History of Art,* E. H. Gombrich writes, "His theoretical prejudices may have thwarted his sympathies. For some extent they deny the very existence of what we call the 'humanities'. If all human beings, including ourselves, are completely conditioned by the economic and social circumstances of their existence then we really cannot 'understand' the past by ordinary sympathy" (Gombrich 1963, 93).

inclusion in the canon of elite art. The sociologist is more interested in the social symbolic use of art, rather than the work itself.[2]

That sociologists generally downplay the art object is, therefore, to be expected, but they may do so from opposed standpoints. From the perspective of Marxian analysts who have viewed art as a reflection of the social relations of production of society, research questions center upon art forms whose content contains a high level of information. By this I refer to literary works in which narrative elements are important, emotions conventionally appropriate; visual arts holding to a narrative and mimetic canon that is readily grasped; or musical works with a literary component (opera, oratorio, song), or in which melodic forms follow nineteenth-century Romantic tradition. It is difficult to disaggregate Marxian aesthetic analysis from ideological and political positions, in particular among analysts working in state socialist countries, especially during historical periods marked by severe repression, as under Stalinism. This makes the sociological orientation predictably favorable to works of novelists implicitly critical of capitalism, as for example, in the historical novel chosen for study by Lukács (1963) or the social history of art (Hauser 1951). The fact is, however, that except to reject it as decadent or formalist their approach has little to say about abstract art or dissonant music.[3]

2 For example, in summing up the 1985 French sociological meetings, devoted entirely to the sociology of art, Jean-Claude Passeron stated: "Is it enough for me just to deliver my aural impression? I'll do it then by playing the role of the *Ingenu* who waits patiently and long for sociology of art to honor the double contract which its name imposes on it: to whit, of course, that it establish itself as sociological knowledge by contributing intelligibility of the same quality and form as other fields *but also* that this sociological knowledge address specifically the knowledge of works as art works, and their effects as aesthetic effects, that is, that sociology of art may succeed in identifying and explaining the social processes and cultural traits which converge to create *artistic value* of art – itself [artistic value] constituting, after all, from the moment that it is certified by social recognition, a social fact as incontrovertible as any other" (Moulin 1987, 449 [my translation from the French]).

3 This is less the case for Marxian analysts working in liberal political environments, such as Adorno and others. Although Engels seems to have turned away from this orientation by the end of his life (Dupré 1983, 269), it continued to hold sway among many of its leading theoreticians such as Plekhanov and

Sociological analysis of the arts has ranged over the sweeping, ideological analysis of Hauser based on Marxian materialism, or the antiMarxian idealist, equally sweeping work of Sorokin (Chapter 7). In recent times it has come to be increasingly focused on middle-range institutional analysis, including commercial markets as well as official support structures emanating from the church, private patronage, or the state (Peterson 1976; Albrecht et al. 1970). The application of organizational sociology, sociology of work, status attainment, and other orientations suggest the breadth of innovation in the social study of the arts.

Michael J. Mulkay's analysis of scientific innovation provides an organizational basis for understanding how a new field of scholarship may be created and what sort of actors are likely to be drawn to it. Unlike Thomas Kuhn's well-known analysis of scientific revolution (1970), Mulkay introduces the alternative form of innovation that he terms "intellectual migration" (1972, 34). Less spectacular than a paradigmatic shift, it may take the form of "modified application of existing techniques and theories within a different area," such as an area of relative ignorance (Ibid., 46). Those most likely to engage in innovative action are individuals marginal to their institutional setting (because of youth or low status), especially in a relatively crowded field (Ibid., 52). Because of the porousness of the art field's boundaries, in contrast to the relative enclosure of legitimate science within universities and institutes, Mulkay's contribution cannot be mechanistically applied to the fine arts. But the processes he delineates are clearly present in the examples of sociologists which follow. These scholars attempt to surmount the limitations of the conventional aestheticist view of art by one or more of the following strategies: contextualizing the art form, so that its aesthetically-based aura is reduced; choosing art forms marginal to conventional categories of art on which to focus, thus carving out a new field for themselves without threatening the existing aesthetic paradigm; importing and employing methods or techniques generally associated with another discipline.

was implemented as rigid policy under Stalin. It is worth noting that the French Communist party, among others, at its height, patronized the most dogmatic styles, even when Picasso offered himself to them (Verdès-Leroux 1979, 33–56).

Marginality, lack of institutionalization, rejection by establishments, and outsider forms are characteristics of the sociological work of several important recent studies of the plastic arts and literature, as well as of musical forms. Sociologists and social thinkers who study the arts, particularly in the United States, seem drawn to works or genres marginal to established categories of fine art or adopt methodologically unusual approaches to the study of the arts. This pattern of choice is evident in the work of Wendy Griswold (1986), Diana Crane (1987), Gladys Engel Lang and Kurt Lang (1988), and in my own study (1983). It was foreshadowed as well in the studies of music by Alan Lomax and Theodor Adorno.

Latter-day revivals of Renaissance drama

Wendy Griswold's study of the social contexts influencing the revival of certain dramatic genres in England focuses, notably, on two forms, the "city comedy" and the "revenge tragedy." Whereas the former centered upon the trickster or con-man, who might use any means for social mobility, the latter dealt with the tension between a desire for private vengeance and impersonal legal institutions. Although originally written and performed in the late sixteenth century to early seventeenth centuries, examples of these genres have been successfully revived in certain subsequent periods. The city comedies came into renewed favor in the eighteenth century, at a time of high economic mobility for middle-class groups, with little political power or honorific prestige; whereas the revenge tragedies had their greatest revival in the late 1950s and thereafter, in response to concerns about student uprisings and other attacks on public order.

Griswold's sociological imagination evokes a richness of insight on the basis of solid and careful discipline. What makes her study unconventional from a humanistic standpoint is that her subject is these genres, not from the perspective of "the great work," but as plays that have appealed to audiences at different moments. Even though her sample includes some of the best playwrights of the period (Ben Jonson, Christopher Marlowe, John Webster), it is not their aura of greatness that is central, but the (partly accidental) fact of the plays' survival and their impact and social use that count. If some of them are still viewed as remarkable literary works, a

criterion of importance to the humanist, it is their social symbolism that is of chief concern to the sociologist, whatever one might say of their quality.

The makers of the "tradition of the new"

The burgeoning of new art styles in a series of efflorescences during the late nineteenth and early twentieth century is still remarkable in spite of cultural explosions in the fine arts since then. Providing the visual aesthetic foundation for what the critic Harold Rosenberg has referred to as the "tradition of the new" (1959), stylistic novelties included (after realism, naturalism, and impressionism) neo-impressionism, cloisonnisme, pointillism, symbolism, cubism, fauvism, expressionism, futurism, constructivism, and many others. For want of a better term, and to provide a label for a potentially important gallery show, the whole bundle was designated *post-impressionism*. In accounting for the emergence of these styles, each an assault on officially accepted academic art styles, popular rhetoric tends to employ a discourse of romanticism. The artists are viewed as driven by the urging of their inner genius to create in ways unacceptable to the staid authority of official art and bourgeois taste. Lonely fighters against convention, artists as creators are necessarily alienated from their milieu because it is driven by material concerns whereas they are true individuals. By itself, this explanation falls into the mythologizing typical of art world participants.

Seeing how the new styles are created, I argue that they are better understood as part of a social process in which networks among artists and other participants become established in a broader socioeconomic context as oriented by political trends (1983). It is not usually sociological practice to analyze the artist's purported deep motivations (Picasso's relation to his father and mother), specific talents (Monet's eye for color, Degas's skill in drawing), or emotional instabilities of individual artists (Van Gogh's ear, Gauguin's primitivist fantasies and fugues) nor either to criticize or laud them for their innovativeness. In the sociological tradition, I emphasize the designation of the social groups responsible for the emergence, discovery, dissemination, and institutionalization of some of the new forms. Unlike art specialists, who are largely concerned with "great art," I look at *all* the art (or as much of it

as possible), whether celebrated or not, and try to account for why some became part of the canon of Rosenberg's "new" and others did not, specifying the characteristics of the "forgotten" art, and the conditions under which celebrity is denied (Zolberg, 1983 and forthcoming).

Labeled by establishment groups not only as barbaric, decadent, or immoral in style, but also as representative of dangerous foreign bodies in the nation, antipatriotic, dangerously cosmopolitan, the art world seems congruent with those labels. It was composed of artists, social networks and circles of patronage, and dealers and literary associates in the most important center, Paris, many of whom were outsiders to Paris itself, coming from the provinces, colonies, or foreign countries. They participated in a process whereby rising social groups, outsiders to established national elites, "marginals" sought, created, and promoted new cultural forms, in a historical moment characterized by the increasing internationalization of economic and political activities.

Among the most prominent outsiders were groups within each society excluded from full participation at elite levels. In terms of religious identification they were composed of Protestants in France, Catholics in the United States, non-High Church Anglicans in England, and Jews nearly everywhere; ethnically, of non – Anglo-Saxons in the United States and England, and individuals of foreign origin or viewed as foreigners (Americans, Irish, Greeks in England, Germans or German Jews in the United States); in class terms, new industrial or merchant elites in France, the United States, England, Germany, Russia, and elsewhere. In virtually all of these places, they also included many women, sometimes artists in their own right, but frequently patrons and collectors.

Without taking a stand on the quality of the art work, I analyze how these "bizarre" styles came to be institutionalized, disseminated, and though reproved for decades by most public opinion, eventually became the centerpiece of new cultural institutions organized by the circles of artists, patrons, dealers, collectors, and writers, acting as cultural entrepreneurs. Now they are sought after at any cost even by establishment museums and attain prices at auction even higher than the works of well-established old master painters (Chapter 1).

By importing into the domain of art-world professionals and humanist scholars the analytic orientation of social status analysis,

cultural movements, deviance, commercialism, and status seeking, I conform to sociological practice (Becker 1982; Moulin 1987) to naturalize a process that is more generally characterized by obfuscation, but at the cost of violating the individualistic ethos pervading aestheticist analysis.

Etched in memory

As a central concept in the sociology of art, reputation is the subject of the final chapter of Howard Becker's book (1982). In it he points out how "[c]onsidering the problem of what lasts, which works persist . . . and how an understanding of lasting . . . affects our understanding of those aesthetic and critical concerns" (Ibid., 352). He shows that the myth of reputation is used to support the idea that there must be "some quality inherent in the work interacting with some fundamental and culturally untouched feature of human psychology and experience . . . [that] identifies works of real value . . ." (Ibid., 368). Becker's skepticism about the truth of this myth is pursued by Gladys Engel Lang and Kurt Lang in their study of the once relatively popular art form, etching (1988, 79–109).

Etching was not only the predecessor to what Bourdieu called *"un art moyen,"* photography (1965), but for nonpractitioners it became a middle-class (and higher) collectible. Although some etchers, such as Rembrandt, Dürer, and later, Whistler and Millet, among others, were considered to be great artists, etching is usually considered a minor form. Nevertheless, there have been times when certain etchings have had a high market value. In the years when etching was very popular huge numbers were made to meet demand. Yet most nineteenth-century etchers are forgotten. Rather than assume that only the best have been remembered, the Langs brought their sociological skepticism to bear on the question. What the Langs find is that the persistence of reputation beyond the grave depends upon a combination of the etchers' own strategic behaviors while alive; efforts on their behalf after their death by their circles (including relatives or descendants); all of which may bring their works to the attention of influential or well-placed institutional and market actors at later times. For reasons that the Langs detail, the chances of a woman etcher attaining and retaining a high reputation are far lower than for a man; higher for an etcher

who is primarily a painter than for one who is primarily an etcher; or for one with a substantial output than with a small one.

Nevertheless, etchings retain their marginality in relation to established categories of fine art because they are by their nature *multiples*. Although for this reason they may not be expected to attain great value, as I argue in Chapter 4, even works that are inherently replicas may be assigned a high value, according to a structure that has become conventional in the art market. Because multiples straddle the boundary between original art and repro-duction, it is even more important for their recognition and rep-utation than for paintings or drawings that biographical information about the artist be known. This ambiguity appears in the summation of the Langs' analysis: "Peculiar to etching as a form of printmaking is that the much-admired images, unlike those of painters, exist in multiples that are neither copies nor fakes. Each impression is a unique original, different in at least some minor way from all other prints yielded by the same plate. For the *amateur d'estampes*, on whom the marketability of etchings and the reputations of their creators ultimately depend, the mystique of the print lies in the opportunity to hold in one's hand a true original that gives a sense of communication with the artist, and across time. In this precise sense, the persona of the artist as well as the work itself comes to be etched in memory" (Ibid., 106).

Unlike art critics who are drawn to the major old master etchings but pay little attention to the bulk of etchers whom the Langs' study, a sociological analysis is concerned with the social processes first, and the quality of the art second, if at all.

Transformation of the avant-garde

More recent processes in the saga of the "new" are analyzed by Diana Crane in her study of recent shifts in art styles (1987). Starting with the appearance of abstract expressionism, which was considered "highly esoteric, excluding from its domain humanistic values, decoration, representation, and the rapidly expanding phe-nomenon of popular culture," subsequently, new styles either ex-tended these features into more esoteric directions or retrieved some of the discarded traditions. Minimalism virtually abandoned the art object as representative of something other than itself.

Pattern painting integrated craft traditions into modernist structural principles. Other styles resurrected the past, either in figurative-traditional ways, retrieving humanist ideas, or as pop art and photo-realism, threatening to destroy the barriers between fine art and commercial art (Ibid., 62–3).

Crane relates the emergence in rapid succession of the new styles to the cultural expansiveness of the post–World War II era in New York as a multifaceted phenomenon: Museums added space and activities devoted to modern art; galleries handling modern art increased from 20 to 300; from a dozen or so, the number of serious modern art collectors grew to thousands; exhibitions by painters increased by 50 percent; according to some estimates, the number of people calling themselves artists grew from 600,000 in 1970 to over a million by 1980; while outside of New York, new public, corporate, or university museums were established, and the federal government became a major supporter of cultural activities. Paradoxically, however, instead of being more open to the new styles to whose discovery and nurturance the modern museums had claimed to be dedicated, except for the Museum of Modern Art's nearly immediate accession of several works by abstract expressionists, when it came to subsequent styles, they all dragged their feet. Although the Whitney Museum exhibited most of the new styles, it acquired them slowly; the Guggenheim acquired even fewer; and the Metropolitan did little to change its reputation for neglecting the latest in contemporary art.

Crane suggests that the reason these museums turned away from innovation was that they suffered organizational strains. The features she points to are not specific to New York but seem to parallel developments in the first modern art center, nineteenth-century Paris. In their study of the decline of the French academic system and the rise of the modern dealer market, Harrison and Cynthia White analyze the collapse of academic structures in the face of artistic expansion. They suggest a phased process beginning early in the nineteenth century, and virtually completed in the early 1900s, a case of failing through success. As the structures of academic training improved, official commissions increased, thereby enhancing artists' career possibilities and attracting enormous numbers of aspirants to try their luck in the field. So many flooded into the institution that their numbers caused a system overload, in

particular for access to the official salons, through which their work was usually marketed. At first the nascent dealer system was able to distribute surplus academic works, but eventually it was swamped. Into the breach came a new breed of dealers, attracted by what they correctly perceived as a potential middle-class market. They diversified into the antiacademic styles, finding buyers for the waves of vanguard art styles as they appeared (White and White 1965).

Parallel to the Whites' findings, Crane asks why the expansion of new museums or enlargement and diversification of older ones catering to modern art did not absorb the work of the new artists. Unlike an art critic, and more like a modern social historian of art, Crane focuses on the emergence of these new styles in relation to general cultural, economic, and social mobility trends in the United States. By analyzing the content of the works using statistical data methods, she imports "hard" techniques into a qualitative field to show that whereas modern museums in the more sophisticated centers (especially New York) rejected many of the new styles, corporations in other regions and less established or regional museums accepted them. In opposition to the aestheticist concerns of the tradition of the new, which had rejected the socially committed art of social realism, folk-ethnic, or narrative elements, some of the new styles (especially pattern and some of the figurative styles) were adopted by marginalized groups of artists, such as women and minorities.

By focusing on process and institutional structure and change, Crane avoids aesthetic evaluation, but provides important insights into outsider art forms and how some of them have become institutionalized.

Music and society

Alan Lomax and Theodor Adorno were both well schooled in their aesthetic discipline of music and experienced in social analysis; both, in different ways, derive their approaches from Marxian theory. Lomax uses two strategies of the kind Mulkay indicates: He analyzes an art form marginal to the mainstream concerns of aestheticians and imports a methodology unusual for an aesthetic analysis. Seeking to show how the music of non-Western societies

and their styles of performance reflect their societal structures and the emotional states of their peoples, he uses mathematics and statistics, survey methods including panel judging, and the methodological tools of social scientists. Theodor Adorno focuses chiefly on nineteenth-century musical genres of Europe, treating the musical forms themselves in part as an aesthetic study. His aim, however, is in large measure the critique not only of music but of society as well. For this purpose he imports sociological and political context into his genre analysis.

Music as reflection of society: the search for correspondences

The idea that art reflects the society in which it occurs is based on the venerable assumption that there exist correspondences between various aspects of culture within societies. This implies that societies and entire civilizations are essentially homogeneous totalities. For better or worse, because it lends itself to stereotyping, the idea that culture is capable of being grasped as a whole underlies research by numerous scholars certain of whom devote themselves to the search for correlations between social structure and art styles.[4]

As a pioneer in ethnomusicology, Lomax integrates his musicological learning with the holistic approach of anthropology to "discover the correspondences between the qualities and styles of art forms on the one hand, and the character of social life and social structures, on the other" (Albrecht et al. 1970, 30). In a clear example of Mulkay's intellectual migration, Lomax frankly adopts

4 Stereotyping is, of course, an ancient tradition, but its modern manifestation, as found in the theories of national character, seems to have its intellectual origins in a combination of romanticism in the arts and the nationalist movements in the political realm. Among thinkers associated with this idea are such intellectuals as Madame de Staël. One finds it embedded in historical theory of the French historian Taine, who subsumed his ideas about culture in the three contextual variables of race, moment, and milieu. As loose as these terms may be, they had considerable influence in, for example, culture and personality studies of the 1940s and 1950s, as well as in theories about the arts and society. Many analyses in this vein do not surpass the level of sophistication of eighteenth- and early nineteenth-century writings which assume that art is the reflection of race.

an externalist orientation, calling upon ethnomusicologists to "turn aside, for a time, from the study of music in purely musical terms to a study of music in context, as a form of human behavior." To that end he undertakes to develop a methodological tool which he called "cantometrics," using it for rating "recorded song performances in a series of qualitative judgments." Selecting thirty-seven traits derived from musical structure (melody, rhythm, harmony, dynamics, among others), encompassing the musical event itself (size and social structure of the singing group, interrelations of group members, quality of voice, degree and kind of embellishment, cohesiveness of chorus and players where appropriate), he applies it to discerning differences among musical styles cross-culturally. Lomax has several panels of judges listen for these specific traits, and then uses their ratings as a measure on whose agreement the validity of the study depends (Lomax 1970).

One of his aims is to demonstrate that there are parallels between the structure and style of singing performance on the one hand and the degree of hierarchy in social structure on the other. With this in mind he shows that among the Pygmies and Bushmen, whose social relationships are characteristically nonhierarchical, singing performances are organized in an egalitarian structure in which no leader stands out as clearly superior to other performers. Parallel to this structure of performance, the musical forms typical of this people are sung in close harmony, the aim of which is to create the collective product rather than to serve to single out individual performers. Lomax sees this as the antithesis of the hierarchically structured performance styles of conductor-led orchestral or choral groups in complex societies, in which coordination of different, though complementary, melodic lines has come to require the attribution of quasi-dictatorial power to a conductor in order to achieve great precision (Lomax 1970, 55–71).

While Pygmy-Bushman society and modern Western societies represent the extremes found by his cantometric analysis, Lomax also discerned three intermediate "master types" characterized by different sets of traits. The bardic style consists of a solo performer as in the Western model, but with different levels of support by the accompaniment. Found predominantly in the Mediterranean circle, the Middle East, and in most Asian tribal societies, Lomax sees it as corresponding to Wittfogel's conception of Oriental des-

potism, derived from agricultural dependence upon centralized systems of public works such as dams and canals. The depersonalized conformity that this authoritarianism invokes is mirrored in singing styles of extreme formalization. The prototypical case is that of the solo singer who upholds an unchanging canon, deviating only with great subtlety and almost imperceptibly from the complex structure that he is obliged to master. Accompanied at times by large orchestral ensembles or choruses, this style involves unison singing and playing, rather than harmonizing. The bardic style typically consists of lengthy songs, paeons of praise for king, God, or lady love, expressing in high-pitched nasal timbre total submission to authority, as demanded by the despotic social structure.

Quite different is the second of these intermediate master patterns, that of the Amerindians, which reflects individualism. In this case not even chiefs have permanent despotic authority, since leadership is called up in response to specific functions in an ad hoc manner. Amerindian singing style reflects the de-emphasis of the individual leader in that, although one individual usually starts a song, the group quickly takes it over, performing in robust, chesty voices. Because they rely on few words and little variation of rhythm, Amerindian performers are able to maintain loose but effective coordination without leadership.

Finally, the Negro African pattern represents the greatest variety of tonal, melodic, rhythmic and vocal quality traits. Leaders and choruses interact, with variations of dominance that seem related to the degree of similarity of their societies to the Oriental despotism model on the one hand (Kingdom of Dahomey, Watusi), or the near-acephalous tribal model more prevalent in other societies. Pervasive in most African song structure is the litany-response pattern, in which solo and chorus are virtually equal, an equality that is found in social structure as well as in musical performance wherever the Negro African tradition exists. Reflections of this egalitarianism are found in the opportunities for social mobility musical performance offers individuals from modest backgrounds, and women, who may become lead singers in performances as well as be powerful actors in the political and economic world.

Aside from the correspondence of singing structure, Lomax is struck by two features of Negro African music, its pervasive eroticism (that he interprets functionally, seeing it as the support of

the widespread polygyny of Negro Africa) and its practicality, in that music seems to play a greater part in organizing all life activities, sacred as well as secular than it does in other cultures. It is to this versatility that he attributes the great popularity of many of its elements throughout the world.

Lomax places music, its structure, and performance in the center of analysis and keeps them there. But if this truncated synopsis of his complex argument gives the impression that his analysis leaves many loose ends, and falls into the trap of stereotypic and weakly argued universalism, the fault must be laid at the door of the method itself, for while Lomax's ability as an ethnomusicologist is not at issue, his relegation of social structure and history to the margins of the analysis is troubling. His method seems to work best when little is known about those features of his societies but becomes most questionable when history and social structure are more thoroughly documented. Thus Lomax takes little note of the sharp distinction between demotic musical forms and traditional ritual or courtly music. Yet in many bardic cases courtly music differs rather significantly from the more popular musical forms. He accepts uncritically the representativeness of his data without considering that the criteria of choice of music to record and the source of his data compose a particular point of view, that of a folkloristic conception of anthropology, with its assumptions of stability and traditionalism of culture content in non-Western or marginal societies. Rather than accept a view of traditionalism as a fixed attribute, it is important to recognize that traditions too are created and re-created.

As the study of Benetta Jules-Rosette shows (1983), traditional styles, even in the third world, are not necessarily of long standing. Lomax tends to favor the most traditional-seeming, picturesque cases to the neglect of "impure" (acculturated or transitional) cultural forms that have lost a good part of their folk character. They may include, for example, popular music influenced by music of Western societies, such as missionary hymns or, more recently, secular pop music from movies, television or, recordings. How would he interpret the music and performance styles that imitate, and some-times in turn influence, Western musical forms? By now some of these, ranging from popular dance music to political songs and dances of nationalist movements, or the two combined, have given

rise to new musical traditions in many non-Western cultures. Although this process is uneven, having more impact on African musical forms which, as Lomax points out, have come into favor all over the world, his analysis does not help to account for the discovery of such specialized bardic forms as traditional Indian music and their acceptance by the Western youth generation of the 1960s and their descendants, via the mediation of the Beatles and other rock groups. As with human culture generally, older forms are frequently and constantly reinterpreted, and while correspondences between the new traditions and society are discernible, their forms and meanings are mediated through complex structures. To view them as "reflections" is overly simple and vague.[5]

Beyond this criticism lies another, equally troubling, and perhaps as difficult to answer. Because Lomax's study rests upon secondary analyses of societal structure and history carried out by other scholars, his societal categories are no stronger than theirs. He relies, for example, on data on African cultures in George P. Murdock's Human Relations Area Files (1949), which while revolutionary in original conception, are notoriously flawed in a number of important respects.[6] It is difficult to see why cultures marked by egalitarianism

5 The problem of assuming that a traditional society or that social traditions are very old and quasi-permanent tends to obbfuscate our understanding of how social change comes about. As Jean-Claude Passeron points out in another context, there is a phenomenon of "lost memory" which makes it seem that what is has always been. "Ethnologists have shown that 'societies without a history' do have a history, and this should put us on our guard." As he warns, " 'Lost memory' is often a loss of memory that is convenient for the legitimization of innovations" (Passeron 1986).

6 Murdock compiled data on hundreds of ethnographic studies, adding these to a data base whose compilation had been started in the 1930s at Yale University's Institute of Human Relations. They allot equal weight to extremely varied societies and contain data from different historical moments, collected with uncertain degrees of accuracy and for purposes ranging from ethnographic description to colonial administration (or oppression). It is not clear which of these purposes is more inimical to sociological analysis. What is certain, however, is that many of the data are old, collected decades if not a century prior to Lomax's analysis, and are marred by the unthinking (or conscious?) sexism or cultural prejudice which characterized the unreflexive social science and humanities of the past. This is not to say that these data sources are worthless, as some anthropologists contend, but that they must be used with extreme caution.

and relatively open statuses, such as the Amerindian, Bushmen-Pygmy, and Negro African peoples would have different musical forms and performance styles.

Finally, though he deals with the overall social structural features of his cases, he neglects the social structure of music worlds (Becker 1982) without which the stylistic stability to which he alludes would be impossible. In constituting a model of developed Western performance style as a base line, he focuses on the symphony orchestra, neglecting the many other forms of musical ensembles that are not particularly authoritarian, but cooperative. They are as likely to be professional groups as amateur, including chamber players, barbershop quartets, glee clubs, and solo performers. It is not surprising that Lomax's analysis proves most plausible in dealing with societies either like those of the Bushmen or Amerindians, or folk subcultures within complex modern societies. But it cannot hope to grapple with complex societies without forcing him into the trap of stereotyping behavior, as did studies of national character.

Despite his critique, as I have argued (Chapter 1), ethnographic methods are of value to sociologists especially for studying small groups or subcultures within complex societies. The varied micro-analytic modes of study to which they have led to some extent have remedied the overly scientistic mode of mainstream sociology. But these methods and orientations have obvious limitations which become apparent in large, heterogeneous, complexly structured societies, surely the case of the large, varied civilizations of Asia and Africa. Instead of being coterminous with the society as a whole, subcultural groups embedded within societies may be deeply marked by their surrounding (and usually) dominant host, or they may be so marginal as not to permit easy generalization to the larger society.[7] This is equally the case for attempts to find correlations between art and social structure. No less than sociologists,

7 Theorists propose different views of the subject. The literature on plural societies, for example, tends to assume that there is more segregation than mingling. Redfield argues that the peasant community of the Yucatan which he studied has no existence without the developed urban society in which it functions (1965). Vidich and Bensman, in analyzing the small town in the context of mass society treat the notion of the autonomous community as a myth.

anthropologists need to take into consideration the effects of macro-structures on the microworlds they study. The extent to which many choose to ignore the embeddedness of their peoples in such worlds, as we see from reanalyzing Lomax's seminal work, reveals the limitations of their findings. When we turn to the analyses of Theodor Adorno, we find different failings, and other important insights as well.

Sociology of music as social critique

The considerable attention of scholars associated with the Frankfurt school of social critique to the arts and literature attests to their standing as intellectuals in the broad sense of the term. Already marginal to existing European university life, as emigrés escaping from fascism, and (often) embittered scholars suffering marginal status in the United States, they attacked American sociologists who were trying to create a profession and discipline in conformity with a scientific model. From today's vantage point their approach is very close to that of literary or art critics, some of whom are drawn to their ideas. Yet they considered themselves chiefly scientific. As Horkheimer and Adorno put it, their goal was "to decipher art as the medium in which the unconscious historiography of society is recorded" (Horkheimer and Adorno [1956] 1972, 101), and called for the application of similarly subtle analyses of how "the moments of inner aesthetics and of the societal are developed in terms of each other and of their interaction." To this end they proposed to allot equal attention to social process and wealth of detail; as much emphasis on distribution and reception as on production of art, to be part of a framework explicitly informed by a critique of society (Ibid., 102–3).

They turned, disingenuously, no doubt, to American sociology in order to glean from it approaches and methods. Yet nearly always, wherever they looked they found fault with American sociological research in general, and rejected what they considered the "primitive manner" of such little cultural sociology that existed. By this they meant what they considered a vulgarized sociology of knowledge, relating peoples' social origins and their consequent ideological orientations or simple content analysis of art works. They argued instead that sociologists who examine the relations

of art and society should focus on "the tension between its content and its form" (Ibid., 101).

Perhaps because of his open antagonism, Adorno in particular struck mainstream American sociologists as quite unprofessional. It is necessary to bear in mind that his failings as a sociologist in the American style (Morrison 1978) may have had as much to do with the fact that as a scholar his knowledge and aesthetic sense were more typical of an educated European of an earlier generation than the American social scientists whom he derided and stereotyped. Adorno has been roundly criticized for his unwillingness to adhere to the canon of sociological procedure for evaluating evidence and for elitism with regard to aesthetic judgment. In fact, the idea that sociologists have the professional right to express their own taste is an issue which is subject to ongoing contention. Those opposed to expressing value stances argue by analogy with Max Weber's value-free criterion that the sociologist's judgment should be reserved for extraprofessional occasions. What is clear is that when sociologists such as Adorno do express their taste preferences, then the preferences themselves become as open to criticism as any other aspect of their analysis. Aside from the mutual antagonism between Adorno and certain American sociologists, therefore, it is important to consider that his taste itself has been disputed.

Some of Adorno's essays on music (opera, chamber music, symphonic music), while by no means characteristic of every aspect of Frankfurt intellectuals' approaches and ideas, provide a body of work in which the advantages and disadvantages of their conceptualizations are laid bare (Adorno [1962] 1976).[8] For the Frankfurt school sociology is not merely an approach which can and should be applied to any subject, but the subject itself must be worthy of being studied in a way appropriate to its essence. As Adorno states in his preface, "A sociology of music in which music means more than cigarettes or soap in market researches takes more than an awareness of society and its structures, and more than a purely

8 Originally delivered as a series of lectures at Frankfurt University in 1962, they were revised and broadcast over North German Radio. As a course they present an overview of his approach through a career encompassing his experiences with the Princeton Radio Research Project beginning in 1939 and based on his musicological education.

informational knowledge of musical phenomena. It requires a full understanding of music itself, in all its implications. A methodology that lacks this understanding and therefore depreciates it as too subjectivistic will only lapse the more deeply into subjectivism, the median value of researched opinion."[9]

This statement is by no means the only one in which Adorno reveals his sense of the importance of the scholar's calling to uphold standards of judgment and quality, a lofty goal that places great responsibility on the intellectual. Yet even those who share a similar conception of the scholarly imperative must be struck by the danger it assumes, that certain subjects are, virtually by definition, unworthy of serious consideration – commodities such as cigarettes and soap. Against his position, I argue that for sociology to be of value, scholars have an obligation to obtain as full an understanding of their subject as possible, whether a priori worthy or not.[10] By joining other critics of "mass society" in refusing to differentiate among the dross that he saw as homogeneous mass culture or mass products for the masses, he probably missed many chances to grasp the variety of modern society.[11] Regardless of the scorn he directed against what he considered trivial, however, it is certain that Adorno raised questions of aesthetic value which are rarely touched by

9 Robert Lilienfeld points out that Adorno's insistence that only a sociologist with professional musical training could be reliable as a sociologist of music, while probably defensible, "was just as probably aimed at Lukács" (1987, 136).

10 The idea that certain subjects are unworthy of serious consideration is more revelatory of the prejudices of the author and, if adhered to too closely, could lead to a blinkered sociological discipline. The fertile harvest of insights resulting from examination of apparent trivia (such as popular sports, table manners, commercial as well as elite leisure behavior) is amply proven by the work of such scholars as Norbert Elias and Pierre Bourdieu (Elias [1939] 1982; Bourdieu, 1984; Elias and Dunning 1986). On the other hand, given that many sociologists, either American or European, who model their work on certain aspects of American methodology, especially quantitative data gathering and analysis, leave out of consideration the substance of the subject that they are dealing with, Adorno and others do have a point.

11 His elitist preconception is one of the causes of the flaws in his work *The Authoritarian Personality* (1950). For a critique of the approach, methodology, and ideological orientation of the work, see Christie and Jahoda 1954.

sociologists, who consider them beyond the pale of their discipline. This is an issue to which I return in Chapter 8.

Adorno's *Introduction to the Sociology of Music* presents a frame of reference which either directly influenced the research questions studied by other sociologists, including some who would not want to be associated with his orientation, or which arose parallel to their work.[12] Whether he focuses on reception, creation, support structures, or other aspects of production, he never loses sight of the musical forms to which these processes are related. Unlike the "primitive" sociological audience surveys whose raw empiricism he derides he analyzes patterns of conduct in listening, *how* people listen, from which he draws implications concerning the changing meaning of listening by setting it into its historical and technological context. Thus, rather than merely gathering data, he traces the changing functions of music, contrasting its role as art as opposed to entertainment, advertising, noise-making, or decoration.[13] Even so, not everyone "receives" music in the same way as everyone else. Listeners can be divided into categories, ranging from nearly

12 Echoes of Adorno's ideas are found in the *Production of Culture* (Peterson 1976); *Distinction: A Social Critique of the Judgement of Taste* (Bourdieu 1984), and many other works. This is not to imply that Adorno has been a direct influence on their work, since his approach and assumptions differ considerably from Peterson's, and although he shares a critical outlook with Bourdieu, he lacks completely the reflexiveness which is basic to Bourdieu's analysis. For those who read Adorno, the peremptoriness with which he asserts his views, many of them unsupported by anything except the kind of "*ça va sans dire*" assumptions which Bourdieu warns against, must be particularly rebarbative. From a literary point of view, the impact of the American experience on Adorno must have been similar to that described by Nabokov in his early novel *Pnin*. Aside from American sociologists, Adorno has also been of great influence on the writing of Jacques Attali, a high-level civil servant, recently a member of François Mitterand's cabinet, and amateur musicologist, whose book, *Noise* owes a great deal to Adorno ([1977] 1985).

13 At the most basic level Adorno considers the relationship of the listener to musical sound, pointing out that the structure of this relationship is different from that of the viewer and the visual art object. "The ear is passive. The eye is covered by a lid and must be opened; the ear is open and must not so much turn its attention toward stimuli as seek protection from them." As a result, music is capable of having direct effects despite one's efforts to escape (Ibid., 52).

professional experts to the most passive, unschooled mass, an aspect of his work to which I return in Chapter 6.[14]

Despite acknowledging the arbitrary and transitory nature of musical genre boundaries, Adorno tries to incorporate all these components into a total understanding of musical form and its relationship to society. To that end he confines himself to certain of the musical forms that developed in Europe from the late seventeenth century to the present: chamber music, opera, and symphony. Adorno considers chamber music to be a form in which the players are central, a musical tradition starting with Haydn and virtually completed by Schönberg and Webern. As a musical structure it is centered in the creation and development of the sonata form, whose performance style is essentially located in the relationship between composer and performers, not necessarily professional players, but dedicated amateurs as well. Typified by a small audience, which is virtually an afterthought from the composers' standpoint, it is a genre that deviates from developments in nineteenth-century music generally (Ibid., 85). For although both chamber ensembles and symphony orchestra tend to play music derived from the sonata form, chamber players dedicate their expertise to playing their parts and work to integrate their playing into a whole, whereas the symphony became a rhetorical, political genre, blustering, decorating, not truly serious. Moreover, even though the symphony orchestra has available a far greater range of resources (instruments, sections, growing repertoire, and audience), because it lacked the community of knowledge with

14 In many ways this is a subtle analysis that has not been sufficiently pursued. Adorno goes beyond the level of individual reception or taste in analyzing the nature of popular music; he forsakes individual or small group categories and turns to the macrosociological level of mass society analysis, arguing that under capitalism music has become a means of lulling the masses into submission, dulling their potential opposition to the injustice inherent in the system. In particular, because music is "nonobjective . . . it can take on many functions, colors, and fill the inner emptiness of our time" (Ibid., 48). Music, therefore, is one of the devices that, Adorno believes, serve to conceal capitalism's pervasive production of alienation. Equally important is his analysis of class and strata, not simply as reflected in music, but as a link for understanding the interconnections of music and society through mediations that provide the structures and dynamics of reflection.

its audience intrinsic to chamber music, symphonic music could not become too elaborate without losing its audience (Ibid., 94). Vital to the continued existence of composers and musicians, the audience places constraints upon them in relation to musical choices. In that light, chamber music can be seen as a refuge for composers who sought to free themselves from the ostentatious symphonic form, who resisted the maintenance of a barrier between composers, players, and audience, and the dictatorship of the conductor which that form demanded (Ibid., 92–4).[15]

Opera as an instance of the lack of congruence between conditions of reception and conditions of production in a form encompassing the ethos of bourgeois individualism, including certain sentiments foreign to modern publics (such as sympathy with the "kept woman") is, by now, an outmoded form. Aside from the time-boundedness of its content, Adorno takes as further evidence for opera's archaism a critical shortage of great performers on the one hand (Ibid., 78 ff.), and on the other, the increasing rarity of audiences with a deep knowledge of the works as opposed to mere superficial recognition of "hit" arias.[16] Yet although Adorno saw

15 Chamber music is a form that was intended for and continues to draw a small public, not because of its inherent elitism – Brahms's works, after all, as he observes, sometimes have a "tone borrowed from Victorian chromolithographs" – (Ibid., 95) but because it has lost its serious amateur patrons. Because it is performed in small halls, it is less authoritarian, more ascetic, and consequently, more autonomous than the musical forms that appeal to passive audiences merely seeking entertainment. But passivity seems to be inevitable in the face of certain social changes. Adorno seemed convinced that amateur participation in music has ended. Unlike the pre–World War I era, he believed, inflation had made private music lessons of high quality too expensive for the modest middle class, and the replacement of ample house dwellings by small apartments eliminated space for the grand piano. In writing its epitaph, he states that chamber music can only exist "as an art for experts, something quite useless and lost that must be known to be useless if it is not to decay into home decoration. . . . Whatever has a function is replaceable; irreplaceable is only what is good for nothing. The social function of chamber music is to be functionless. Even this function, of course, is no longer performed by traditional chamber music" (Ibid., 102–3).

16 Ironically, he cites as evidence for this observation audience studies done in 1949 by the State Capital of Hannover, without commenting on whether they are more sophisticated than the "primitive" research of American sociologists. His interpretation of the data is that elites are now separated into

this decline as inevitable, he made an exception of the operas of Alban Berg, *Lulu* and *Wozzek*, works that advanced operatic evolution toward antimimetic, atonal, expanded harmonics, dense counterpoint, and serialism innovated by Schönberg. In spite of the fact that – or *because* these works were not appreciated by opera audiences, Adorno considered their musical form to be the telos of the art form.[17]

While American sociologists import sociological methods into their studies of the arts, Adorno both imported and exported. Not only did he contextualize aesthetics, but he brought aesthetic critique into societal analysis. His work is imbued with the conviction that one should never separate aesthetic form and content; music theory and social theory. Moreover, in opposition to the dominant scientistic incorporation of value-freedom, he insisted that the sociologist of art is bound to include evaluations of quality because aesthetic quality is essential to the critical project. As a serious musician he appeals to musicologists ordinarily repelled by more externalist social scientists (Winter 1985). By consistently keeping in mind the social structural constraints and opportunities of music professionals, he rarely commits the naïve errors of simple reflection theorists who tend to equate aesthetic structure with societal structure at a general level.

> an intellectual stratum on the one hand (professionals, civil servants, executives), and a middle class on the other (businessmen, lower-level civil servants, workers, service employees). Opera has become a form of middle-class entertainment, while the intellectual elite prefers its drama spoken, in the theater. As a result, opera is "a species of art that is outliving itself and will hardly survive the next blow" (Ibid., 83). A more "primitive" sociologist than Adorno would have bothered to indicate convergences of these findings with an already large literature on status differences in the *Yankee City Series* (Warner 1942) and the rise of new bureaucratic sources of status in modern societies. The analyses of Bourdieu on the cultural capital of class fractions supports to a large extent Adorno's observations (Bourdieu 1986), as does the audience study of DiMaggio, Useem, and Brown (1978).

17 It should be pointed out that Adorno had daring and rather idiosyncratic ideas about music, which he saw evolving in a unilinear, progressive direction that brooked of no turning back. Thus he welcomed Arnold Schönberg's atonalism as a step toward the future and appreciated Alban Berg's operas, in spite of his revulsion from opera in general as an outmoded genre. In fact, he considered Stravinsky's experimentation with classical forms retrograde, and Puccini's operas as no better than hackwork (Adorno 1976; Jay 1984).

On the other hand, by refusing to take seriously popular music, jazz, folk music, and other sources of sound, he misses opportunities open to less critically oriented social researchers, who are far more capable of tracing connections between composers and musicians of different musical worlds in order to elucidate the creative process. When it comes to sounds emanating from sources of which he disapproves, Adorno does not follow his own stricture, that the boundaries separating musical forms are arbitrary and shifting. Moreover, this rejection leads him to see an end to amateur music performance, when it has boomed, not only in classical performance, but especially among young lovers of rock and folk music. Not surprisingly, from the point of view of sociology, whereas music continues to be made, Adorno's writings about musical forms have the quality of historical closure.

In contrast to Adorno, Lomax attempts to grasp the whole of music, rejecting (apparently) no traditional source, no matter how primitive or divergent from European high culture. To the contrary, he explicitly avoids the music tradition that is so precious to Adorno. Yet Adorno's analysis, for all of its parochialism and oversimplification, suggests that if sociologists are willing to make the investment and steep themselves in an art form, they may make an important contribution to their conceptual toolkit.

In all of the research examined, the researchers have never underestimated the art works which they studied. This is not always the case of the orientation that I examine in the next chapter, in which art as object serves as a starting point and is mainly an organizing focus for the analysis of social processes. This perspective is not tantamount to the reduction of art to its supposed determinants, nor do the examples presented lack subtlety. On the contrary, they suggest that sociology of art has greater intellectual scope than previously imagined.

4. The art object as social process

The division of labor separates the product as such from each individual contributor. Standing by itself, as an independent object, it is suitable to subordinate itself into an order of phenomena, or to serve an individual's purposes. Thereby, however, it loses that inner animation which can only be given to the total work by a complete human being, which carries its usefulness into the spiritual center of other individuals. A work of art is such an immeasurable cultural value precisely because it is inaccessible to any division of labor, because the created product preserves the creator to the innermost degree.

<div align="right">Georg Simmel, The Conflict in Modern Culture and Other Essays (1968): 45–6</div>

The ideology of the inexhaustible work of art, or of 'reading' as re-creation masks – through the quasi-exposure which is often seen in matters of faith – the fact that the work is indeed made not twice, but a hundred times, by all those who are interested in it, who find a material or symbolic profit in reading it, classifying it, deciphering it, commenting on it, combating it, knowing it, possessing it. Enrichment accompanies ageing when the work manages to enter the game, when it becomes a stake in the game and so incorporates some of the energy produced in the struggle of which it is the object. The struggle, which sends the work into the past, is also what ensures it a form of survival; lifting it from the state of a dead letter, a mere thing subject to the ordinary laws of ageing, the struggle at least ensures it the sad eternity of academic debate.

<div align="right">Pierre Bourdieu, "Habitus, code et codification," Actes de la Recherches en Sciences Sociales 64 (1986): 40–41</div>

UNLIKE STUDIES that accept certain kinds of works as givens, in this chapter I show how the definition of the art work itself may be taken as problematical and analyzed in terms of the process of its creation. I focus on two aspects. Instead of assuming its existence as a given, sociologists who work in this mode undertake to explain how a work comes to be defined qua art. Secondly, and related to it because based

on similar assumptions, sociologists may treat art primarily as objects to be deconstructed to reveal aspects of social structure and process using whatever sources of indicators are available. If those sources happen to be art objects, they stand as good a chance of being consulted as any other social indicators.

The first type of analysis, in which art works are seen as the products of collective work efforts rather than as individual creations, is most closely associated with the approach of Howard S. Becker. In his book, *Art Worlds* (1982) he treats art as a social construction that can best be understood as involving a variety of actors, including some whose social power permits them to attach value to objects.

Although this interpretation of the arts is compatible with the Marxian analysis of the commodity nature of art works under capitalism, that is not Becker's point. His is a broader perspective, which makes the general argument that under *any* social conditions, whether capitalism or something else, art works are created through processes in which several – even many – social actors participate. Not only does he see changes in the meaning of art, but Becker posits the coexistence of a number of different art worlds, whose actors engage in the process of creating art de novo, by including and excluding works from the category as they define it. He argues that the definition of what constitutes art is relatively arbitrary, and more dependent upon social consensus than inherent to a work's aesthetic qualities. One of the implications of this approach is to throw into question the idea of the uniqueness and genius of the individual artist.

Other scholars using art as a sign for something else may treat art works primarily as unobtrusive measures of social, historical, political, or other societal processes; or as a way to understand broader cultural meanings. These social processes and cultural meanings are at the forefront of their concern, rather than the art work itself. In examining a work of art they may start by post factum explanation of how it came to be defined as art or, like Becker, they may assume that the boundaries of art works are perpetually subject to redefinition. As against the common sense view of art as a specific concrete object, whether painting, sculpture, movie, poem, musical work, or play, the art work is taken as synechdoche, representative of a total social experience. Furthermore, in this type of analysis the boundaries of a work are not

considered coextensive with a particular object as such, but changeable by subsequent social definitions. Although this approach is similar to the orientation of certain art critics and aestheticians who implicitly or explicitly view an art work as part of a process (Berger [1972] 1981; Danto 1986), it is far more likely to be a strategy of sociological rather than aesthetic analysis.[1]

The idea of disaggregating the art work by attempting to contextualize it, thereby resolving its mystery, as I suggested in Chapter 1, is jarring to many aesthetic specialists. For whereas even sociologists strongly sympathetic to art are able to accept its social embeddedness, this approach is foreign to the disciplinary orientation of traditional aesthetics. It is not that they differ completely from social theorists, but whereas social science rests on the scientific foundation that any findings are provisional and may be overthrown by later study, a strong tradition of aesthetics is lodged in intellectual ideas founded in part upon patently mythical premises. So central have these become to the tradition of their disciplines, however, that modifying them is threatening. These premises are that a work is to be understood as a unique object, and that it is made, ultimately by the genius of a single creator.

The idea is embodied in the statement of faith by Georg Simmel, cited in the epigraph to this chapter where he speaks of the art work as a totality inaccessible to division of labor. Art world participants usually couch their comments in similar symbolic or idealist aesthetic language, rarely allowing material matters, such as the state of the art market (which others think has some relevance), to intrude into their aesthetic definitions. By contrast, sociological analysts such as Becker imply that this totality may exist in the minds of aestheticians, but not in the art work itself. Although they do not necessarily simplistically reduce art to financial transactions or political weapons, they incorporate the fact that art is not immune to market considerations, may be embedded in political concerns at the international and national level of the state on the one hand, and at the middle or micro-level of academic institution

1 Approaches of this kind are explicitly analyzed by Hugh D. Duncan (1953), and in the institutional analysis of M. C. Albrecht (1970), among others, in one way or another, dealing with a variety of art forms. They include Griswold (1986); DiMaggio (1982): and the Langs (1988).

building, on the other. Finally, as implied by Bourdieu, the reception of art itself is a plural phenomenon that makes for the continual re-creation of art works with each re-reading.

Because the tenets of aesthetic faith seem so much at variance with the sociological perspective, sociologists find it necessary to challenge the assumptions composing it and their intellectual implications. They do so not necessarily with the intention of claiming that all art works are equivalent to one another, regardless of whether they attain heights of sublimity or descend to depths of banality, but to reopen discussion between humanist and social scientific fields. In this chapter I heighten the contrast between the two orientations by disaggregating the components of uniqueness in art and artists, pursuing their implications for the creation of material and other social values. I then confront the creation of value extrinsic to art because of the multiplication and replication of art objects. The prophetic insight of Walter Benjamin suggests how technological advances in replication have threatened previous definitions of art, and led to redefinition of uniqueness of the work and the creator. These ideas reveal the social construction of the definition of art and its values; the obverse is to see how even unique works may be changed or socially reconstructed – the "re-readings," as Bourdieu's statement in the epigraph suggests, and their implications. The case studies by Madeleine Akrich of the Beaune altarpiece and that of Robin Wagner-Pacifici and Barry Schwartz of the Vietnam Veterans' Memorial in Washington, D.C. show how the works are treated as images of different social moments, and sometimes as icons.

Unique artists, unique art works

The two principles which are at the foundation of aesthetic value in the modern world, that the work is the creation of a single artist and that it is unique, compose an interlocked structure taken for granted as fact by a large body of lay opinion and as a convention among art specialists, artists, and art professionals (art critics, art historians, aestheticians, musicologists). At the simplest level this is supposedly guaranteed when a painter signs his name to a work, proving that the work was made by him. This principle is so

central that a great deal of energy is expended upon assigning an author to specific works, and if a work is clearly the product of collective action (e.g., a movie), art world actors have tried to exclude it – unsuccessfully – from consideration as art, or failing that, as I have shown in Chapter 1, to incorporate it into the framework by designating, sometimes arbitrarily, a single creator for it.

Not only is a work of art supposed to be an individual creation, it is also defined by its uniqueness or, at the least, scarcity or rarity (Moulin 1978). The prototype of uniqueness in this sense is the original work by a master artist, whether oil painting or drawing. Its criterion of uniqueness (parallel to creation by a specific artist) is the palpability of the master's hand in or on the work itself. These forms of plastic art contain within themselves the originating elements that compose their aesthetic value and their realization in their total presentation or public appearance, or phenotype, as, borrowing the biological term, Rémi Clignet suggests (1982, 10). However, originality and uniqueness do not mean the same things for different art forms. Plastic or visual art and literary or performed art encompass different kinds of uniqueness. Literary or performed works are only partially realized in these terms. Because of their intrinsic structure, they are not complete in and of themselves but are completed by performance or by publication, processes that also lend them a good part of their social (including economic) value. Ironically, in modern times the importance of uniqueness is accompanied by increasing possibilities for duplicating or multiplying works.

Even though these examples seem to imply that it is modern technological innovation which has brought on the problems of artistic redefinition, this interpretation is not my intention. It would suggest, wrongly, that prior to their invention or diffusion only original and unique works were made or recognized as valid art. Yet originality was not always a prerequisite for a work's inclusion in collections, either for private individuals or for museums. Other criteria have been important, both before originality gained sway, and since. For example, in the past, the preciousness of materials used in making art works was more important. The reasons for their use as art materials merit a brief comment.

Precious media, precious art works

Subsidiary to uniqueness and the artist's hand today, though primary in the past, is the value deriving from the actual materials used by the artist for making the art work. The difficulty of accepting this notion currently attests to the success by early twentieth-century avant-garde artists in having works made of ordinary objects, even rubbish, acknowledged as being of artistic (and commercial) value.[2] Along with the attribute of the materials used, the art object's physical size in determining market value may seem trivial (from the aesthetic standpoint), yet it has been a fairly constant and relatively stable gauge employed by participants in the art market, especially for the routine art works which dominate art market transactions (Moulin [1967] 1987; Crane 1987).

Why should the holders of treasure convert it into works of art or precious bibelots? As Joseph Alsop has noted, rare stones and metals, such as gold and silver, the traditional treasure materials of rulers and the wealthy, filled their coffers but were normally invisible to anyone but themselves and their guards. If transformed into artifacts, this lucre could be made to play a double role: as symbolic display of their owners' status, as well as being available for melting down if ready cash were needed (Alsop 1982). Whether this interpretation accounts for the practice before the development of other investment opportunities, it became customary for wealthy individuals to commission craftsmen to make objects of the treasure they had amassed. The uniqueness of the objects was far from being the most important consideration, since the objects were routinely transformed into liquid assets.

Even the attachment of extraordinary value to great old masterworks is a relatively new development. In his analysis of the rise of the modern auction market for art works, Nicholas Faith has shown that only since the 1890s have Old Master paintings, even of the universally recognized great artists, such as Raphael, attained prices higher than works by a great eighteenth-century

2 Picasso and Braque were not the only ones who made collages out of scraps of newspaper, bottle labels, pieces of tin, and wood; Duchamp took the process several steps further by using whatever came to hand to make his assisted readymades; Kurt Schwitters created his *Merz* by combining large quantities of nearly anything lying around.

ébéniste or Renaissance silversmith. He insists that "only in the past hundred years has the market ennobled paintings to a rank above objects whose major virtue was the lavish materials, skill and ingenuity that went into them" (Faith 1987, 29–30; 85–95).[3]

These considerations have been challenged by avant-garde artists since the beginning of the twentieth century and, to some intellectuals, have come to be extraneous to the valuation of the work itself (Chapter 5). Yet they continue to influence the monetary value of art work, as shown by the tracks they have left in the hierarchy of value that has come to be established through the workings of the art market. The basic components of social value include, first, the assignment of a creator's name to the work; and secondly, the value of the materials of which it is made (oil paints, fine brushes, prepared canvas; rare, carefully selected stones or other expensive materials) (Alsop 1982; Moulin 1987; Berger [1972] 1981, Chapter 5). Generally, drawings and watercolors on paper continue to be less costly than oil paintings by the same artist (Moulin 1987), plaster casts than works made in marble or bronze. This would be true even of works by the leading Renaissance artists, such as Leonardo, whose drawings are extremely valuable because there are virtually no other works in any medium by him that have come on the market in over a decade, or are likely to do so in the future. But these are not absolute criteria, as modern possibilities for duplication of art works indicate.

Multiples, reproductions, copies: negotiating artistic value

Aside from the fact that it is the artist's name which may give value to any agglomeration of matter, or that dealers generally ask higher prices for large works than small ones, the problem of uniqueness itself is an increasingly complex and debatable matter. One of its aspects has to do with illicit copying or forging of art works. Much more subtle is the danger to uniqueness and originality

3 It might be mentioned in passing that the United States Internal Revenue Service, which for decades allowed collectors of art who donated works to museums to deduct the paintings' appraised market value from their gross income, regardless of what they actually paid for them, permitted artists who donated their own works to deduct only the cost of materials!

when works are, by their very nature, multiples and, therefore, intrinsically not unique. Multiples are both a boon and a threat to the artist and to the art market itself. On the one hand they have opened possibilities to dealers for soliciting a larger pool of potential purchases; but on the other they threaten dealers' attempts to control supplies of art and, consequently, prices. Moreover, their existence impinges on the symbolic meanings attributed to art. As a result, although multiples have come to abound in the domain of art, their legitimacy has shifted in varying degrees. Nevertheless, their standing has come to conform fairly closely to a created hierarchy of symbolic and economic value.

Because it challenges the myth of the artist's hand this analysis applies not only to two-dimensional, or visual art, but to any work that can be copied precisely. In sculpture, because of the practice by many artists of making small maquettes, which are then replicated to desired size in foundries or carved by stone cutters, the question of the artist's hand is particularly problematic. Although taken for granted in the nineteenth century, in recent times these sculptural practices have reached the extreme among certain modern sculptors, who merely write instructions for their (chiefly large minimalist) works to be constructed in steel mills. In cases such as these it is assumed that the individual artist both originates the idea and supervises the work, or at least gives it his finishing touches and, of course, signature. But matters take a different turn when others create or recreate works *after* the artist has died. Though sculptors may create the form, they are not able to supervise their castings posthumously.[4]

At the limit of multiple art are mass produced objects – pictures, china statuettes, songs – taken by aestheticians and scholars as beyond the pale, and thereby unworthy of discussion. A broad consensus on an artistic hierarchy of value existed until recently, whereby mass media art was the outer limit for the meaning of art until the creation of pop art and ensuing redefinitions of other

4 This question was raised by critics reviewing the completed *Gates of Hell* by Rodin, over a half century after his death. More recently, in reviewing a number of books about the English sculptor Henry Moore, Anthony Barnett raises serious questions about Moore's practice, especially during the last years of his life, of leaving to his forty assistants the task of enlarging his miniscule maquettes to very large sized works (1988, 547–8).

objects. While most aestheticians had rejected such art as unworthy of discussion, Walter Benjamin explored the implications for the aesthetic values attributed to art when it is reproduced on a large scale (Benjamin 1969). Starting with his analysis of the fetish-like qualities of paintings, he argued that the mechanically reproduced art, in particular the cinema, was the destroyer of the idea of art imbued with quasi-magical aura.

Though not the only component of aura, the uniqueness of the artist's hand is one of its major elements. In addition, aura includes the work's connection to elite patrons and owners, or its centrality to important historical events of state and church. In that regard, traditional works of art such as paintings are esteemed far beyond ordinary objects, because their aura is congruent with the principle of magical contagion, as defined by Frazer in his classic work, *The Golden Bough* (1911–15). It is incorporated into the market value attributed to works of art in direct proportion to the work's closeness to the unique creator: Art works whose surface has been directly touched by the artist's hand, such as oil paintings, drawings, and watercolors, are more valuable than art made in a medium where the artist is relatively remote. Woodcuts, etchings, engravings, lithographs, serigraphs, and, recently, photographs as well, correspond to the increasing distance and, usually, the mediation of technical specialists between the artist and the finished work.

This principle makes it clear why photography and its practitioners' eventual claim to social acceptance as artists raised consternation among art world participants. Aside from direct competition with portrait painting, photography seemed the province of technology rather than art, the photographer a technician rather than an artist. His touch was not perceived as being present on the picture he produced by mechanical devices. Yet in spite of the apparent absence – incorrectly perceived – of the artist's tangible impact on the finished work, after considerable and protracted "negotiation," sometimes even litigation, all of these reproductive media have come to be potential or actual candidates for inclusion as art media (Ivins [1943] 1960; Moulin 1978; Lynes 1980).

The process of inclusion by art world gatekeepers of these new media involved compromises about what constitutes genuineness. Typically, two forms of rationales are put forth in favor of multiples. Proponents of new forms seek precedents in the work of acknowl-

edged great artists of the past (for example, Vermeer who used devices such as the camera oscura as a painting aid). Secondly, they point to attributes in the new media analogous to attributes of paintings or drawings, such as proof of the artist's hand and signature on paintings. To these are subsequently conjoined criteria specific to the medium of the particular type of multiple. This commonly entails placing a higher value on an early state than a later one, on the grounds that earlier states are more distinct in appearance than later ones.

The quality of distinctness, although more recently contested by artists, has come to be taken as the canon of aesthetic and technical perfection as opposed to later states that show signs of wear or seem faded, at least, to experts. Although experts perceive quality differences in such forms as woodcuts, it can be argued that the issue is less to insure clarity of line than to have a work closer to the artist's hand and to limit the numbers of copies. This is supported by the fact that preference for an early state continues to be used as a criterion even though the technological advances in recent photographic processes have considerably reduced the differences from one state to another. Although the technological processes that permit duplication of pictures or statues in relatively large numbers have a long history, their explosion in the nineteenth and twentieth centuries has created, not only problems of authenticating genuine works from copies, but actually of redefining art works themselves.

In this regard, photography would seem to have little to do with the material value based on precious materials. But like all other art forms, it too has a history of value construction. After being considered a technology appealing to gadgeteers, photography became a pastime of the well off on the one hand, and simultaneously, a livelihood for small businessmen; almost from the beginning it became the medium of art for the average man (Bourdieu, Boltanski, et al., 1965). Throughout its history, however, certain photographers have tried to transform it into an art by associating it, either in content and formal qualities, with academic painting or linking it to avant-garde art. Stieglitz did both, in succession. By now photography has attained the institutional accoutrements and the aesthetic remoteness of a fully accepted art form.

The assumptions of uniqueness and unitary creation have, therefore, been called into question, though with differing degrees of

ease, depending upon the aesthetic structure of the art form involved. Generally poets and novelists and painters and sculptors are assumed to work as individuals in creating their works, although there are questionable cases that indicate this is oversimplifying an activity much more collaborative than meets the eye. At the very least, as in the case of the novelist, Thomas Wolfe, an editor may play a major role in creating novels. Moreover, many painted works were made by teams of apprentices and assistants, under the supervision of the "name" artist.

The idea of unitary creation in the case of a performed work contains the built-in ambiguity of, at a minimum, being refracted through an interpreter's lens.[5] In fact, many performed works involve more in their presentation than a single interpreter, such as a solo instrumentalist or actor. Their performance may entail a large number of musicians or even an entire acting troupe with director, producer, supporting stage crews. When it comes to recordings, radio, television, movies, and other means of transmission or reproduction, the numbers involved expand enormously, because these media require the creative and interpretive complement of actors, and many more – veritable teams of relatively specialized workers, many, though by no means all, of whom consider themselves and are acknowledged to be artists, or at least craft specialists in their own right.[6]

In spite of the obvious multiplicity of collaborative creators, in order to valorize a work critics tend to seek out and assign principal responsibility for its creation to a single individual, sometimes post factum. Depending on the art form, the designated artist may be the film's director, the opera's music director, the orchestra's conductor, the theater's director or writer, as the case may be. Unless a plausible individual creator is found or designated, the standing of the work as *art* is in doubt.

5 Although some consider the interpretive role as less original than that of a composer or writer, it is worth noting that Simmel takes the musical interpreter or the actor as a serious artist.
6 A sign of this identification of artistic workers with artist/craftsmen is that many of their unions are called guilds. For example, the Writer's Guild includes employees who are not artistic writers, but researchers, whose actual writing is of the most utilitarian sort, and who are not responsible for a finished product but work in a complex division of labor in the context of bureaucratically structured organizations.

Examples of this aspect of designation of works as "art" are numerous, and predate the expansion of mechanical reproduction of art, such as in movies. For example, art dealers sought the help of experts to help attach name labels to paintings whose creator was unknown. Among the most famous and successful combinations of dealer and connoisseur were Duveen and Berenson. Bernard Berenson owed much of his success to his ability to provide plausible attributions of artists' names to unsigned works. Even when no specific artist's name could be found, Berenson would claim to discern stylistic similarities among unsigned works by unknown artists that proved the works were by the same painter. If works were truly dissimilar to those of any known artists, but among themselves shared a number of common stylistic features, he would create an artist, such as "Master of (the name of a town)" or "Teacher of (the name of a known painter)".[7]

Although the idea of genuinely original works has sometimes been assigned importance (e.g., pieces of The True Cross and other relics), until relatively late in the nineteenth century, *copies* of art works were virtually as acceptable as originals. Many museums routinely gathered up copies of oil paintings, plaster casts of classical sculpture, and wealthy art lovers or collectors regularly commissioned artists to make copies of paintings for them. As Paul DiMaggio shows in his study of the Museum of Fine Arts in Boston, only in the early twentieth century did plaster casts lose their legitimacy as museum displays (DiMaggio 1982; 1987). The history of classification and reclassification, or "framing," of art shows that genuineness and uniqueness as criteria for artistic value are not fixed, but are negotiated by interested actors as part of a social process involving the introduction of new rationales, in this case, the romantic notion of the artist whose unique touch makes his work radiate the aura of its creator.

The heavy dependence of a work's market value on its reliable attribution to an important artist has given rise, both in the past and today, to an industry of forgery. Rooting out fakes is an

7 The idea of a name or a "brand name" has come, in modern times, to be represented by a signature attached to fashion design as well (Bourdieu and Delsaut 1975, 7–37). In the case of mechanically reproduced works, the attribution of value is more complex. This is a subject of some debate, as I have indicated, since it is genuinely difficult to assign unique responsibility for collectively made works.

important occupation for collectors because the financial stakes are high. Equally important is the reputation of experts such as museum curators and art historians. Paradoxically, however, attempted forgery may lend value and, thereby, additional aura to an artist, since it implies that the artist's work is worth the trouble. Because the discovery of a forgery or, more innocently, of a misattribution, may take a long time, it continues to be a lucrative endeavor.[8]

Ease of designation should be at its maximum when it comes to paintings or frescoes, such as Leonard da Vinci's *Last Supper* or Raphael's *Sistine Madonna,* works either firmly attached to buildings, with historically documented proofs of creation, or of completely authenticated provenance. Yet misattributions, forgeries, or fakes arise as problems with respect to most classes of works of any value. This is especially true of antiquities or old masters, to the dismay of sometimes well-trained professionals who are more easily duped than might be expected.[9]

8 For example, a leading collector of Renaissance drawings, Ian Woodner, made his first purchase in 1959 of what turned out to be a forged Raphael. Not until five years later was the faking unearthed by the British Museum when the drawing was donated to it. Meanwhile, however, Mr. Woodner had sold it and purchased a unique drawing by Benvenuto Cellini for $18,000, today worth up to $4,000,000 (*Economist,* July 11, 1987, p. 92). The relabeling of Rembrandt's works, including paintings of impeccable provenance has been the cause of anguish to museums that hold most of them. For example, a painting of a girl at a window, owned by the Art Institute of Chicago (purchased from the Demidoff collection in the early 1890s) is now merely "attributed to Rembrandt." Presumably this problem should not arise in the case of works created by artists still alive, since the artist can be consulted as to the authenticity of the work, though even here there are ambiguities. In recent times the most notorious case of doubtful attributions, even when the artist was living, is that of Salvador Dali, who was accused of having signed hundreds of blank sheets on which various of what are said to be his lithographs have been printed. Other problematic instances arise in countries whose laws assign to certain executors full control over determining authenticity. Often the person whose authority to certify attributions is the widow of an artist, or another close relative. Supposedly Suzanne Valadon, the mother of Maurice Utrillo, connived in falsely attributing many works to him, for a fee (Cabanne, vol. 1, 1975).

9 Denis Dutton's *The Forger's Art* explores the outright faking of a number of Vermeer works by Han Van Meegeren. Outright fraud is but one possible temptation for those who make attributions (Dutton 1983).

The process of accurate designation is easily explained in market terms, since dealers have much to gain from faulty attributions. Even for works that do not usually circulate, other interests may be as important. This is particularly likely for public art or works in which the public or the nation as a whole may be considered to have an interest. As the case study of the altarpiece in the city of Beaune (Akrich 1986a; 1986b) will illustrate, it is sometimes in the interests of art world participants to assign a doubtful creator to a work of art, especially if it is not clear who the actual one was. If one name is more in vogue than another, then the chances were good, in the past at least, for that name to be the one affixed. It might also be thought that market value is of no importance to works that will never be sold, as is the case for art in national or museum collections. But as the altarpiece study shows, sale has not always been excluded, nor is it merely material value that is at issue, but other interests as well.

Is a thing of beauty a joy forever?

The premises of uniqueness and genuineness that have become central to the study of art are embedded in a changing social context with direct and indirect impact on the definition of works as religious icons, great art, high-quality decoration, or mere trinkets. Following Bourdieu (epigraph, Chapter 4), all of the re-readings, re-seeings, redefinitions together make up the work of art. Congruent with that idea, Madeleine Akrich reconstructs the political transformations in which a specific work is a pawn by examining the social history of successive receptions. In the process she is able to re-create the several eras through which the work develops, and illuminates those ideas in a case study explicitly incorporating social history as interactive macrocontext for microprocesses of political, economic, and cultural interactions, as follows (Akrich 1986a; 1986b).

In addition to conferring the accolade of stars to restaurants in their red guide, the Michelin Tire Company performs a similar service for tourists (as well as for chambers of commerce and tourism, not to speak of their own product line) by according recognition to sites of interest throughout France (and other countries) in their green guides. Among their three-star selections is the painting on an altarpiece, a polyptych, known as *The Last*

Judgment, by Rogier Van der Weyden. Located in the two-star city of Beaune in the Burgundy region, it is the main embellishment of the two-star Hôtel-Dieu complex. Founded in 1443, functioning as a hospital until 1971, and still in use as a nursing home for the elderly, the hospice is now primarily a place "well worth a visit or even a detour." The altarpiece has been moved to a room especially constructed for it in its one-star museum (Michelin 1977, 56), and remains the only three-star attraction in the city.

Perhaps without it tourism would flourish anyway. After all, Burgundy is justly renowned for its wine and cooking; historically Beaune was politically important as a center for the Dukes of Burgundy; architecturally its character has been carefully maintained, enhanced, or restored. In the words of the Michelin writers (Ibid., 55) "Visiting the vineyards is the indispensable complement of visiting Beaune: art lovers and lovers of good wine will be equally gratified." Thus it seems that the city has everything to gain by touching both bases, vinicultural and cultural.

Madeleine Akrich raises questions as to how significance and value came to be bestowed upon the altarpiece. In the process of answering, she re-presents the work anew, showing its transformation each time through the eyes of another individual or group, in each case in the context of their interests, whether primarily ideological, aesthetic, economic, or as part of civic boosterism. By this Rashomonic strategy she forces us to reexamine our conceptions of artistic greatness in light of its creation, its mythologized re-creation, and the consequent modifications of the work, both physically through restoration, but especially, symbolically, by application to it of new discourses. Thus, although the altarpiece had been in plain sight for four-and-a-half centuries, it was said that virtually nothing had been published about it, until its chance rediscovery when it was – miraculously – rescued from centuries of accumulated dirt and overpainting by a young art professional who happened to be passing through the town (Akrich 1986b, 426).

Nearly forty years later (the late nineteenth century), in his book on the work, Father Boudrot, the hospital's chaplain, opens his narrative with the account of that rediscovery, quoting at length from a letter written to him by the discoverer, now the (mature) chairman of the Antiquities Committee for the region. Recalling

how astonished he was to find such a great work (at the time, attributed to Van Eyck), he repeats his own judgment as to its value. In the antiquarian's statement, it is clear that he explicitly means *monetary* value. It is this story as reported by Father Boudrot that was for a long time taken to be an accurate account, and is still used as the basis of current tourist-guide copy. However, Akrich casts doubt on this story, showing that the work was not as unknown as the "rediscoverers" claimed. Rather she argues that the mythmaking process itself requires that miracles and mysteries become attached to the art as an essential part of value enhancement. What the "discovery" of the altarpiece succeeded in doing was to bring it to the attention of other art specialists who wrote concerning its attribution, iconography, and aesthetic value.

Perhaps not surprisingly, as a result of the recognition of its purported value, certain hospital officials began to talk of selling the altarpiece in order to improve the hospital's budgetary condition, but they met with opposition. In the context of the mid-century religious revival, and driven by a desire to enhance the religiously based charitable character of the institution, Father Boudrot led the fight on behalf of the religious faction to retain the altarpiece in situ as a devotional relic. It was in the religious faction's interest to enhance its religious character as opposed to either its monetary value alone, or its purely aesthetic standing. Those were the grounds they used to contest the interpretations proffered by art specialists. Although the experts had relatively easily corrected its attribution from Van Eyck to Van der Weyden, they disagreed upon its iconography, which remained somewhat unclear. When Father Boudrot wrote his account, therefore, he insisted that a definitive explanation of the work could not be arrived at on aesthetic or art historical grounds alone, but depended ultimately upon biblical textual analysis. Moreover, as a religious work, it was his contention that its main impact on viewers was expressive rather than aesthetic, appealing to religious sentiment rather than to taste. From this point of view he showed that its subject matter could be explained as the judgment of God on sinners, pointing some to Paradise and others to Hell.

At the same time, Boudrot emphasized the traditional status of the work as an intrinsic part of the Beaune hospital. Pointing to

the images of the founding patrons in the altarpiece itself, he was able to argue against its sale to outsiders. Remarkably, he succeeded in gaining universal recognition, not only of its theological significance, but of its aesthetic quality, while at the same time preventing the charitable institution that was its base from losing it or selling it to outsiders. In this way the work served for over a half century as a symbolic adornment of the hospital.

Akrich shows that the work qua art cannot be grasped without examining the processes involved in its definition and subsequent redefinitions. To begin at the beginning, the fifteenth-century patrons had commissioned not just any artist, but had turned to a highly reputed one; they stipulated the use of the durable medium of oil paint on sturdy material; of a subject appropriate to an institution in which patients and aged inmates were brought to die.

Although not altogether unknown the work might have drawn little attention from outsiders until it became the subject of professional debate. As a result of undergoing that part of the process, as Akrich shows, the altarpiece's standing shifted back and forth between those who viewed it as an "object of art" (*une oeuvre*), properly attributed to an important painter, and those who regarded it primarily as a work of moral and religious importance, of local importance. It was this, at times conflictual negotiation process that resulted in physical changes as well as its transportation from one end of the country to the other.

This came about in the late nineteenth century when it underwent "restoration." For this purpose it was sawed in half (the better to fit on the train that carried it!) and repainted (to a degree probably unacceptable by present-day conservation principles). In the course of these transformations it was also exhibited in Paris. Like the necklaces and bracelets of the Kula Ring (Malinowski 1922), the altarpiece made the round from its provincial home to the center of the French universe, indeed, of the entire world, since it was displayed as part of the 1878 World's Fair, thus acquiring still more "aura" (Benjamin 1969; Akrich 1986a, p. 265). One result of this event, as Akrich points out, is that a new actor in the social process of artistic production began to emerge or, rather, in her words "to materialize" (1986a, 265): the public. The creation of the public in the late nineteenth and twentieth century is linked to the growth

of transportation and communication, though these factors are only a part of a densely interrelated set of processes including the religious revival alluded to above.[10]

But the re-readings of the work did not stop. In the twentieth century, supported by the increasing influence of technocratic medicine and the rise of welfare state financing, the centuries-old dominance of nursing order nuns, themselves increasingly weakened by a decline in vocations and the inadequacy of income from the charitable foundation, came to an end. In Beaune as elsewhere a new hospital was built and the old transformed into a minor institution. From serving as the focal center of religious activities, including festivals, the major activities of Beaune life gradually recentered on the chiefly economic activities of the wine market.[11]

Meanwhile, the question of the status of the altarpiece reemerged. The World War II period was taken up with a negotiated process through which divergent groups competed for acceptance of their preferred definition of the work. Ultimately two views came to dominate, that of the central state agencies (High Commission for Historic Monuments), which demanded an historically faithful renovation, and the local administrators of the Hôtel-Dieu who, with the end of its effective functioning as a hospital, sought alternative uses for the buildings. The idea of enhancing its attractiveness to tourists emerged as a general movement in the increasingly affluent society. This entailed placing the work in a new location, supposedly to maintain it in a better state of conservation, but at the cost of eliminating its functional context.

In a controversy which lasted several years, with shifting stances and alliances, actors with personal goals as well as interests at-

10 The nearly simultaneous development of rail transport and the rise of new places of pilgrimage, such as Lourdes, is worth exploring. Even where there existed no obvious miracles, the arts were used as ancillary to both the religious revival and the incipient tourist/pilgrimage industry. For example, a large number of religious monuments, including shrines or giant crucifixes were constructed, especially on high places, so that they could be seen from neighboring towns, or be used as a journeying goal by pilgrims.

11 According to Frank J. Prial, wine columnist of *The New York Times*, the hospices own about 140 acres of vineyards, donated to the charity over the centuries, producing valuable burgundy wines (*New York Times*, Nov. 30, 1988).

tributable to their position or the groups they represented, fought the question out through successive administrations. The winners, according to Akrich, seem to have been the forces of commerce, the businessmen of Beaune. They showed that they understood the public in a way congruent with what Bourdieu and Darbel (1974) revealed in their study of museum publics. Using their marketing know-how, the wine merchants succeeded in turning an esoteric painting, originally intended to glorify religion and its patrons and frighten the dying into repentance, into a work of "absolute beauty" for tired drivers and their hungry families.

Another way of putting it is that rather than see the picture as old wine repeatedly poured into new bottles, it is important to remember that the wine itself does not remain unchanged. In the aging process it may improve and become more valuable, or it may deteriorate. However defined, it is important to recall that like the Beaune altarpiece, its quality is a negotiated assessment and an acquired taste among a continually changing set of social actors.

By the criteria of art historians, connoisseurs, or aestheticians Akrich's study is a failure because she does not view the work of art for its own sake. Her description of the polyptych is so vague that it is unclear how many panels compose it, on which sides are the portraits of the donors, what colors the painter used, and any number of other items of information which are the stock-in-trade of art professionals. From the standpoint of sociology, however, her analysis is remarkable. Her strength is in the perceptive analysis she offers of crucial historical moments through which this work became an *oeuvre d'art*. As she puts it, "The object and the networks in which it is situated are indissociable . . . since through this relative construction of an absolute, we have seen the simultaneous construction of the object and the networks" (Akrich 1986a, 277).

The net effect of this study is to demythologize explicitly the steps by which social processes of revalorization transforms things into art works. Far from being an absolute of perfection from its very beginnings, the miraculous emanation of an artistic genius, it is, in "the last judgment" of society that *The Last Judgment* gains its standing. Actually, implied but not stated in her account is the idea that this is merely the "latest" judgment in a chain of reassessments.

E pluribus unum or *Ex uno plures?*

The study by Robin Wagner-Pacifici and Barry Schwartz of the Vietnam Veteran's Memorial in Washington, D.C., though encompassing a far briefer time span, which, by comparison with the Beaune altarpiece is virtually contemporaneous with the events commemorated, shares some of the attributes of Akrich's study. Although they focus on a particular work of art, it is not its analysis qua art that is central to their re-reading, but rather they show that its aesthetic aspects, controversial as they became, cannot be taken apart from its political function as a civic monument. The authors are concerned with its attempted use as a device to perform the Durkheimian function of sustaining traditional beliefs, in the context of a pluralistic society, in which "several conceptions of the past compete with one another." Their theoretical problem is to understand how sacredness can be plural, and how the characteristics of the particular work are related to plural unity (Wagner-Pacifici and Schwartz 1987).

As background, it will be remembered that the idea of making a memorial to an unpopular war came not from the government, but from a group of its veterans. It was intended to consist of a wall on which would be engraved the names of all known Americans killed in the conflict. Without detailing the aesthetic controversy surrounding the selection of the winner, a minimalist, unadorned black wall, composed of two segments meeting to form an obtuse angle, the authors point out that its design (selected from fourteen hundred submissions) was hotly contested. After considerable discussion, although the basic monument was accepted with no obvious modifications, another work, the statues of three members of the military by a sculptor working in a figurative style, were placed nearby, though out of sight of the wall.[12] Finally, on a tall shaft, the American flag was added to complete the ensemble.

The authors' analysis of the monument involves three meaning dimensions: the exegetical (what people say about it); the operational

12 Although Wagner-Pacifici and Schwartz do not detail the men's appearance, the fact that one is a black is congruent with their analysis. Moreover, they note that feminist groups were bringing pressure to add a female figure to represent female military personnel, predominantly nurses, whose names were engraved as individuals on the wall. Since their paper was presented, it has been announced that this demand will be met.

(how people behave in its presence); and the positional (how it is concretely related to other existing monuments). They derived exegetical meanings by analyzing official statements (oratory and journalistic accounts); operational, from the observations made either by themselves or others, and analysis of objects and messages left at the memorial by visitors; and positional, from locating the work in the context of other well-known monuments on the Mall. In this way they acknowledge that the usual boundaries of art that critics and aestheticians use cannot provide the basis for a complete interpretation.

Rather than study any of these matters using a decontextualized microanalytic framework, they try to ground each observation in the political, historical, and ideological moment, viewing their combination as an intrinsic part of the construction of artistic symbolism and of the art work itself. In light of the controversial nature of the war, the first question was to understand why any monument would be erected at all. Ordinarily, a monument would have served as a reminder of a glorious event, but in this case there was little to wish to remember, except by those whose children, spouses, friends, and lovers had been killed.[13] On the basis of the published record of Congressional Committee and Fine Arts Commission discussions, the researchers suggest that the monument was specifically intended to reunify the polity torn by dissension over the legitimacy of United States involvement in the conflict, and the defeat the nation had suffered. They sought a means of doing this while at the same time soft-pedaling the event itself. To this end the commission adopted the unusual strategy of excluding overt political content from the design itself but required that it include the listing of the names of the dead. Given this goal,

13 It is interesting to note that the perhaps equally unpopular Korean conflict, in which nearly six million troops served in the short (three-years) span, witnessed the deaths of nearly as many as died in Vietnam (57,000). Yet as an editorial pointed out, the closest thing to a monument it has received was a movie and a popular television series, "M*A*S*H." Although gaining congressional support in 1986, the veterans had great difficulty in persuading President Reagan to make the necessary appointments to the organizing panel so that a site could be assigned (on the Mall near the Vietnam memorial). Funds raised in the private sphere have been slow to arrive, but nearly half of the first $2.5 million is the donation of a South Korean automobile company (*New York Times*, Nov. 11, 1988).

it made sense to the original commission to select an abstract design, place it in a prime location, but nearly underground, angled unobtrusively to other, less controversial monuments.

The monument is not only a black wall covered by names. Two major additions have changed its character, as Wagner-Pacifici and Schwartz point out. First, in response to both the pluralist composition of the nation and the differences in attitudes to the war, the result of the competition was successfully contested and, through a compromise, the figurative statues and the flag were put in place to overcome the objections of conservative political opinion. Secondly, and unexpectedly, the deportment of visitors to the monument changes its appearance each day, to which subject I will return. In its totality, the authors show how the ensemble succeeds in expressing "at once the unity and contradictions of society" (Wagner-Pacifici and Schwartz 1987, 7); the continued ambivalence about a still painful past. As opposed to what Durkheim and official oratory have claimed in the past and what Robert N. Bellah has noted in his analysis of civil religion (1970), the authors argue that collective memory is not to be drawn only from the positively seen past, but from "that aspect which best articulates the opinions and concerns of the present" (Wagner-Pacifici and Schwartz 1987, 8).

Aside from the exegetical, as I have indicated, the authors analyze the deportment of visitors as well. They observe that in a city with an abundance of monuments, this memorial attracts immense crowds of friends, family, and tourists in general, making it one of the most popular sites. Rather than being defined as an aesthetic object, the wall evokes emotion and invites offerings, mementoes, written messages, as if it were a place of religious pilgrimage.[14] Indeed, it appears that the wall with the names of the dead attracts much more attention and devotion than the statues. If the interpretation of the authors is correct, then the memorial is successfully achieving the commissioners' aims, because it draws attention to the sufferings of individual human beings rather than to the inglorious conclusion of an unpopular war. But even more, it represents the

14 It should be noted that this is the case with other monuments on which names make up the principal substance, such as the Holocaust Memorial in Brussels and the memorials to the military dead in modern wars.

nation itself, consisting of those who, like the disparate parts of the monument, "abide together without touching" (Ibid., 7).

In that regard, they concur with Walter Dean Burnham whom they cite, in seeing the 1970s and early 1980s as a period of "fundamental shift in collective values and self-conception – a 'reactionary revitalization movement.' " If that is the case, then their conception of the work as composed of a mixture of genres, and its placement or positioning, which includes the negotiations, political and aesthetic, along with the somewhat unexpected subsequent deportment of visitors, converges with Becker's collective action and editing, Bourdieu's successive re-readings, and Akrich's view of the continuing dynamic of artistic redefinition.

In their paper Wagner-Pacifici and Schwartz do not probe the orientations of the artists themselves. Although recent art study tends to be wary of how literally to take artists' statements of intention, or even more, how to reconstruct the intentions of long-dead artists (there is very little known, for example, about the thinking of artists such as Rogier Van der Weyden, the painter of the Beaune altarpiece), because the Memorial is a contemporary work, and the artists have not been silent, their ideas may provide additional support for the multi-vocality of the work. It is interesting to note that Maya Lin's winning design had put off many people who objected to a variety of matters: the design of the work itself (black, austere minimalism); the fact that she was a young female student at Yale (an undergraduate), and Chinese-American. As a result of protest, Frederick Hart, the only figurative sculptor to have won a prize in the competition at all (third place), was offered the opportunity to modify his own overall design appropriately so that it could be added, and did so.

In a somewhat mean-tempered interview (Hess 1983, 124), Hart claims that when Maya Lin's design was announced, a "democratic" outpouring of protest letters reached the White House and were forwarded to Secretary of the Interior James Watt, in whose domain the monument fell. He defends his style preferences as "humanisitic" in opposition to what he terms the "nihilistic," "art in a vacuum" of Lin's abstraction; his art as "democracy in action" and populist as opposed to her "elitist" art; his art as cognizant of the tragic loss of nineteen-year-olds as opposed to hers, which he characterizes as "contemptuous of life." Despite the clearly ideological terms

of his argument, it is Maya Lin whom he blames for the politicization of the controversy because of her insistence upon a black wall, emphasizing a black moment in history and death, which appealed to antiwar liberals, rather than a white one, which would have given dignity to the "nineteen-year olds, not the generals." He implies that if she had not refused to compromise her design by accepting a white background, there would have been no need for the invitation to him to erect the statues. Maya Lin herself justified her choice of black as "more peaceful and gentle than white. White marble may be very beautiful, but you can't read anything on it. I wanted something that would be soft on the eyes, and turn into a mirror if you polished it. The point is to see yourself reflected in the names" (Ibid., 123).

In light of the abstract nature of Lin's design, it may be unclear why and how messages political or otherwise could be read into it, whether by liberal doves or conservative hawks. Minimalist abstraction, after all, has no other content than what is seen. But the history of political and aesthetic movements over the past century shows a long, though somewhat inconsistent association of liberalism and abstractionist art, and conservatism with figurative realism. Although the arts and politics are not neatly related in the terms suggested, on the whole, certain "avant-garde" art styles, including romanticism, realism, naturalism, impressionism, and cubism are usually associated with (in their historical context) liberal or left-leaning movements or political orientations. Major exceptions include individuals such as Degas, who allied himself to the anti-Dreyfusards, thus rejecting many of his close friends and art world colleagues; certain symbolist painters, if not the movement more generally; the English vorticists, and Italian futurists, who were more overtly elitist and antidemocratic than many. In fact, among the futurists, some allied themselves to Mussolini and the Fascist movement (Poggioli 1971; Chipp 1968).

The additional commentary by Frederick Hart reveals the politicized basis of the selection process in which the conservative administration was able to impose its preferences, though without completely repressing the symbolic forms it opposed (Hess 1983, 124). On the whole this supports the interpretation of Wagner-Pacifici and Schwartz but suggests the need for greater attention

to an element that they incorporate inadequately, and that is central to the analysis by Akrich – the longitudinal nature of the process. This is a criticism that may seem unfounded because the authors specifically argue against the mythical contemporaneity of micro-analysis by reconstructing the discourses used by actors in various institutions. They explicitly interpret the past in light of the present, considering the monument in the context of the shift to Burnham's "reactionary revitalization movement." However, they do not go far enough, because even though the time span under consideration is brief, less than a decade and a half at most, the major changes of the 1970s are not all indicative of a single direction or the same tempo, and it is not clear whether they represent the true rise of a political force in the country as a whole or the attraction to a single individual, a very popular president.

Despite their intention of contextualizing the events politically, beneath their nuanced interpretation of discourse and visual representation, they rest their analysis on a cross-sectional time frame that emphasizes an overly abstract pluralism. They neglect the different rhythms of development in the society and polity, not making it clear that the process of announcing the competition, judging the entries, selecting the winner, and constructing the monument encompassed and coincided with a regime change at the presidential level (from the Carter administration to that of Reagan) that lasted eight years, with immediate effects on executive appointments. The effects of the new president were less immediate or lasting at the congressional level, while his impact on the judiciary is likely to last far longer, regardless of climate of opinion. Because it was the change in the presidency that coincided with Burnham's reactionary revitalization movement, the next administration may make sweeping changes in the executive branch of government, rejecting ideologically right-wing appointments, with a return to more technocratic ones, regardless of which party is in power. Finally, although the monument was intended to reknit a pluralist society, that it was the brainchild of a Vietnam veteran concerned with what he deemed to be the neglect of fellow veterans, with the support of private individuals (the Texas millionaire Ross Perot) and donations by thousands of other veterans (Hess, 1983, 121), there is little evidence that the groups in American society sundered by the conflict have been reintegrated into unity.

What this suggests is that pluralism in its variety cannot be encompassed in the analysis, no matter how striking, of a single monument. But the method, even though limited in scope, is capable of revealing in vivid light aspects of society that might escape notice with more conventional methods. Like the Beaune altarpiece, the Vietnam Veterans' Memorial will be read and re-read in time to come, and perhaps in unexpected ways. What is certain is that in the future it will have different impacts on visitors, who will interpret its significance in light of the new and continually renewed present in which they find themselves.

Using art works as do Akrich and Wagner-Pacifici and Schwartz, as measures or indicators of social processes and reflections of political culture, would seem to have little to do with the uniqueness that aestheticians emphasize. There is little or no question as to provenance, genuineness, and genius (although the works can be and have been judged more or less favorably by some critics and art world authorities). What is suggested here is that the nature of the works themselves, their location, auspices, and function make the kind of criteria appropriate to apply to other art forms secondary. Public art is different from collectible art. As a rule, it is not moveable, and when it deteriorates it may be refurbished without raising questions about the over-restoration that those who conserve individual art works in museum collections now avoid. This is the case, unquestionably for the Vietnam Memorial; the Beaune altarpiece is different, and more ambiguous. Its near sale by the hospice that owned it testifies to one form of difference; the fact of its overrestoration to another. Now that it has become a public monument, under the control of a national agency, its sale (under French law) is effectively barred. But though it belongs to the nation, it is not a national monument in the same sense as a representation of political culture.

Although the works composing the Vietnam Memorial have been discussed in aesthetic terms, at the moment it functions more like the gravestones and steles marking the Normandy beachhead of World War II or the Belleau Woods battlefield of World War I than an art work.

As those who used to denounce nineteenth-century official sculpture (now back in fashion) have shown, it is rare for a public monument to succeed at being both aesthetically winning and

politically functional. The fact that art works are required by law to be included in government building complexes as art or decoration makes their situation even more ambiguous than works whose primary purpose is to be commemorative. When art works are commissioned for public display, primarily for aesthetic or decorative purposes, they may cause controversy because of their aesthetic appearance or for political reasons, or both. The controversy surrounding Richard Serra's *Tilted Arc,* placed in the plaza of a major federal government building in New York City, has usually been taken as an instance of aesthetic disagreement, but Judith H. Balfe and Margaret Wyszomirski (1985) provide evidence that it too falls into the category of ideological repugnance.

Although primarily an aesthetic object rather than a commemorative work, like Maya Lin's monument, it is a huge wall-like piece. It is not below ground or shiny black, but (initially, at least) rusty (corten steel). It has no names to provide a concrete link of sentiment for viewers to relieve its immense expanse. Presumably, the commemorative function is taken care of by the federal office building itself, named in honor of the late Senator Jacob Javits. According to Balfe and Wyszomirski its political meaning is simply that it was commissioned under the Democratic administration in fulfillment of the "percent for art" required as part of federal building construction. There is no evidence, of course, that it would be better appreciated by Democrats than by conservative Republicans. In any case, it has now been removed.

If the history of the New Deal post office mural design project is a guide, it would appear that local concerns, at least in the 1930s, were frequently at odds with the designs accepted by the federal agency. As Karal Ann Marling shows, local interests frequently clashed with the choices of competition administrators, for aesthetic, moral, and political reasons. They fought over depictions of semi-nudity, socially unacceptable imagery (in certain regions, especially in the South, nonhierarchical arrangements of black and white people were rejected), or in relation to pompous-looking works generally (Marling, 1982). But there was no effort made to combine genres, subject matter, and style in particular post offices. The regional political divisions of the United States could be accommodated in this art form because the post offices and, therefore, the works were segregated from one another by distance. None

bore the weight that Wagner-Pacifici and Schwartz so poignantly analyze in the Vietnam Memorial.

Wagner-Pacifici and Schwartz appropriately analyze the process of its creation, the nature of its modification, and its reception by the public as indicative of American political culture, but their central concern is not the aesthetics of the work itself, except insofar as it reflects American pluralism and serves to modify Durkheimian theory. They delineate a way of understanding society through art without reducing either to the other. At their best, these analyses succeed in presenting society and art as encompassing their different kinds of uniqueness, which is renewed and modified over time, both aesthetically and politically.

5. Are artists born or made?

Before the problem of the creative artist analysis must, alas, lay
down its arms.

> Sigmund Freud, "Dostoevsky and
> Parricide," [1928] Vol. V *Collected
> Papers* (1950):222

I'm not a believer in rules . . . I'm a believer in artists. I believe if
Michelangelo worked in matchsticks, we'd all think matchsticks
were wonderful.

> Kirk Varnedoe[1]

All artistic work, like all human activity, involves the joint
activity of a number, often a large number of people. Through
their cooperation, the art work we eventually see or hear comes
to be and continues to be.

> Howard S. Becker, *Art Worlds*
> (1982):1

INHERENT IN THE CONTROVERSIES concerning the na-
ture of art, whether in the art world per se or in the generally
problematic cohabitation of sociology and art, is the agency
by which it is created, centering on the person – or personnage –
of the artist. Does it matter *who* creates the work? How the creator
comes to be an artist? Whether the artist works alone or as part
of a group? The answer to these questions may seem clearly positive,
but as I have shown in Chapter 1, corresponding to the ambiguity

1 Varnedoe, adjunct curator of painting and sculpture at the Museum of Modern
Art at the time, and now director of that department, is cited in an account
reported in the *New York Times* (October 23, 1987, C40). He made the
comment in connection with the purported boom in popularity of ceramic
sculpture among less affluent collectors. With regard to the issue at hand, in
this statement he reveals the bias of the "museum man" who collects artists
or, at one remove, collectors of certain artists. His skepticism as to whether
it makes any difference which medium an artist chooses, as long as the artist
is outstanding, is indicative of his position. Not trivial, incidentally, is the
fact that collectors of clay sculpture have much to gain if it comes to be
defined as an art medium rather than mere craft.

surrounding discourses about art – whether it pertains to the realm of the sacred or the profane – a related ambiguity inheres in the artist.

Whereas Freud seemingly throws up his hands in despair at the mystery of artistic creation (though he was not deterred from attempting to fathom it), implied in the statement of Kirk Varnedoe cited in the second epigraph, is the by-now conventional idea that the artist is to be accorded a degree of centrality next to which the art works themselves are diminished, relegated to the sidelines. No doubt not intended by the head of the painting and sculpture department of the Museum of Modern Art, his statement implies that what counts is the creator as star, a celebrity whose actual artistic accomplishments may pale by comparison with his or her fame. At the opposite extreme, exemplified in the idea of the "death of the author" (Barthes 1977; Foucault 1979; Bourdieu 1986), responsibility for creation by a specific artist is overshadowed by re-readings and re-creations of works by successive receptors. Less dramatically, as Howard Becker asserts in the third epigraph, the individual artist is prosaically transformed into a team player, one of a number of possible collaborators. Indeed, as he presents the process of artistic production there is little difference between creation and reception (Becker 1982).

Assuming that it is not so easy to dispose of the artist as some extreme death-of-the-author proponents seem to believe, it is noteworthy that although a small number of artists are universally recognized as extraordinary, unique, innovative, powerful (among the superlatives employed to characterize them), the majority of them either engaged in routine activities or attain a moment of fame only to be rather quickly relegated to the margins of aesthetic regard. This view is congruent with ordinary concerns of the fields of sociology of work, occupations or professions which emphasize routinized types of activity, including recruitment and career patterns in relation to a variety of societal processes. Research on industrial workers and even high level professionals including cultural elites has been fruitfully pursued using these approaches (Sarfatti-Larson 1977). But when it comes to artists and writers there are limits to what sociologists have been able to accomplish. For whereas routine art workers and even prominent artists may be readily encompassed

in the analysis of Howard Becker, it does not adequately account for the *exceptional* artist.[2]

Though because of the rarity of "great" artists, it might not seem worthwhile to include them in the sociological project, since the Western art world centers on the ideal of exceptional talent or genius, their omission falsifies the sociological analysis of art.[3] For even though sociology generally espouses a nomothetic rather than an idiographic orientation (Chapter 2), preferring to deal with generalizable cases and avoiding emphasis on the individual in constructing its object of study, the very character of art in Western societies makes it almost impossible to exclude individual artists from its purview. As in Weber's conception of the bases of leadership, sociologists are obliged to incorporate the rare as well as the routine, the innovative as well as the traditional. This entails including unusual artists along with ordinary ones in a broadened framework. By "democratically" lumping together, as Becker does, outstanding artists (Duchamp or Ives), along with other nearly nameless "mavericks," or "supporting players," he succeeds in normalizing them as humans but risks trivializing their art. This is an underlying problem in much of modern sociology because of its emphasis on interpreting and explaining social phenomena by demystifying or debunking them (Chapter 1).

Theories about artists tend to cluster around two types of approaches, individualistic or sociological. Individualistic ones include explanations deriving from aesthetic scholarship and psychological study. In particular, the Freudian tradition in psychology sees the

2 This is not to say that no other sociological conceptualizations of the artist exist. The artist as worker, as represented by Becker, is a more extreme version of the artist as intellectual, in that it allows little mystery to adhere to the social role.

3 This is the case not only of scientistic or structuralist sociologists, but even in the case of Max Weber himself. As Ferenc Feher has pointed out in his analytic critique of Weber's study of music, the actor is mysteriously anonymous (Feher 1987, 153–4). More generally, as Norbert Elias has pointed out, "Weber never succeeded in solving the problem of the relationships between the two basically isolated and static objects seemingly indicated by the concepts of the single individual and society. Weber axiomatically believed in the 'absolute individual,' in the above sense, as the true social reality" (Elias [1970] 1978, 116–17).

artist driven by unconscious motivations – a quasi-neurotic who channels his near-pathology into a socially permissible path. Freud's warning in the epigraph to this chapter is similar to that of aesthetic specialists (Donaghue 1983), that there is a mystery in artistic creation whose explication is problematic (Chapter 5). His assertion testifies to the conflation of the near-neurotic and the highly gifted individual in the course of cultural developments from the Renaissance to the romantic era.

Far from being exhausted by psychoanalytic theory, psychology of a different kind imagines the artist as bearer of a rare talent or gift that may be studied from the cognitive rather than the affective standpoint. Cognitively oriented psychologists deal with the interrelated questions of creativity and intelligence. Those whose work is most relevant for this purpose tend to cross the disciplinary boundaries between social psychology and sociology concerned with microinstitutional processes, with which they share similar perspectives. Both virtually exclude analysis of the encompassing macrosocial context (Rosenberg and Fliegel 1965; Griff 1968; Strauss 1970; Getzels and Csikszentmihalyi 1976; Adler 1978; Becker 1982).[4]

Whereas psychologists have tried to explain the process by which artistic abilities emerge as a reflection of the individual's internal traits such as talent or intelligence, drives and impulses, or reactions to personal experience, sociologists generally take talent as a given and focus on the institutional supports and constraints surrounding cultural production more generally, seeing participants mainly as role players. The social role is sometimes treated as if it were a fixed, reified position in society, but it may also be thought of as being in process of construction. Similar to other social roles, that of the artist emerged through macrohistorical processes in interaction with microstrategies of those who attempt to play them (Bourdieu 1979). Where sociologists and social psychologists concur is with respect to the importance of social factors in permitting or impeding the emergence, recognition, and support of artistic talent. They try to understand the artist's role at a middle range of institutional

4 Macroanalytic approaches at a broad level of generality that leave the mediating structures and processes vague and mysterious (Sorokin 1937; Kavolis 1972) are dealt with in Chapter 7, where I evaluate their contribution to understanding artistic change.

linkages or chains of connections of one to the other, to major secular trends, and to macrostructures in society (Wittkower and Wittkower [1963] 1969; Elias 1978, 128).

Even though their images of the artist differ sharply from one another, empirically they overlap considerably. This is explained partly by the heterogeneity of the category of artist and by the fact that many artists, regardless of type, usually work in a variety of milieux (or fields) and at diverse tasks (Nash 1970; Csikszentmihalyi and Robinson 1986). Since the popular image of the artist as romantic hero has acquired a certain prestige, the aura associated with the hero artist is sought and appropriated by other less original practitioners, or even amateurs. The oppositions among the respective approaches of psychologists, sociologists, and, increasingly, art historians mean that they interpret differently three fundamental questions: How do people become artists? How and what do they create? How do they survive?

Even though their conceptions of artists differ, they usually accept the notion of "art" itself as unproblematic. But as I showed earlier (Chapter 1), such an assumption is belied by the evidence that art is a social construction. In the final section of this chapter I suggest that whatever the conception of the artist, whether individualistic expert in emotions, virtuoso performer, role player in an institutional microworld, or alienated pawn buffeted by broad social structural forces, the artist is best understood as arising from and interacting with those forces. In other words, just as art is a social-historical construction, so is the artist.

Before turning to the creative artist, a special type of actor in the art – society domain and field (Robinson 1986), I consider the confluence of three trends of thought: the claim to the artist's uniqueness, the quasi-sanctity of the art work, and the inseparability of the artist from his or her creation. Together they form a structure that tends to conflate the artist with the work, dissolving the boundary between them, with consequences for how the artist is imagined.

Boundaries between the artist and the work

From a common-sense point of view an artist is one who creates something – music, poetry, pictures, statues, dance – socially rec-

ognized as art. Although it is sometimes held that people who create or make art put a great deal of themselves into their work (an idea attributed even to those who do outstanding work on things not considered art, such as crafts, furniture, or routinized objects), this is not usually taken literally. We view the artist as one who makes things which are separate or separable from him or herself. Except for property rights which permit the artist to sell or make contracts concerning the works, or moral rights, which extend the artist's interest in the work beyond its immediate sale or use, the work is no more a part of the person who makes it than any other property. But the idea that the work of art is separate from its creator is nevertheless ambiguous.[5]

In a sense the artist can be his own art work, either in whole or in part. For the psychoanalyst Otto Rank the idea of the self-creation of the artist is founded upon the romantic conception of the artist as genius (Rank 1982). But it can be understood in other terms as well, ranging from the prosaic to the startling: The artist may create a work and perform in it; the artist may enhance the luster of his or her works, or even receive greater attention than any work that he or she creates because of extraordinary personal qualities; or the artist may literally *use him or herself as an object of art*.

At the most conventional level artists make self-portraits or perform in dances, plays, or operas. Less conventionally they may engage in performance works or conceptual art. The problematic nature of this practice is revealed by the artist Chris Burden, who had himself photographed as he was shot and wounded by the gun of an associate; or an artist couple who spent a year roped together, concluding their "performance" by putting themselves on view (for several days) in a gallery until they were publicly unbound. Technically, these are all performances, but they differ fundamentally one from the other. In the conventional examples the artist is expected to be detached from and in control of the performance; in the unconventional, art and life are deliberately

5 Ironically, artists often feel themselves, or are expected to feel, alienated because of this separation from their work. Alienation is considered the fate of the modern individual in society, capitalist society, from a Marxian standpoint, or more generally.

fused, the boundary between them crossed so that artist and work are one.

Although not to be interpreted in the same way each time it occurs, this idea has a long tradition. Narcissus of Greek mythology is one of its prototypes, a case both of art object and cultural consumer par excellence. Midas, who by his touch alone could turn any object into gold, created a statue by inadvertently touching his daughter. As a result, he might be viewed as the first aleatory artist. Aside from classical mythology whose prototypical characters are generally presented universalistically, historically existing artists lend themselves to the contextualizing analysis of sociologists. This is the case for Chatterton, who has come to be a central character in plays and paintings, serving as avatar of numerous romantic poets throughout the nineteenth century and the subject of recurrent novelistic imagination. Beau Brummel comes even closer to the idea of self-made art object since, unlike Chatterton, who tried to write poetry, Brummel's own achievement was to fabricate *himself* into what would be the prototype of the dandy, *arbiter elegantiae* for society, an end in himself. As reanalyzed from a sociological viewpoint (Smith 1974), he represents self-creation within a decrystallized social system, through the strategic use of resources to acquire deference, or celebrity. Celebrity itself has come to be associated with the rise of artistic stardom and the creation of "personalities," so that almost regardless of talent or abilities, it has become the object of art, an idea pursued more recently by Andy Warhol. In these examples the art work, if it exists outside of the artist at all, is quite secondary to the artist as personnage.[6]

At the opposite pole, rather than being elevated to mythic proportions as in the romantic canon, the author or artist is demoted to being a mere participant in a collective process. This idea has been advanced more or less directly by literary critics and theorists as the "death of the author." Mikhail Bakhtin ([1940] 1968) or Roland Barthes (1977) come close to suppressing the artist or author altogether. They redefine the process of creation itself as

6 It would be possible to multiply examples endlessly: exhibits in freak shows; participants in sensationalist, real-life melodramas who go on lecture circuits or sell the rights to their story to ghost writers or movie makers.

one in which the receivers (readers) engage in a continual process of interaction with and interpretation of the work of art or literature (Barthes 1977), becoming in succession participants in the creative process, along with the polysemic narrative process. In effect, somewhat as in the interpretation of Bourdieu, there is no *single* artist, any more than a completed work in the crystallized sense of a final product (Bourdieu 1986). Although arriving at this conception from different assumptions, Howard Becker's formulation is similar. He adumbrates a process which he calls "editing" (1982, Chapter 7), whereby the collective action of artistic production is implemented, not only by collaborating authors and their actual editors in face-to-face or relatively close interaction, but by all those who have some impact upon the work as a social object.[7]

As ingenious, provocative, and plausible as is this de-emphasis of the role of the artist, particularly since it elaborates the process whereby art objects continue to change even after their "completion," it is neither satisfactory sociologically nor as intellectual strategy more generally, because amputating initial creation distorts the sociological project of understanding the relations of society and art as much as does ignoring reception.[8] It is true, as Becker shows with numerous examples, that the isolated genius is often helped considerably by co-workers, and that the art work that reaches the public has already undergone considerable editing. Nevertheless, even Becker himself usually attributes a body of work to a principal author. Despite the fact that creative genius is more often myth than reality, it cannot be said that art works give birth to themselves by some parthenogenetic process. Let alone the fine arts, even in the realm of commercial or industrial arts, when teamwork is the norm, certain individuals are assigned the roles generally recognized as seminal, original, or determining. They may be referred to as "the talent" or "the creatives," or be entitled "artistic directors"

7 For a particularly succinct and lucid analysis of the death of the author idea, see Janet Wolff (1984 Chapter 6).

8 This is one of the criticisms leveled at the "production of culture" approach, its insufficient attention to analysis of cultural reception (Peterson 1976). The problem has been addressed in recent years by Wendy Griswold who has developed a more encompassing framework of analysis. In a different cultural domain, that of sports and games, Elias and Dunning (1987) have incorporated both reception and production of culture into their work.

(Hennion 1981), and are highly regarded for as long as their products are commercially successful, a criterion prone to negotiation.[9] As in fine art, where it is important for collectors or publishers to have a designated creator (Chapter 4), the "name" that counts for the public is not the production team, but the artist, whether a single player or group. I consider next views about how creators, whether in the singular or plural, come into being, are recognized, and by what kinds of social actors.

Commonalties and divergences in images of the artist

As discussed earlier, for aestheticians the artist is uniquely gifted *and* essentially alienated from routine life. Aestheticians believe that the great artist is exceptional and cannot be analyzed simply as if he were merely one of a type.[10] They are not like craftsmen, artisans, or commercial artists, because fine artists make things that are not instrumentally useful but belong to a spiritual realm as difficult to define as are the mysteries of religion itself. Aestheticians rarely pay attention to "routine" or journeymen artists, assuming that if an artist is talented his gift will inevitably unfold, though its social recognition is not necessarily swift.

Psychologists do not usually attach the same degree of uniqueness to artistic traits as do aestheticians. Even when they consider talent to be innate, they differ as to explanations of its subsequent course of development. For Freudians the artist is an individual coping with drives universal to the human species. To social psychologists the artist is a creative individual or intellectual of more or less ability who engages in a learning, problem-solving, or problem-seeking project. Regardless of which school of psychology they

9 The process of negotiation among directors, producers, and screen writers in relation to copyright and residual payments on the material side, and moral rights in the transformation of movies by colorizing, cutting to conform to codes of family viewing, or for commercial breaks on television, are notable instances.

10 For an account of the emergence of the artist as an autonomous professional and the development of his alienation from society, see Wittkower and Wittkower ([1963] 1969). For the sake of brevity, when speaking of the actors in the world of art, such as painters, writers, composers, etc. I use the term "artists." Following Howard Becker, I refer to other art world actors and agents, such as connoisseurs, art historians and philosophers as "aestheticians."

identify with, whether with behaviorism or one of the qualitative humanistic psychologies, psychologists predicate their analyses on the *particularity* of the individual.

These images contrast vividly with some sociologists' conception of the artist as *worker*. Whereas the artist as sublimated quasi-neurotic or as bearer and manipulator of talent is specifically defined as a unique, even extraordinary individual, the artist as worker is part of a social category or type of the (merely) ordinary – the routine. Intrinsic to this ordinariness and, consequently, predictability, is its incompatibility with the romantic (and popular) conceptions of the artist as divinely inspired creator. In fact, in societal terms such as these the romantic conception of artist is virtually oxymoronic.

In recent times certain psychologists have studied the processes, supports, and constraints that reveal talent to society, making artistic careers possible. From a sociological standpoint, however, they do not go far enough in revealing the interlinking of the multiplicity of institutions in which artists are engaged and that impinge on them. Because both psychology and sociology deal with human behavior from naturalistic premises it may not be immediately evident that they are nearly as incompatible as either of them is with aesthetic disciplines. Although psychology is its disciplinary cousin, sociologists have expended considerable effort in carving out a domain based on the premise that human behavior is best understood in terms of a *social* actor, bearer of an internalized society, as opposed to that of the *individual* actor in a basically adversarial relation to society, or at the very least, to whom society is external.[11]

11 Norbert Elias condemns psychologists and social psychologists for basing themselves on what he takes to be the unfounded assumption of the existence of the individual, even theoretically distinct from society. ". . . the division between conceptions of the person and conceptions of people in society is an intellectual aberration. . . . Their theories shine a spotlight on the discrete person, yet how he is embedded in society remains at the shadowy limits of their vision and interest, undiscriminatingly called 'background', 'milieu' or 'surroundings.'" Elias goes on to warn sociologists against falling into the opposite trap of restricting "the scope of sociological theories to 'society' alone, which puts ideas about society under the magnifying glass, critically examines them and seeks to reconcile them with other available knowledge – yet does not do the same for ideas about the individual. It goes without saying that one thing cannot be done without the other" ([1970] 1978, 129).

The social view of human behavior was championed by Emile Durkheim who contended that it is impossible to understand behavior such as suicide or crime or ways of thinking about values, beliefs, religion, and aesthetics in individual terms alone. For Durkheim the individual has a double existence, on the one hand idiosyncratic and on the other rooted in society (Durkheim 1953).[12] He saw the very concept of the individual as commonly imagined flawed. Sociologists and social psychologists working in this tradition conceive of them as exemplars, fulfilling their role requirements more or less successfully. Taken to an extreme, as by some structuralist sociologists, the individual, not excluding the artist, becomes a social type or player of social roles. Like the metaphor of officeholders filling bureaucratic slots, artists may be imagined as so far from unique that they are seen as filling the "societal position of artist." This implies that even though the artist may be involved in constructing that position, like most social actors his degree of autonomy is severely limited (Bourdieu 1975).

Such a conception is clearly opposed to the concerns of aestheticians for whom the paramount issue is how to define quality.[13] Whereas social scientists, as a rule, are committed to viewing social phenomena in a neutral fashion, aestheticians have traditionally focused on "greatness," on the presumption that understanding of that term

12 Durkheim's polemic against psychologistic explanations in works such as *The Division of Labor in Society, Suicide,* or *The Elementary Forms of the Religious Life* should be understood at two levels, the intellectual and the institutional. In the context of the French university world of the late nineteenth century, he was striving to carve out a place for what came to be his revision of Comtean-based sociology, as opposed to certain more established academics and intellectuals, such as Le Play and Tarde, who had appropriated a disciplinary self-definition as "psychologist."

Beside the French psychological tradition, the psychology of art and the creative process have three principal forms: as a psychoanalytic question (Rank 1932); as the Gestalt of perception and cognition (Arnheim 1966); as a social psychological matter, particularly though not exclusively for cognitive psychologists (Wittkower and Wittkower [1963] 1969; Gardner 1973, 1985; Getzels and Csikszentmihalyi 1976; Csikszentmihalyi and Robinson 1986). A sophisticated, though biologically-oriented, precursor to modern social psychology of art was the Soviet scholar, L. S. Vygotsky ([c. 1925] 1971).

13 Among the few exceptions to this rule is the study by Getzels and Csikszentmihalyi, but it relies for its measure of quality on the opinions (informed though they may be) of art teachers or others who are involved in evaluating students (1976).

is shared. Their focus implicitly rejects study of lesser works and their creators. Not surprisingly, they deride what they take to be the propensity of sociologists to lose sight of the distinction between great art works and minor ones.

Finally, the subject of study by these disciplines, the artist, stands in a more or less adversarial relationship to all of these contradictory approaches. Artists are more likely to view themselves as unique individuals in the romantic mode, or as individuals in one or more of the psychological modes. Even while complaining about what they take to be the injustices imposed on themselves by societal pressures, most artists reject theories that attribute responsibility for their woes entirely to external constraints, as if these could account for the greatness to which they aspire (Rosenberg and Fliegl 1965).

Artists: unique or ordinary?

"Alienation," "genius," "neuroticism," "otherness," and similar terms have become stereotypical characterizations for artists. Far from assuming that these traits are natural, that compared to ordinary people artists are exceptional, however, it is important to recognize that these features are historically grounded rather than universal and timeless.

The analysis by Rudolph and Margot Wittkower casts light on these ideas by showing that such qualities are not inherent to artists in and of themselves, but are associated with specific changes in the status of the artist. As the Wittkowers encapsulate it, artists used to be undistinguished from artisans; to both was attributed the sign of Mercury, "the patron of cheerful, lively men of action . . . [but] with the emancipation of artists, they came to be characterized as born under the sign of Saturn . . . the planet of melancholics." Accordingly, Renaissance philosophers perceived in them the "Saturnine temperament: they were contemplative, meditative, brooding, solitary, creative" (Wittkower and Wittkower 1969, *xxiii-xxiv*). There has been very little systematization of data about recent artists along the lines that the Wittkowers' analysis would suggest, and as the theoretical formulations and the empirical findings associated with them imply, there is little consensus on how an artist is conceived.

Psychological perspectives

The psychoanalytic tradition

The central assumption of psychoanalysis is that the origins of individual creativity arises from conflict in the repression of libidinal desires. Following Freud, it tries to connect an artist's work to his psychic life, especially in childhood. Generally, whereas all human children are capable of producing childish fantasies, most merely repress them; neurotics are unable to control them; but creative individuals, the rarest, are able to use them to achieve psychic balance by sublimating, or diverting them into creative channels (Freud 1947). Some psychoanalytic thinkers see the artist as akin to "the shaman, who is scientist, artist, doctor, and priest all rolled into one." Like shamans, artists are in close touch with their unconscious and that of others. They combine this capacity with discipline in controlling and transforming the forces thus unleashed into expression in the form of play (Endleman 1967, 352–3).

Undeterred by the warning implied by Freud himself in the epigraph to this chapter and the shortcomings of Freud's own efforts in analyzing historical artists, such as his imaginative but historically unfounded analysis of Leonardo da Vinci, psychoanalysts are accused of mechanically interpreting and reducing artists and the content of their works to no more than neurotic effusions. As the Wittkowers put it, at their worst they turn "the victims of their attention into near textbook illustrations of all the known complexes" (Wittkower and Wittkower 1969, 292). Even with less animus than is contained in the Wittkowers' assessment, it is clear that the psychoanalytic assumption of the universality of psychic processes actually militates against taking account of the particularity of individual artists. Moreover, it relegates the social world in which the individual artist exists to a position of unimportance, and it is unhelpful in accounting for the enormous variations in artistic styles, the changing meanings attached to signs, and in dealing with the increasingly important institutionally patterned behaviors that have existed.

Nevertheless, despite the dangers inherent in reconstructing the past life of artists, a goal that tends to be limited to the most prominent, far from typical of artists who have slipped out of sight, their study may help to clarify the meanings of works as

projections of the artist's inner states. What it does not help to explain is why, given the assumption of universality of the inner psychological processes, only certain individuals become artists whereas most do not; why, though many may start out to become artists, most stop; and on what bases those who become artists choose certain art forms and styles as opposed to others. Since psychoanalysis deals largely with intrapersonal factors, in order to make use of its insights into personality, it is necessary to con-textualize individuals by elaborating the aesthetic traditions and institutional constraints under which they create.

Social psychological approaches

Beside psychoanalytic approaches, other schools of psychology have tried to deal with artistic creation, some emphasizing cognitive development, others, affective or emotional capacities, with more or less emphasis on the social context in which the individual exists. On the whole, although they rarely deal concretely with larger social worlds, social psychologists tend to be more sensitive to the microsocial interactions of the individual, and with an outlook informed by theories of socialization or learning processes. Unlike Freud and his intellectual descendants, they are likely to avoid retrospective analysis of distant or dead artists, the stock-in-trade of the psychoanalytically oriented, and focus their attention on the living, capable of being interviewed and tested, whether to seek out cognitive qualities or personality traits more generally. Their studies rely on the toolkit of data gathering by tests of creativity, interviews, surveys of opinions, and observation, an empiricism that may degenerate into the obvious, but when used with subtlety and finesse reveals something of the processes of creation that broader social analysis neglects. At the least they provide generally accurate information about artists, and at their best suggest linkages to institutional structures in which artistic work takes place.

Cognitive psychology

The work of Howard Gardner in the field of cognitively-based social psychology follows a path parallel to the study of intellectual development by Piaget and his followers. He views artistic creativity

and appreciation as a developmental process, but though he is cognizant of the seemingly universal and generalized talent found among children, as against the psychoanlytic emphasis on intra-personal causation, he attributes a greater role to external factors in explaining why talent tends either (in most cases) to decline with age or (more rarely), become specialized or focused on a specific art form.

In trying to account for its loss, Gardner examines specific life histories, taking account both of individual personality configurations and of environment and community support. He interprets artistic creativity as more than a resolution of inner turmoil and founded on the capacity of humans to symbolize and to abstract; to being together intellectual and spontaneous play qualities. He posits as internal to the human individual three process systems, each developing in a specific direction. They include "making" (acts or actions), "perceiving" (discriminations or distinctions) and "feeling" (affects). On the face of it, an individual with artistic ability shares some characteristics with those having scientific ability. But whereas both artistic and scientific ability, as developmental processes, share a similar orientation to problem solving, they differ in that whereas science emphasizes intellectual communication, art also involves communication of subjective knowledge between individuals through the creation of nontranslatable objects (Gardner 1973).

Rather than assume that talent unfolds inevitably, Gardner emphasizes that these processes depend upon a concatenation of personality traits of which talent is only one. In combination with other qualities, they propel an individual into a creative or related field. For example, the individuals with "particularly strong wills, organizing ideas, dominant personalities, drive, motivation, and talent" are capable of becoming critics (or scientists). Those with "strong discriminatory and logical powers" may become members of audiences or (performers). Finally, individuals with "deep capacities for feeling or keen sensitivities to the details of experience and the subtleties of interpersonal interactions" enter "alternative paths" which are defined as art. But none of these capacities is enough to make an artist without the appropriate environmental structures. As Gardner acknowledges, "The emphasis has fallen, perhaps excessively, on the personal and family factors that contribute to development, but I have tried to suggest as well that the sur-

rounding community exerts its influence on the growing child by supplying standards and providing models, by exerting encouragement and criticism, and by insisting on the effective communication of ideas and feelings" (Gardner 1973, 295).

Creativity as problem finding in social context

Cognitively oriented social psychologists like Gardner have tended to emphasize art as problem solving, but this is not true of all. For example, the studies of creativity carried out by Getzels and Csikszentmihalyi emphasize *problem finding* rather than problem solving alone (Getzels and Csikszentmihalyi 1976). This ability is of critical importance in the modern societies that prize originality and the new, whether in science or art, commercial products, or autonomous culture. Aside from purely cognitive concerns, however, these social psychologists also try to understand something of concern to many who deal with art – the question of whether the artist is different from other people.

Although some researchers minimize difference in personality among artists[14], whereas others, such as the Wittkowers, claim that the rise of status uncertainty produces the alienation often attributed to artists, recent research has given rise to more nuanced interpretation. In a study of art students that Getzels and Csikszentmihalyi conducted in the 1960s, they focused on certain crucial personality variables including capacity for divergent thinking, "problem finding," a configuration of high aesthetic and low economic values. They recognize that talent alone is insufficient to account for the art students' success. Such qualities as the student artists' ability to get attention from teachers and peers; flexibility in responding to demands, though not specifically germane to creativity, are important in the context of the highly competitive art world, with its influential gatekeepers and market preferences in which artists had to maneuver.

14 Bernice T. Eidusun, for example, contends that "no differentiation of the artist as a distinct personality type has been found in evidence offered by psychological tests, which shows that artists are not temperamentally unlike other persons and that they differ among themselves more than they differ from unselected groups" ([cited in Pelles] 1958, 13–28).

The importance of features unrelated to talent or personality was confirmed in a follow-up study of their original subjects two decades later. It turned out that the most talented student-artists were not always the ones rewarded by success.[15] Actually, only a tiny number of the former fine art students (slightly more than 8 percent), lived primarily off their art at midlife, but women were less likely to stay artists than men and were more often found in applied art fields than fine art (Csikszentmihalyi, Getzels, and Kahn 1984, 1). Although around half were working in art-related activities, such as teaching and graphic or industrial design, women were considerably more likely to have left art altogether (Ibid., 297). The women who remained artists suffered more difficult living conditions than the men; they generally were earning between 50 to 85 percent of men's earnings. Yet by the character traits that they had early evinced, women were more likely to have the personality and qualities associated with the artistic stereotype.

Successful women had shown inner personal qualities, such as cognitive skills and value orientations, more predictive of success than men. This was thought by the researchers to derive from their substantially higher socioeconomic background than the men. For men, success seems to depend more on external rewards, recommendations to useful gatekeepers, and supportive intimate groups (Ibid.; 369, 381). Yet in terms of personality, they found that "the image of the artist as socially withdrawn, introspective, independent, imaginative, unpredictable, and alienated from community expectations is not far off the mark." In fact, if Getzels and Csikszentmihalyi are correct, the artists they studied are not very different from the Renaissance stereotype (Getzels and Csikszentmihalyi 1976; Lindahl, Getzels, and Csikszentmihalyi 1986).

Besides pioneering in the study of artistic creativity, the work of Getzels and Csikszentmihalyi overcomes one of the central difficulties inherent in most psychoanalytically oriented research by going beyond post factum case study. Instead of confining themselves to acknowledged creators, they look at subjects who are in the

15 The longitudinal research research design incorporated Erikson's theory of developmental stages, assuming that as young adults the artists were resolving identity questions, and, approaching middle age, they were dealing with the crisis of generativity.

process of becoming artists and show that the qualities of the individuals are understandable only in the context of forces outside the artist. As they put it, the "ever-present social environment helps and hinders the development of artists in unpredictable, impersonal ways" (Ibid, 3). This acknowledgment of the effects of the state of the economy or political trends suggests that it is necessary to study how artistic careers function within institutional and market conditions, as do the sociologists Gladys E. and Kurt Lang (Chapter 3). This is central to the analysis of sociology of art today, as indicated in the work of Becker and Bourdieu.

Sociological views of the artist

Among the sociologists who have, in recent years, taken the artist as their subject, Pierre Bourdieu and Howard Becker offer some of the most challenging ideas to the field. Although they bring unique, sometimes incommensurable, intellectual backgrounds to their studies, their research shares certain similarities, as do some of their findings. Bourdieu pursues a French philosophical concern with fundamental questions of epistemology, whereas Becker is oriented to the tradition of pragmatic, American, matter-of-fact empiricism. Both of them value and make use of ethnographic methods and outlooks, though in rather different ways. Neither takes for granted the existence of art as a category, but views it as socially constructed.

Becker's *Art Worlds* (1982) was the summum of his thinking on the arts in society, encompassing a series of elaborations of essays published over several years and an approach developed in his studies of deviant subcultures, as well as his own experiences as jazz musician and photographer. He starts from the perspective of microscopic interaction among participants, moving gradually to increasingly larger sociational patterns that serve as the basis of, and eventually coalesce, into large, complex societies encompassing a variety of art worlds. The "worlds" in which artists work exist as more or less institutionalized subcultures that normally have little to do with one another. Each centers around one of four principal types of artists: integrated professionals, mavericks, folk artists, naïf artists. This subcultural analysis presents the arts as relatively self-contained and segmented one from the other, more

like a mosaic than a collage. In the tradition of the Chicago school of urban sociology, art worlds are like neighborhoods making up a city. As is the case for the Chicago school as well, he gives little detailed attention to the overarching macrostructure of society and polity within which these worlds function. It is not that Becker is unaware of the importance of the state in providing a structure of opportunity and constraint, but that he tends to assimilate it to "other art world participants," even as he notes its capacity to punish those people guilty of creating undesirable work by death, imprisonment, or other kinds of sanctions (1982, 191).

For Bourdieu the macrostructure in the crystallized forms of the state, the system of social domination, and the unequal access of members to valued goods, material and symbolic, comprise a looming presence that needs to be constantly incorporated into sociological analysis. When it comes to the arts and artists, only by conceiving of creators as acting within a field which includes production *and* consumption can a sociology of artistic creation have any validity. As he writes, "The sociology of cultural works must take as its object the totality of relations (objective ones and also those effectuated in the form of interactions) *between the artist and other artists,* and beyond them, the totality of actors engaged in the production of the work or, at least, of the *social value* of the work (critics, gallery directors, patrons, etc.). . . . What people call 'creation' is the conjunction of socially constituted *habitus* and a certain position (status), either already constituted or *possible* in the division of labor of cultural production (and, moreover, at a second degree), in the division of labor of domination" (Bourdieu 1980, 208–12). In terms of this framework of production of ideological values, the artist produces aesthetic values as do others, in parallel realms of value, such as religion. Whereas Becker views art worlds as self-contained units, in some ways extremely segregated from, or at most, tenuously connected to others, Bourdieu's work is informed by an anthropological holism even when he addresses himself to complex societies.

Becker shares with Bourdieu the conviction that in the domain of art much remains to be demystified, but he differs sharply in his understanding of the symbolic realm in society. Becker's demystification strategy takes the form of a descriptive re-creation of how the art process functions. By depicting artists as workers

whose creations, far from being the result of mysterious forces, are the products of cooperative action by (often) nameless collaborators, he dethrones the aestheticist conception of fine art. In contrast to Bourdieu, however, he virtually excludes the conflict analysis that is central to the latter's approach. Instead, he works within the Simmelian conception of social interaction in which conflict is assimilated to sociation or cooperation (Simmel 1955, 14–16), though without specifying theoretically the various forms of conflict as elaborated, for example, by Lewis Coser (1956). Central to Becker's conceptualization is the *process* whereby art happens or comes about. He shows convincingly that it is not, as in the romantic myth, the spontaneous action of a genius, but the collective action of a variety of social actors, many of whom are not usually designated as artists. Participants in the making of art are guided by existing conventions as they work in the context of societal institutions that permit, encourage, or impede their activities. Artists gain reputations with the help of support personnel such as critics and other art writers. In this regard Becker's approach takes account of some of the same societal phenomena as does Bourdieu's. Whereas Bourdieu incorporates the historically grounded process whereby the hierarchical standing of social statuses, art forms, institutions, circles, and the changing nature and value of capital in all its forms, material or symbolic, come about, Becker offers little guidance for understanding what impels the processes of artistic creation and diffusion, stylistic choice in relation to extant styles, and innovation in general.[16]

Despite these lacunae, Becker's image of contrasting art worlds is convincing, in particular with regard to naïf artists who often live isolated from the mainstream of society more generally and may not even consider what they do to be art in the conventional sense of the term (Becker, 1982, 258–9). But his approach is so grounded on the primacy of interaction that it leaves the macro-sociological level of society in shadow and inadequately theorized. One consequence of this is that his premise of the segregation of art worlds makes it difficult to account for the "crossing over" among diverse "art worlds" that has actually been the norm. Even

16 His principal case study of a historical process in art concerns a medium (the stereopticon), its rise and demise, rather than an art form per se.

though certain art worlds are relatively segregated from others, it is well known that the arts impinge and infringe upon one another, making it difficult to establish and maintain boundaries against encroachment. This is evident when artists try to prevent their works or stylistic devices from being appropriated by competitors, and by the near impossibility for barriers to be maintained against the entry of art styles and forms, including even stigmatized ones, into the realm of legitimated art. As I will show in Chapter 7, institutions such as the French Academy or repressive political regimes guard against outsider art with considerable but only partial success. Whereas it is conventional to assume that their repressive power prevents certain art forms from being created, their failure to bar change needs explanation as well.

The artists' viewpoint

As hostile as they are to the study of how the creative process itself takes place, artists, as Bourdieu has pointed out, willingly tolerate sociological analysis of cultural reception or consumption, an orientation tantamount to toleration of a double standard. Implicit in aestheticians' ideological disapproval of the social study of artists, combined with toleration of studying publics, according to Bourdieu, is that they consider the public as minor actors, merely economically motivated and, therefore, spiritually inferior to creative artists, who are taken to be imbued with the sacred flame (Bourdieu 1980, 207). From the artist's point of view as well, in the long run the evaluations by those not initiated into the inner circle of taste have no relevance to the intrinsic value of art itself, which is presumed to be eternal. Beyond commitment to the ideology of artistic greatness, it is evident that information about how the public thinks of art is useful to dealers and artists in their product or marketing strategies, while at the same time permitting aestheticians and artists to criticize the tastes of publics or patrons.

A consequence of considering artists as partaking of the sacred is that it may close off the possibility of explaining them and their origins by applying scientific criteria of evidence, for, as Bourdieu argues, analogous to religion, their myth embeds them in a world of the ineffable, of faith and belief. Just as when theologians and spokesmen for institutionalized religion resisted attempts by scholars

to apply an Enlightenment-based canon of description and rational analysis to its study, aestheticians, critics, and connoisseurs similarly oppose those who try to "explain" artistic creators as if they were ordinary social phenomena. Their resistance makes it clear that what they defend has the force of an ideology. But this is not all there is to art, as Bourdieu implies when he criticizes a sociology that reduces art and creativity to no more than instrumental behavior like any work or production. He insists that art and literature should not be treated in a reductive fashion; that they have an internal history which needs to be incorporated into sociological analysis. Sociologists should be aware of this internalist lore since it is basic to the autonomy of the field (*champ*) of art.[17] By autonomy of the field he means the analytic construct based on elements discernible to the scholar in patterned ways. Lest this be taken as a concession to the idea of the singularity of the artist, thereby falling into the aestheticist trap, it should be noted that his construction of the aesthetic field is merely a special case of a procedure featured in Bourdieu's approach to other substantive issues.

Increasingly, the narrowness of the aestheticist formulation is challenged by certain modern aestheticians, art historians, and others influenced by newer social historical and social scientific approaches. Many of them have addressed questions in ways compatible with social scientific problematics, both as to the form and content of art, and how artists function in the context of their supporting institutions and patronage sources. However, the progressive broadening of aesthetic perspectives is not a one-way process in which aesthetic scholarship improves itself by learning from sociology; sociologists in turn are becoming aesthetically educated as well. Their informed use of aesthetic ideas and the importation of sociological understandings into the work of aestheticians should

17 In this context it is important to note that Bourdieu uses the term "autonomy" differently from its usage by artists or aestheticians. Autonomy in their sense distinguishes works with purely aesthetic ends from the practicality of crafts to justify the quasi-sacred standing of Art as opposed to the routine nature of craft and decoration. As Bourdieu observes, "The pure intention of the artist is that of a producer who aims to be autonomous, that is, entirely the master of his product, who tends to reject not only the 'programmes' imposed *a priori* by scholars and scribes, but also . . . the interpretations superimposed *a posteriori* on his work" (Bourdieu [1979] 1984, 3).

help to avoid the only too frequent obfuscation that has plagued the social study of art.

Toward a useable synthesis

Although the analyses of Bourdieu and Becker illuminate the processes of art production, neither elaborates adequately the processes whereby individuals are drawn to be artists or to choose art as a career as opposed to other employment. Becker's "art worlds" approach, with its emphasis on collective action and institutional process, makes artists seem passive to an extreme. Bourdieu's structural analysis portrays the individual as trying to maximize his or her chances (to the extent that he or she understands them and their implications) for success, but the drive underlying artists' behavior and the process whereby it emerges are not adequately specified and do not distinguish them significantly from any other kind of aspiring professionals. While it is clear that artists and intellectuals share certain qualities, cognitive psychological studies show that they are not exactly the same (Gardner 1985). But given the complex nature of the world (or worlds) of art, psychological analysis is insufficient to account for the involvement of individuals in creative art. Instead, as Becker reminds us, it is necessary to consider them as involved in an artistic division of labor in which they may play social roles, not all of which are specifically artistic.[18]

Artists may be classified according to whether they do the ordinary or the extraordinary, the routinized work of the "integrated professional" or the paradigm-shifting innovations of the "maverick," in Howard Becker's formulation. Although, as my allusion suggests, Becker's categories bear some resemblance to the idea of Thomas Kuhn, with the routine artist involved in the equivalent of normal science, and the unusual, or maverick, artist producing revolutionary innovations, regarding change in sociology, the analogy between

18 In the course of this chapter I use Bourdieu's conception of "individual" in the Durkheimian sense of containing society in his being. Bourdieu expresses this idea in the concept of "habitus." It is important to recognize that this does not entail a purely deterministic individual. Rather, it assumes that individuals are likely to engage in tactical and strategic behavior in the context of institutional constraints. What and how much of the institutional constraints and social expectations they recognize are themselves factors that need study.

art and science is not total (Kuhn 1970). Whereas Kuhn's scientific revolutions always refer to innovations of the *new*, artistic revolutions may refer either to novelty or revival. Moreover, depending upon the particular task the "artist" carries out, whether as a principal creator or one of the many supporting personnel, in Becker's terms, the preferred or most adapted artistic personality and the kinds of talent may vary considerably.[19]

Art may be innovative or traditional; it may be newly made or rediscovered by unusually creative individuals or by reliable, workmanlike ones. The creators of avant-garde art are, conventionally, expected to be of the unusually creative type, but this may also be true for those who recognize or rediscover old and forgotten art forms. In a sense, they may be just as inspired as the "problem finders" of Csikszentmihalyi and Getzels (1976). Moreover, as Harold Rosenberg implied in his essay "The Tradition of the New," the creation of novelty itself may become routinized. I present these possibilities in Table 1.

Suggested in this table is the idea that innovative art can be highly original work created by rare or unusually gifted individuals – often viewed as charismatic – such as artists associated with the avant-garde movements of the nineteenth and early twentieth centuries. As with creativity that results in new art, the rediscovers of the old (not always distinct from each other) frequently act as a team, some as spontaneous recognizers of ideas, and others as cooperators.[20] Often they work in concert, more like co-conspirators than in the routinized manner now taken for granted. They include, in the visual arts, artists such as the antiacademics Courbet, Monet, Gauguin, Van Gogh, Cézanne, and Picasso. Among composers, some of the most prominent were Berlioz and Wagner in the nineteenth century, and Schönberg and John Cage in the twentieth.

Innovation in the form of reviving traditional art forms or styles or by rediscovering and valorizing neglected art may require as

19 The idea of tracing parallels in art and science is by no means new. Previous efforts along these lines have been suggested by Diana Crane (1978), Rémi Clignet (1983), and many others. In Chapter 7 I examine them in the context of accounting for aesthetic change.

20 In the early nineteenth century Le Brun tried but failed to gain recognition for Vermeer's works; somewhat later the critic-historian Théophile Thoré-Burger succeeded, as Francis Haskell has pointed out (Haskell 1976, 18).

Table 1. *Artists by style and content of work*

	Innovative	Traditional
Artists by approach to creation		
Problem Finders	New art creation (Fine art or design; music; literature; movies)	Creative rediscovery (With newly created meanings)
Problem Solvers	Tradition of the new makers (Prototype variants, fine or commercial)	Tradition followers (Antiques; academic art; English country houses; ancient music; nostalgia)

Note: It is difficult to schematize the complex character of artists as social role players without losing the dynamic character of their behaviors, and the collective nature of artistic creation. A more complex table would incorporate more clearly the involvement of supportive actors in each substantive field, noting that supportive personnel may be the source of innovative ideas. Howard Becker's analysis goes a long way to highlight this phenomenon, especially with respect to the art forms in which execution is carried out in a complex division of labor. For example, etchings or other multiple process art forms are frequently made by the collaboration of an artist and technicians, not to speak of musical and theatrical performances. It is also possible for subsidiary players, such as critics, to become artists in their own right. This is clearly the case of the French film critics, some of whom became scenarists, movie directors, and actors.

much verve as actual creation de novo. Historically the two activities are not mutually exclusive because the recognition of old arts has frequently been the accomplishment of creative individuals, some of them artists in their own right. Often with the support of others acting as explicators or publicists (like Becker's supporting personnel), they have innovated by creating novel or reviving interest in old art, either by reinterpreting it or by incorporating its elements into their own work. Picasso, Braque, Matisse, among others, recognized the importance of primitive art, previously consigned to natural history collections; Sir Walter Scott played a major part in the revival of interest in the Middle Ages and helped create the genre of the historical novel; Viollet-le-Duc in France helped revive interest in Gothic architecture, which he restored, and was inspired to incorporate some of its elements in the private homes he designed; the Pre-Raphaelite Brotherhood played an important part in re-discovering (or re-evaluating) the work of "Italian Primitives," or early Renaissance painters, and modeled their own antiacademicism on elements of those styles. But as Francis Haskell shows, the innovators in the rediscovery of older art are not necessarily artists seeking inspiration wherever it may strike them. They may also be artist-dealers (J-B-P le Brun), critic-art historians (Bernard Berenson), art dealers (Duveen), museum curators (Hugo von Tschudi), writers of travel guides (Mrs. Graham or Lady Callcott) and a variety of other individuals who consciously or unconsciously have "collaborated" in art making (Becker 1982).

Becker's analysis reminds us to be wary of assuming that only one artist is to be credited with a work. Rather, he sees art as a collective process that, without supporting personnel, may not lead to public expression. This is just as likely to be the case when it comes to innovation, since introducing new ideas in the face of entrenched interests is likely to require complex strategies. As Charles Kadushin shows, in many domains it is frequent for new ideas to be promoted by circles or coteries (Kadushin 1976). As I show in a study of avant-garde artists at the turn of the century, they consist of other artists (not necessarily less talented than the most prominent), engravers and lithographers; patrons, writers, critics; dealers, publishers, government officials (Zolberg 1983, Chapter 3). Supporters may have different qualities: talents, forms of "intelligence" (Gardner 1985), including commercial astuteness,

linguistic articulateness, charm or appeal to people of influence, reliability, and doggedness. Only spokespeople (critics and publicists) require inventiveness that may be as important as it is for the creative artists themselves. The others collaborate in different ways to provide a variety of subordinate supporting services. If they do not perform in a satisfactory manner, they are relatively easily replaced (Zolberg 1983), or the art form (or style, movement, idea) is likely to disappear.

Adjacent to the world of the fine arts this can be seen in the world of design, particularly of fashion. There too, innovative creation is at a premium, as it is in commercialized popular art forms more generally. Even though they are not considered to be on a level of prestige comparable to fine art, nor are they autonomous in their aesthetic practice, fashion and commercial designers exercise many of the same talents as artists. This is equally true of commercial music, whether the popular songs or movie music of the music industry, or commercial jingles. The chief difference is that the commercial creator is expected to be a reliable producer, with success measurable on audit, even at the cost of charismatic spontaneity.[21]

What is the emotional origin of these artists' creativity? Unfortunately, little is known of their putative emotional states, and retrospective analysis is hampered by the mythmaking of interested parties, including in some cases the artists themselves. It is difficult to extricate the romantic aura of charisma from (possibly) sublimated neuroticism. This is one reason why the sociological idea of the demystified artist-as-worker or artist as career strategist may seem more reasonable and satisfying. Nevertheless, superimposing these types on the Table raises questions. First, how are the three di-

21 The degrees of freedom for fine artists are not infinite, but their eccentricities have generally been tolerated for longer than is the case for those whose work requires commercial success. Impressionistically it appears that there has been more toleration of, for example, the alcoholism of a Pollock than the drug abuse of a Calvin Klein. Although it is difficult to compare behaviors with a gap of three decades, it was Pollock's wife who tried to control his drinking by removing him from his old haunts, whereas in the case of Calvin Klein and other fashion designers, the commercial imperative, apparently in the form of pressure from their business associates, forced them to undertake rehabilitation in an institution.

mensions to be fitted into each of the boxes? I suggest that each category of art needs to be considered, not as a reified structure, but as "work in progress." Assuming that even in the case of fine art, such as poetry and painting, where it is most plausible for a single individual to be the artist, in other forms other participants perform necessary ancillary tasks (editing, publishing, priming or stretching canvases, etc.). Obviously, this is even more appropriate in collaborative art forms such as the performed arts, in fashion and design creation, and in architecture.

The charismatic type, implying as it does a sacral or quasi-sacral basis, with potential impact on followers and publics, is most notable in the rare category of innovative art, and less prominent at the creative end of the other categories.[22] On the other hand, to reach public attention and be disseminated, all art forms require the organizational abilities of other personnel. The charismatic may be an appropriate characterization for entrepreneurship that is associated with complex organizations.[23] But the position of this type of artist is extremely fragile because, as is true of the charismatic leader and the sublimated neurotic (two types that are not mutually exclusive), the artist may be adored at one level, but only as long as he produces miracles. The Freudian sublimated neurotic may be permitted to function only to the extent that he or she is considered innovative, spontaneous, unexpected in ways difficult to duplicate or rationalize. Success is a necessary ingredient of the charismatic's continued standing. However, consensus on how to measure success

22 Revivals may, of course, also be connected with charismatic types of creators. Certain architects, such as Philip Johnson, who has renounced his modernism in favor of nostaligic quotation, may be charismatic, although his success may have more to do with his assured standing in architecture as a profession and business.

23 See for example, Richard A. Peterson's analysis of the different kinds of arts administrators in the nineteenth century and currently, at which time bureaucratic and administrative skills are more needed (Peterson 1986). However, it should be noted that even today, when according to Peterson, managerial and administrative competence are at a premium, bureaucratic talents are not sufficient by themselves. Even the most prominent organizational heads are also noted for their charismatic force. Examples are Pierre Boulez, Philippe de Montebello, Peter Brook, and other leaders of major orchestras, opera houses, and museums. Charismatic leaders of cultural institutions today generally delegate authority for administrative operations to others.

may be difficult to reach for fine art. Generally relatively easy in commercialized production, such as commercial music where the numbers of records sold may be counted, along with other measures of varying validity (Nielson ratings, advertising pay-off of commercials); nonmaterial value is elusive and may be assigned late, according to the myth, after long suffering or even decades after the artist's death.

The question of how someone becomes an artist is perplexing to scholars in different ways, according to their disciplinary orientation. Social scientists have studied aspects of the opportunity and reward structures surrounding artistic careers (Crane 1978) and career trajectories (Rosenberg and Fliegl 1965). Aside from the social psychological studies examined above, the onset of the attraction of individuals to a creative role in the arts appears to have been left primarily to biographers and novelists. If despite or because of personality tendencies, intelligence, or talent, as most sociologists and social psychologists have observed, these are so easily overwhelmed by societal constraints, whether of externally imposed gender role requirements, interacting or combined with and abetted by internalized role preferences (*habitus*), understanding how people become and remain artists is possible only on condition of examining the larger support structures of society and how they impinge on artists themselves. Scholarship on patronage, politics, and cultural policy (Zolberg 1983) indicates that the ideology, cultural policy, and politics of different support structures have varying impacts on the kinds and styles of art created by artists, as well as on the artists themselves. Although these structures do not determine the creative process, they clarify how and why people are drawn to be artists, by what means they are selected, through what agents or agencies, the nature and trajectory of their career, what they create, and how they – sometimes – survive (Crane 1978, 57 ff.). Not the least of these institutions is the public, a phenomenon that may be defined as a sociological concept, but must be seen as having a socially constructed history. In the next chapter, therefore, I examine the cultural supports and constraints, including the publics, as they developed in different societies.

6. Structural support, audiences, and the social uses of art

UNLESS THEY MAKE ART WORKS only for their own pleasure, regardless of personality makeup or type and level of intelligence or talent, artists depend directly or indirectly on social structures that provide them support. These may encompass a gamut of mechanisms, processes, institutions or agencies that reward or penalize artistic performance or creation. They range from simple, direct relations between artist and patron to relations of great complexity involving intermediaries, networks and circles (Kadushin 1976, 111; Peterson 1979).[1] Not only do they provide avenues for recognizing talent and innovation and for entry into jobs or commissions, but they also disseminate such new knowledge to broader constituencies, including the publics or audiences for the arts that have become pervasive in modern societies. No matter how much they claim to be unconcerned about them, artists are obliged to gain their favor.

Support structures for the arts may be characterized as a two-way funneling device through which art works move from artist to client, and compensation from client to artist. This is a useful metaphor only if taken in all its complexity. In the first place, cultural support, creation, dissemination, and reception are not merely processes of economic exchange, but symbolic ones as well. Secondly, neither actor on either side of the relationship is merely a passive recipient, but interacts with others in processes of negotiation, selection, and conflict. Thirdly, just as artists themselves gain or lose standing depending upon the prestige of the support structure, the "quality" of the audience and the value placed on the art form, audiences, too, have much at stake as a result of their artistic choices. In light of the mutuality of the relationship, since in certain ways they are inextricably entwined,

1 Charles·Kadushin emphasizes the importance of intellectual, expressive, and audience circles and networks as a heuristic conception for tracing the development of support structures for innovations and performance in a variety of fields, including the arts. Unfortunately, he does not analyze the connections of circles and networks to larger audiences.

it is important to keep *both* sides in mind, within the sociohistorical context in which they exist.

It is misleading to take audiences for granted as a constant social category because they have arisen in the West through macro-historical processes in the contexts of social structural and political developments. Audiences are only one of several different kinds of support structures for the arts, and not always the most important. Their institutional predecessors have, to this day, left their mark on how the arts are evaluated, as well as in how much regard their audiences are held.

Since art is loaded with multiple significance (political, economic, psychological, symbolic), explanations for artistic choices, both by artists and their supporters need to be examined. Two sets of ideas about audiences have confused their analysis. The first takes audiences to consist of autonomous actors, an assumption of market researchers or sociologists relying heavily on survey methods. The second considers them as the manipulable sheep of mass society, the outlook of certain Frankfurt school theoreticians (Held 1980, 107–8). Neither of these formulations is consistent with most empirical observation. Although it is frequently assumed that audiences may be conceived of merely as individual actors, atomistically using the arts only for their pleasure, as individualistic economic actors, their aesthetic choices show them to be acting in terms of group memberships, using the arts for more complex ends, but including economic goals as well as symbolic ends, on the basis of cultural codes. While their behavior is mediated, and the nature of this mediation is itself an important subject of study, in modern times arts audiences are too heterogeneous in social characteristics and taste preferences to fit the model of a mass.

My consideration of audiences is informed by aspects of existing theoretical and empirical approaches from which I critically select elements for the light they shed on their nature. They encompass a broad range of approaches, from macroanalytic frameworks to microscopic study. Some of them are informed by Marxian theory, such as the Frankfurt school (Adorno 1976); others by the cultural materialism of Raymond Williams that implicitly treats the connections between the arts and cultural intersubjectivity as institutionally constituted and reproduced over time (1981). Among middle-range theoretically informed research I include the generally

non-Marxian institutional analysis, such as that of the "production of culture" approach (Albrecht et al. 1970; Peterson 1976; Crane 1987). Finally, ethnographic and interactionist case studies emphasize the microanalytic approach (Adler 1978).

Unlike many sociological studies that implicitly assume a universality of their categories, thereby neglecting their historical construction, in what follows I relate audiences and other kinds of support structures to the arts. Taken alone each of these approaches to the social study of art has failings and gaps, but applied in combinations appropriate to their subject, they may further our understanding. Audiences are not the only form of support that artists depend upon. Furthermore, audiences have themselves been oriented by historically grounded processes and traditions, whose traces, though faded, continue to be felt.

Let the artist live: societal supports and constraints

The play by the Polish dramatist Tadeusz Kantor, *The Artists Must Die* (perhaps more accurately "Let the Artists Croak!") centers on an allegory whose theme is the incompatibility of artistic freedom and authoritarian political systems. In elaborating this point Kantor uses relationships between semihistorical artistic figures and successive Polish regimes from the Middle Ages to the present. Not all such situations have been as dramatic as both the reality and myth that Kantor presents, but the tension on which politically aware artists such as Kantor himself focus are a probable source of strain, or at the very least, a recurrent malaise, because unless they are invulnerable materially and politically, artists depend upon external sources of support for their livelihood.

Whereas under repressive regimes it may be nearly impossible for them to create just what they wish, even in the most liberal they are never completely free from restrictions. This is because, inherent to the very institutional supports that permit them to work (the free market, for example), are material constraints: marketability depends upon making a profit, which in turn depends upon consumer preferences, governed by demographics and the changing meanings of cultural codes, both dependent in turn on various unpredictable factors (Zolberg 1980; 1982; Goldfarb 1982).

Support structures apply sanctions, positive and negative, ranging in force from severe to mild. These include material and symbolic

rewards and deprivations, and may be monopolized by a single structure or distributed by a plurality of sources. As the midwives of art they may ease artistic production or, conversely, abort its creations. Historically, in the West their concrete forms include church, royal, municipal, or private patronage; state bureaucratic administration; and the commercial market. Their analysis suggests that they have different effects on the art styles and forms that artists create or produce and that are disseminated for public consumption (Hauser 1951; Pevsner 1940; White and White 1965). Finally certain features of important support structures have become prototypes, or provided traditions that persist in contemporary institutions and in ideas about artistic value. These evaluations intersect with the status attributed to those making up the public for particular art forms, genres, and styles.[2]

Subdividing the public: fine art and popular art

In all the countries of the West, industrial development, national political transformations, consumer merchandising, technologies of cultural production and dissemination were accompanied by expansion of ventures in art and music, exhibitions, and performances. Most were commercial endeavors, some more restricted than others, but many relatively inexpensive. Among the most popular were fairs that served governments to advertise their merchandise, culture, and national symbols (Altick 1978; Holt 1981; Rydell 1984). Generally, differential costs, restricted subscriptions societies, and hours making shows inaccessible to working people, together, served to limit public access for most events to middle-class publics. Moreover, European countries retained strong aristocratic traditions, if not discriminatory laws, so that equality of citizenship was far from the norm. But the United States, as Tocqueville noted, had institutionalized equality (for whites, at least), a structure with implications for the arts that continue to haunt American cultural institutions to this day, in the recurrent themes of populism and elitism (Zolberg 1986).

The cultural conflict between elitism and equality was exacerbated by the combined effect, in the post–Civil War era, of wealthy new

2 For an analysis of particular institutional arrangements by which rewards are allocated, see Diana Crane's article in Peterson, 1976.

groups, many of them having profited from the war itself, being confronted by new waves of Irish and German immigrants. Although they tended to be absorbed by the manpower needs of the expanding nation, culturally and socially they became an affront to their successful predecessors. Older established settlers who could afford to shielded themselves from the unwelcome contact with these lower-class groups who enlarged the populations of the cities by using the protective devices of erecting geographical and social barriers against them. Moreover, not only did they seek to bar contact with the poor, but even with well-off competitors, redefined as outgroups, such as Jews (Mills 1956)[3] In the process, they also created new definitions of art (DiMaggio 1982).

DiMaggio delineates three interrelated sets of strategies that they adopted to achieve and maintain high social status: displaying art works in prestigious institutions; soliciting elite audiences and excluding popular publics; creating scarcity to enhance the monetary value of art. In order to achieve these results elites and their agents undertook to reclassify or reframe art.[4] Instead of the relatively undemanding leisure activities of the first part of the century, Boston's elites, for example, sought a more demanding, austere, and uplifting kind of art. They, along with elites in other cities, founded or transformed existing museums and orchestras by excluding crowd pleasing music and visual art.[5]

3 Among the exclusionary strategies they adopted were to create social registers, private clubs, and cultural institutions with restricted governing bodies. Along with the institutional matrix, they adopted distinctive life styles for themselves and their children, whose socialization into these new forms of distinction became their means of creating and maintaining dynasties.

4 Specifically, they discarded certain art forms that had previously been visited by a heterogeneous public, and retained or adopted art forms that appealed to intellectually aware publics rather than to the modest audiences with whom they had previously shared entertainments. For example, concerts of the newly established Boston Symphony Orchestra performed only symphonic music, to the exclusion of interpolations of arias or what came to regarded as light music; the Museum of Fine Arts discarded its collection of popular plaster casts, previously the backbone of the sculpture collection, and replaced them with original pieces of sculpture, even if they were mere fragments.

5 This change is noticeable as well in other cities, such as New York, particularly with respect to the purification of a body of entertainment to which "respectable" women could come, as Kathy Peiss and other historians have pointed out (Peiss 1986).

Commercial art markets

Thus far I have dealt only with the conventional fine arts, but if that were all, then this would be an overly narrow view of aesthetic culture. It leaves out of consideration the bulk of the arts to which modern societies are heir, the highly developed sphere of what has variously been termed "popular" or "mass" culture. Usually considered separately from the arts of academic, churchly, or academic traditions, these art forms either serve specific functions (background music in stores or elevators; advertisements; political satire) or are intended for light entertainment (pop music; commercial musical theater and light plays; detective, science fiction, romance novels or movies; comic strips). Rather than treat this category of works as if it were art made by artists, many consider it a trivial, committee-made product for a large, undiscriminating public. These qualities are out of keeping with the usual conception of fine art in three ways: Popular commercial art makes no claim to be disinterested; it lacks the aura of the individual, romantic genius creator; it attracts the many rather than the "happy few." The implications are that popular commercial art is qualitatively different from fine art. Yet, as I have pointed out, even fine artists are not expected to be purely disinterested when it comes to being paid. In addition, whereas certain fine art forms are made by collaborative action, even commercialized art may result from a guiding vision of a creator.[6]

Debate about the blurring of boundaries between fine art and popular art tends to be corrosive because it has to do with hierarchical rankings not only among art forms but social status as well. Because cultural stratification involves high stakes, both material and symbolic, in the struggle for rank among art forms the winners have much to gain in status. For the artist, being associated with the highly valued social definition of fine art provides a warrant for access to patronage from governmental, foundation, or other honorific sources; for the institutions that foster fine art (museums,

6 Crossing the boundary between commercial and fine art is a fairly common practice. A number of "Ashcan school" painters including John Sloan, Everett Shinn, and George Bellows made a living as illustrators. Vladimir Dukelsky wrote orchestral music while also composing in his popular career as Vernon Duke, and Anaïs Nin wrote pornography when she was unable to have her serious novels published.

symphony orchestras) nonprofit status wins fiscal advantages (derogation of real estate taxes); finally, the audience gains not only the (presumed) pleasure and stimulation of the art, but symbolic rewards as well, for exercising good taste and, in the United States and, increasingly elsewhere, if they make donations, fiscal advantages as well.

Rather than naïvely assume that people freely choose to be members of art audiences solely because of the pleasure they expect to derive from art works, sociologists, cultural administrators, and artists themselves know that this is only part of the story. Although they explain the variations in different ways, they are aware that exercising free choice does not explain why members of the same arts audience have a great deal in common in social origins, income, education, occupation, and other characteristics (Bourdieu and Darbel 1969; Gans 1974; DiMaggio, Useem, and Brown 1978; Lynes 1980; Bourdieu 1984). Since audiences and publics provide the raw materials of modern support structures, both for commercial and disinterested art forms, their characteristics are a persistent subject of discussion.

Among social critics of every stripe – members of the Frankfurt school, Herbert Gans, Howard S. Becker, Pierre Bourdieu – the themes that pervade or underlie analysis are how art forms are ranked and why; with what social consequences for artists, for the public, for the durability of the art form; and with what effect on how we think of art itself.

Debates about the status of art forms

Although art forms, styles, and genres are made for and adopted by different social groups, because of the dynamics of the processes, their hierarchical ordering changes somewhat as well. Yet crosscut by recurrent jockeying for social position among artists, connoisseurs, art historians, critics on the one hand, and audiences on the other, the hierarchical structure of cultural value is reinforced by persisting processes and structures of inequality. Regardless of political differences, the idea of distinctions between high and low forms of art and their assignment to high or low values are generally accepted in modern societies. Moreover, though the criteria on which rankings are based are not always evident, the ways in which

the arts are ordered affect how those associated with them are regarded as well. On the basis of commentaries on aesthetics, taste, and audiences, the stock-in-trade of a wide assortment of writers, social critics, market analysts, academics, and applied researchers, I represent in the form of a simple bipolar typology a summation of their most usual viewpoints (see Table 2).

Although it is structured as a simple dichotomy between high art and popular or mass art, in view of the complicating nature of art forms associated with multiple media, I include in this typology the additional dimension of *originality*. This is needed to encompass the rarity of works where ownership and access are limited, as opposed to *reproduced or reproducible art works,* intended for larger publics. Aside from this nuance, I have deliberately made the typology as conventional as possible, as if the definition of what to include in the category of art is unproblematic, omitting many types of art, especially from non-Western societies. Table 2 presents the art forms of the West in a two-dimensional format, necessarily lending them a seemingly timeless, static character that inevitably dehistoricizes the art forms. In reality, of course, most cultural forms have occupied different places in the value hierarchies of their societies than that in which we find them today.[7] Interestingly, the underlying assumptions for hierarchical differentiation are congruent with those developed in the academic canon, themselves deriving from the theories summed up in the Kantian aesthetic, to which I return below.

With this array as the basis of discussion, I turn next to the typologies underlying the analytic distinctions among audiences made by a group of influential scholars and writers, including Russell Lynes, Theodor Adorno, Herbert Gans, Howard S. Becker and Pierre Bourdieu. Except for Lynes, all are or have been academic social scientists. Choosing to include Lynes may, therefore, call for some justification. Whereas he is a popularizer rather than a scholar, I believe disciplinary boundaries need not bar adverting

7 The cause of changes in the status of art genres and forms is attributed by Jacques Attali (Attali 1985), to the appropriation and monopolization of certain musical forms by elites and by the state. As a result, courtly music came to be split off from popular forms. Peter Burke has shown how spheres of elite culture came to be carved out of what had been relatively undifferentiated entertainment (1978).

Table 2. *Types of art: A hierarchical view*

Fine art	Popular art
Original or live works	
Symphonic music, chamber music	Popular music, folk music
Opera	Musical comedy
Serious academic contemporary music	Jazz
Art works in museums or galleries	Works sold at·art fairs or stores
Public monumental art	Cemetary gravestones
Ballet	Show dances
Modern dance	Folk or ethnic dance
Serious drama	Melodrama
Experimental theater	Light comedies
Reproduced works[a]	
TV – educational channel	TV – light programming
Art and classic films	Popular films for entertainment
Serious novels/nonfiction	Mass market novels/nonfiction
Limited circulation periodicals	Mass circulation periodicals
Poetry/literary criticism	Advertising blurbs
Art comicstrip books	Mass circulation comic books

[a]Certain original works, of course, exist as well in reproduced form. Music may be recorded or broadcast; plastic art may be reproduced. In the same way, original works may be broadcast on TV or other media.

to relevant intellectual contributions whatever their source. With respect to the arts this is particularly germane and is based on the precedent of worthwhile practice, as I showed in Chapter 2. Not only do the arts compose a domain interpreted by university scholars, but because the arts inhabit a world of practice outside of academic boundaries, they are analyzed by other writers as well. This is not to say that all critics of the arts and journalistic accounts are of high enough caliber to be seriously considered, but Russell Lynes, in particular, has provided journalistic accounts of art fields that are informative and perspicacious. Moreover, they have exerted considerable influence on the public, as well as on academic thinkers (Lynes [1949] 1980; [1970] 1982; 1985).

As a critical social analyst, Theodor Adorno represents a point of view of the arts in the tradition of the mass society formulation.

More properly sociological, the theoretical perspectives of Herbert Gans, Howard Becker, and Pierre Bourdieu represent divergent intellectual traditions, each emphasizing different aspects of the arts, audiences, and artists. But they share with Adorno a critical outlook on modern capitalist society, a recognition of the importance of status inequality, hegemony, marginality, and their consequences for art, artists, and publics. All of their studies have deliberately crossed disciplinary and genre boundaries, and broken through culture-bound categories. Although individually their analyses suffer from certain flaws or lacunae, together their theoretical strategies are indispensable in highlighting aspects of the social standing of the arts.

Adorno and critical theory as evaluation

Although it stems from Marxian theory, Adorno's approach goes beyond the nineteenth-century limitations of Marxian ideas about art to take into account the rise and effects of modern technology and economic organization that permit the development of mass culture and by implication, the creation of a "mass audience." He argues that, whereas art should exist for its own ends, it is insidiously used to reinforce the false consciousness of the public at every level. On the one hand art rationalizes the inequities of the capitalist system, and on the other, foists anodyne entertainment on the public to divert their attention from their oppression (Horkheimer and Adorno 1972). Adorno goes beyond Marx by incorporating as well psychoanalytic insights, especially with regard to the emotional release that the arts, particularly music, may supply.

Although at times he tends to reduce some art forms to ideology, a tool of oppression, and he is pessimistic as to the possibility of overcoming the trammeling of art by repressive capitalist structures, as I have shown in Chapter 3, Adorno's assumptions about art are far from naïve. As opposed to a value-neutral social science, he maintains that scholarship should not be divorced from an active socially committed project. Consequently, he takes on as central problems the laying open of these connections and, rejecting value neutrality, pays attention to the question of aesthetic quality. But quality is precisely the feature he denies to most of the art made in market-based societies, especially by commercial production

processes, whether intended for rich or poor. In those terms he is consistent in taking as the most telling dimension of artistic distinctiveness, not its expense or its appeal to the wealthy, but its "seriousness," or intellectual depth.

"Serious" music, for example, makes demands on the listener (and is therefore sought after by serious listeners), whereas popular music merely provides background entertainment (Held 1980, 101–3). This does not mean, however, that all serious music is *good* music, since even classical music may be false to the higher project of art by catering to coarse tastes.[8] Yet it is only in serious music that one expects norms of high technical competence and originality, whereas popular music is unoriginal and simplistic, because it is not *created*, but is *produced* through a division of labor among segmented task performers. In making this distinction, Adorno's typology disregards the collective aspect of the fine arts and refuses to acknowledge that technical perfection and artistry are far from unknown in commercial popular art.

As a trained musician and musical scholar, Adorno brings to audience analysis unusual familiarity with the art form itself. This is both an advantage, giving his statements a certain authority, and a disadvantage, in that he is unable to divest himself of prejudices stemming from disciplinary commitments, not to speak of personal loyalties as an "insider" in the music world. He makes subtle distinctions among different ways of listening to music by different kinds of audience members, according to their level of knowledge. At the top are "the expert," nearly always a trained musician now; and "the good listener," who has a grasp of musical logic, but is less technically trained. Socially the good listener is often situated in the aristocracy or upper bourgeoisie. Next are "the cultural consumer," typically a voracious listener, record collector, and information gatherer, with a preference for old music; and "the emotional listener," for whom music is a source of irrational release, and who prefers easy clichéd romanticism. Both of these types are often petty bourgeois, but the latter is likely to be antiintellectual.

8 Presumably this explains why he despised Puccini, whose operas demanded little effort on the part of the audience, providing easy recognition and appeal. Why he rejected Stravinsky and Hindemith is more problematic (Held 1980, 100).

Finally, "the resentment listener" prefers early music played in a dogmatically "genuine" manner, and strongly opposes commodified music. Sectarian, nostalgic, masochistically austere, the resentment listener is often a member of the upper levels of the petty bourgeoisie, in social decline.

Separate from the others are "the jazz expert" and "jazz fan," whom Adorno assigns to a category similar to that of "the resentment listener," in their purism and aversion to classic-romantic music. In fact, he lumps together indiscriminately all commercial popular music, including "pure jazz." Finally, he accuses those who listen for entertainment or recreation of not knowing music itself, but merely wanting it on their radio or record player, because for them, listening is a nearly unconscious act, more akin to an addiction than a serious involvement (Adorno 1976, 15).

Adorno seems deliberately to have developed these complex and refined categories to distinguish his own analysis from those of empirically oriented sociologists. Whereas the latter tend to view art preferences as reflections of social status, even when Adorno suggests such patterned relationships, he avoids drawing direct linkages between them.

In the final analysis, the only music that counts for him is the "serious" music of the progressive avant-garde and certain of its forerunners. Here his criteria for approval are so idiosyncratic that it is difficult to see how they can be applied by anyone but himself, according to his own tastes or friendships. Furthermore, since he excludes from the valued category of seriousness any music that has the faintest commercial hint, his typology is tainted with arbitrariness.

It may be inevitable that ranked dichotomous typologies suffer from defects such as these because of their relatively unyielding formalism and, frequently, underlying elitism. Even when they start from different assumptions than Adorno's, they assert the importance of high art and denigrate low taste. Some observers avoid these defects by introducing modifications appropriate to their assumptions about how society operates and the meanings of taste differences in light of their theoretical frameworks. Among the least theoretical but most influential observers of taste and, consequently, prestige of art in American society, is the journalist-editor, Russell Lynes, whose orientation, opposed to Adorno's,

leads him to a completely different interpretation of roughly the same patterns.

Russell Lynes and taste making

Finding that the heterogeneous character of modern consumer societies makes a dichotomy of fine and popular art too constraining for fruitful elaboration, Russell Lynes assigned the arts to social categories that he called "highbrow," "middlebrow," and "lowbrow" ([1949]1980).[9] The key to his analysis is that art is a consumer good, an idea that leads him to go beyond art alone, to consider many different aspects of life style and taste.

Lynes integrates art with clothing, domestic architecture and design, recreation, entertainment, philanthropic causes, and voluntary associational activities. In addition to his tripartite typology (later augmented with still more subheadings), Lynes incorporated into his study the dimension of time, coinciding with changes in the social standing of art forms and fashion. He provides a broad set of observations and suggests relationships between taste in art and in style more generally that nearly all scholars have harvested for inspiration (Bourdieu 1984).

In his account taste changes follow a relatively orderly trajectory, whereby highbrows and lowbrows are in alliance against middlebrows. For example, in looking at tastes for the visual arts in the mid-nineteenth century (1850s to 1860s), he attributes to highbrow tastes the Italian primitive paintings, and to middlebrows such art as academic style landscapes, while Currier and Ives prints belong to the world of lowbrows. Later in the century (1870s to 1890s), highbrows turn to works such as Whistler's *Arrangement in Gray and Black,* No. 1 ("Mother"), middlebrows to what may be characterized as degenerate academic art of a semipornographic nature

9 In his classic essay on the public's taste, Lynes, then editor of *Harper's Magazine,* described what he took to be the stylistic aspects of three social class levels. The article had such immediate appeal that *Life* magazine, then the leading publication in the visual media, in turn published an article about it, augmenting the argument with a visual chart. He devoted the book, in which he subsequently expanded his ideas, to what he saw as a historical process from the nineteenth century on.

(his example is Gérôme's *Pygmalion and Galatea*), and lowbrows come to admire paintings of action and heroism, especially in the conquest of the Far West. By the decades of the 1910s to 1920s, highbrow taste moves to Van Gogh portraits, while Whistler's "Mother" has sunk to middlebrow level, and lowbrows flock to spectacular movies, such as those by D. W. Griffith. Finally, by the 1940s through the 1950s, Whistler's famous painting completes its descent to lowbrow standing, Van Gogh's portrait descends to the middlebrow rank, and Griffith's movies have shot up to become the darlings of the highbrows who frequent New York's Museum of Modern Art.

Unlike most books of its kind, *The Tastemakers* has rarely been out of print since it was first published in the immediate post–World War II era. This lasting popularity would itself be worth sociological analysis that is outside the immediate concern of this book. Its durability owes much to its qualities as an amusingly written, gently satirical depiction of American society, coupled with a comforting discourse on American social structure that emphasizes fluid and fuzzy class lines, permissive of high levels of mobility.

Attractive as it must have been to read, this depiction of the (apparent) openness of society, and absence of barriers to mobility revealed the consequences of presenting people with choices for which they were unprepared and about which they must therefore have felt some anxiety. This must have been the case especially as they entered the new (for them) expanding corporate world. In these terms, the book's central implication is that just as a corporate image was coming to be an important creative goal of firms, corporate employment was the locus for newly arrived middle-level executives fresh from their accelerated liberal arts cum vocationally oriented postsecondary education. For newly affluent organization men and their wives, faced with the unknowns of corporate culture, reading Lynes's book could, like the etiquette books of the past (Elias 1978), be helpful in avoiding faux pas: of furnishing their homes with bad design, ordering the wrong cocktails, or mistaking modern art for mere scribbles. Without presenting an overtly ideological rationale, Lynes takes for granted that change and social mobility are permanent features of American life and of the arts. By implication his account suggests that knowledgeable

consumerism can serve to promote upward social mobility and mitigate the formation of rigid class barriers.[10]

Despite the frivolous tone and untheorized ideological underpinnings of his book, the virtue of his typology resides in the details he provides on middle- and highbrow tastes. The book's major defect is in poverty of substance when it comes to lowbrow culture. Whereas Adorno scorns lower-class or mass culture because he considers it false consciousness, ideological, and unworthy because of its poor quality, even Lynes, who starts from different premises, has little interest in lower status groups. For more depth of inquiry into their life styles it is necessary to turn to the work of other sociologists, such as Herbert Gans.

Herbert Gans and art as a human right

Although he follows pathways parallel to those of Lynes, it is clear that Gans is a sociologist and not a journalistic essayist. As a social scientist his background provides a valuable foundation for analysis because he never underestimates the material constraints on the expression of consumer tastes. He is, however, less concerned with the implications of their symbolic use as signs of social standing than Lynes, Veblen, and Weber. Refusing Adorno's elitism, he does not criticize popular tastes but focuses his criticism instead on the social arrangements by whose effects many groups are deprived of access to highly valued culture. Secondly, instead of devoting most of his attention to upper status groups, he addresses himself equally to examining lower status, less privileged groups.

10 It is significant that Lynes was writing after World War II, which had considerably slowed consumer spending, already diminished by the depressed economy of the 1930s. The late 1940s saw a boom, not only in car buying, but in the aid of government subsidized loans to veterans for housing construction, scholarships to cover costs of higher education, and family allocations that permitted many to have children at the same time that they were in school. It was, however, not only the loans and other material aid that caused the expansion of consumption, but the combination of (enforced) travel for service people and higher education for many of them that exposed many people to new experiences and may have impelled them to seek styles different from those learned as a result of their social background.

Unlike either the acute social observer Russell Lynes, or the critical social theorist Adorno, Gans's "taste cultures" encompass art forms and styles that cut across socioeconomic status and geographic location, with regional variations, urban, rural, and suburban, degree of proximity to cultural mainstream, or isolation from it. Writing in the 1970s, he incorporates several varieties of youth, black, and Hispanic cultures, as well as the culture of rural whites, treating them as legitimate forms. In this way he tries to overcome the indiscriminate lumping together of lower middle and lower class culture.[11]

Modern American taste cultures

1. High taste culture

 User- or creator-oriented; small audience, many artists or critics; well-educated; "classical" art forms, "difficult" avant-garde forms, exotic art ("primitive"), literature and architecture; popular art forms; similar to Adorno's category of "the expert" (Adorno [1962] 1976, 4).

2. Upper-middle taste culture

 Upper-middle class, well-educated professionals, managerial; not art professionals; unconcerned with formal aspects except plot and stars; follow critics and opinion leaders; fast-growing category.

3. Lower-middle taste culture

11 This tendency is particularly noticeable in the *Yankee City* studies of W. Lloyd Warner (Warner 1942, Vol. 2). Publicly recognized expression is far easier to study than cultural expression of groups isolated from the centers of power and influence. As Frederick Law Olmstead observed in 1859, "Men of literary taste . . . are always apt to overlook the working-classes, and to confine the records they make of their own times, in great degree, to the habits and fortunes of their own associates, and to those of people of superior rank to themselves. . . . The dumb masses have often been so lost in this shadow of egotism, that in later days, it has been impossible to discern the very real influence their character and condition have had on the fortune and fate of the nation" (Thernstrom 1975, 1). As difficult as the task may be, historians are increasingly accepting the challenge implied. Social scientists such as W. Lloyd Warner did not yet recognize the gaps in their understanding of status cultures as a result of the unexamined biases implied by their ahistorical methodologies, as Thernstrom shows.

White-collar, semiprofessionals; high school and (increasingly) college graduates; unadventurous tastes; "respectable" entertainment, with as little conflict as possible.

4. Low taste culture

Skilled blue- and semiskilled white-collar; low education; popular TV, action and adventure movies; relatively small purchasing power; sexually segregated choices (pin-ups for men; colored prints for women).

5. Quasi-folk low culture

Unskilled blue-collar and service jobs, grade school education, often rural or rural origin, frequently nonwhite; blend of folk culture and commercial low culture of pre–World War II era.

In his typology of the arts and life styles, "taste cultures" summarized here, Gans schematizes the components of a symbolic universe for aesthetic culture (1974, 75–94). Instead of denigrating the awkwardnesses of the uneducated and isolated vis-à-vis high culture, he embeds his analysis of taste in a reformist project, treating each group's preferences as though they had the same validity as others. This does not mean that Gans himself has no preferences, but he does not permit his own educated taste for the fine arts to cause him to deride the tastes of the less educated. Instead, he argues that if "society" considers taste to be a problem, then the onus for overcoming "bad taste" is on government, which should allocate the means for creating greater equality for the deprived.

This stance makes it clear that Gans considers culture as a *right* parallel to rights of citizenship, welfare, and education. Public agencies have the obligation to provide for it, through cultural institutions and live or electronic media sources. He assumes that if lower status groups are given better educational opportunities, they will come to desire and seek access to richer fare than commercial pop art forms. Since groups marginal to society because of poverty, age, race, and ethnic discrimination are least likely to have access to live performances, public radio and television should broadcast programs that appeal to them. But as long as the state does not provide sufficient education to enable its citizens to grasp more complex, abstruse, or richer culture, it owes them access to the arts they want without condemning them for wanting them.

By comparison with the treatment accorded to lower status cultures by others, such as Lynes or Adorno, Gans's plea is unusual. Adorno viewed all but some truly autonomous fine art as hopelessly commercialized under capitalism. From Adorno's standpoint the very marginality and parochialism of certain groups, and the association of others with commercialized popular culture, prove that they are both victimized by the political and economic forces of which they are pawns, and that they cannot possibly create autonomous art, or appreciate it. Given these premises, there is little chance that he would have accepted Gans's reasoning that taste is a matter of choice, and that people have the right to the art forms they want, regardless of how pundits such as himself may evaluate them. For Lynes the neglect of lowbrow taste has another explanation that has more to do with the intended audience of his books. Since Lynes was addressing rising middle-class readers on the premise that their mainstream taste was the future wave, it is not surprising that he treats the cultural production of isolated rural or lower class groups as a possible *object* of educated high or middlebrow tastes, rather than as belonging to people with tastes of their own.[12]

In contrast to both of them, beside paying attention to the taste cultures of marginal groups, Gans opens the question of how to evaluate cultural forms in the face of egalitarian values. This is an important issue in American culture, and implicit in other countries as well, though rarely confronted so openly. Gans's orientation is essentially pluralist, liberal, and consumerist, an approach that is not without controversial overtones.

Becker's art worlds: consumption as production

As his object of analysis Becker takes "not the art work as isolated object or event but the entire process through which it is made and remade whenever someone experiences or appreciates it." For

12 In fairness to Lynes, certain of the distinctive taste cultures that Gans features may not have existed prominently in the late 1940s (youth culture, certain ethnic cultures), or were so remote from mainstream life that they had little impact except on Library of Congress ethnographic collectors.

this reason, the contribution the audience makes to the art work is particularly important (Becker 1982, 214). It is apparent, however, that this framework of social interaction conflates reception and production so thoroughly that in Becker's formulation the audiences are undistinguished from the artists. This is evident when he locates the work of creating (or producing) art in four kinds of "art worlds," each of which is centered on a particular type of artist as worker. In Becker's account, as I have indicated (Chapter 5), their worlds have little to do with one another, whether at the level of artists or of "support personnel," who collectively participate in producing and distributing their works. Within the art worlds themselves, audiences are among these supporting personnel, receiving the works and reinterpreting them, with the result of changing their meaning with each exposure. Superficially and, from a certain standpoint, fundamentally, this framework resembles the approach of Bourdieu, as suggested in Chapter 4.

Becker focuses on the interactions that produce the labels of art and non-art, art and craft, fine art and popular art, naïf art and professional art of both conventional and maverick artists. He reveals the socially constructed nature of art, and how it is valued. He shows, for example, how an artist like Robert Arneson, working in ceramics, creates objects looking like teapots or typewriters that are nonfunctional (Ibid., 284–5). Instead of useful objects, they make things that potentially attain the standing of the Kantian autonomous art work to which Bourdieu refers. In the opposite direction, Becker shows that fine art artists may turn to craft work or reorient themselves to commercial ends, thereby changing the nature of the work they make. The objects, music, books, and dances are not inherently either art or craft until they are so defined by social actors and groups made up of practitioners, spokesmen, and influential members of the public.[13]

Becker's approach, like that of most of the sociologists under consideration, incorporates the intention of demystifying art, thereby

13 The sociologist, in the Weberian tradition, should refuse to participate in the construction of artistic value and remain neutral, neither scornful of popular art nor overly impressed by fine art. This is a position that is generally

avoiding what Marxian analysts refer to as the fetishism of the object. However, he is so opposed to the mythology of artistic reputation (Ibid., 352 ff.), that he makes short shrift of analyzing how high evaluations of art come to be; of considering why, even though art works and art forms eventually die, certain of them are more durable than others; of differentiating the work of making art from other types of work. His approach is not Marxian but derives from the phenomenological foundations of symbolic interactionism. Far from the totalizing conception of conventional Marxians or the aestheticizing, evaluative analysis of Adorno that incorporates aesthetics into a broad framework of social critique, Becker starts with the assumption that, as in all social fields, it is in the regularized interactions among creators and their supporting personnel that social meanings arise.

Because in this interpretation it is difficult to distinguish the audiences for whom works are intended from the artists, since all become participants in the creative process, and production and reception merge, we learn a great deal from Becker about how artists live and work within the constraints of institutions, or if rejected by existing institutions, audiences, and patrons, how they deal with these problems. He points out that whereas many simply give up, others become liberated from the demands of creating with others in mind and become mavericks and innovators, free to reject conventions. These include Charles Ives, who wrote music that was unlovely by the standards of the time and seemed impossible to perform (though it is now performed); Conlon Nancarrow, who avoided dependence on performers by composing on piano rolls. At the same time, Becker's heavy emphasis on the production of art work leads him to neglect as, for different reasons, does Gans, the symbolic use of cultural codes by audiences and the social forces that impinge upon them. It is in the works of Pierre Bourdieu that these questions come to the foreground.

pervaded by ambiguity. One might argue, for example, that Becker's view that aestheticians' choices are necessarily arbitrary and elitist represents his own anti-fine arts bias. In that light his treatment of Leonardo da Vinci as supporting personnel to Marcel Duchamp's *Mona Lisa*, the "assisted ready made" may be a sign of his own populist biases.

Bourdieu's aesthetic violence

Compared to the cheerful trivialization of life styles in the observations of Russell Lynes and the socially committed, liberal analysis of Herbert Gans, Pierre Bourdieu offers a pessimistic account of how the arts and life styles are used. He sees taste preferences as cultural signs that help perpetuate social inequality, so that those of the dominant classes, to the manner born, imbibe taste and facility in its display from birth to adulthood so thoroughly that their entire demeanor exudes their superiority. In their "habitus," their social status is revealed to be (virtually) natural, whereas those not so lucky may struggle to acquire the highly prized habitus, but come to realize that it is beyond them. Their only recourse is to admit, pathetically, that great as it is, high culture is not for them because they are not good enough for it. They are supported in their self-abasement by other social institutions, such as schools and their gatekeepers.

There is no need in Bourdieu's analysis to sniff out conspiracies or to imagine that commercialized popular culture by itself befuddles the minds of lower status groups. Sociological study of the creation of cultural value reveals how standards are established and imposed, not by force but by making them seem natural. Akin to Antonio Gramsci's idea of the hegemony by the dominant groups in western capitalist society (Gramsci 1985), Bourdieu's analytical foundation is usually taken to derive from the Marxian tradition. In fact, however, he is highly critical of simplistic adaptations of Marxist sociology (Bourdieu 1984). His position is far closer to Max Weber's, in the sense that whereas Weber's class analysis stems from Marx's "relations to the production and acquisition of goods," Weber's status analysis emphasizes the *consumption* of goods (and services) and how they are composed in particular life styles (Gerth and Mills 1946, 193). Implicitly, when individuals seek to understand, appreciate, and collect art works, regardless of what else they are doing, they are expressing an aspiration to membership in a status community of the cultivated (Bourdieu 1984).[14]

14 Parallel in many ways to this analysis is Veblen's perspicacious observations of Gilded-Age America, in which style and art-related objects and activities are used for conspicuous display and as a symbolic seal of approval for leisure-class prowess and what seems idleness.

Bourdieu's studies of tastes, based on interviews, ethnographic studies, and survey data, reveal what others have noted, that upper, middle and working-class people have different preferences in art, as well as in style more generally. Thus far, it would seem that his studies do not diverge from the overall patterns described by Gans, Lynes, and most other scholars. But he goes beyond most of them by rigorously theorizing on an epistemologically analytic basis the necessity of encompassing the whole process of creating socially valued symbolic capital in the form of art and its associated social practices, both by the artist and the audience. His analysis does not stop at a simple functional relationship between socialization and consumer preferences because class rankings are insufficient by themselves to serve as heuristic devices for understanding taste rankings. Rather, he analyzes the *ways of having aesthetic taste* and the qualitative meaning of interpreting art (Bourdieu 1984, 506). Beside using art for its symbolic meaning as signifying codes, audiences have diverse expectations of what they may acquire from contact with it. Their expectations may include intellectual challenge, aesthetic stimulation, moral edification, emotional expression, or entertainment.

Bourdieu argues that it is necessary to take account of both the conscious use of art and style as instruments for status striving, and also the unconscious, nearly automatic behaviors embodied in the habitus associated with empirically observable status groups. He represents social status by a three-dimensional social space whose crucial features are the kind of capital under consideration (economic, cultural, social), its volume, and the individual's or group's trajectory of change, or pathway from social origin. In these terms it is possible, though rare, for individuals to rank high on all three forms of capital and have a high social origin in each. This might be the case of heirs to wealth from the more esteemed status groups (in France, the *grande bourgeoisie*), who are also highly educated. Members of this class fraction are more likely to retain (and want to retain) their standing over time, from one generation to the next than those with other combinations of capital. Their success in doing so is fostered by the fact that the most durable and easily inheritable forms of capital are ascriptive characteristics, such as noble ancestry. Second is ownership of material capital, such as real estate, money, or goods. Last in durability and trans-

missibility is the cultural capital of education. Although under favorable political conditions cultural capital may be made available to and be acquired by those of modest social origin – and it may even be transmitted to some extent to a succeeding generation – education provides a more fragile legacy than other forms of capital. Social reproduction is increasingly predictable and probable, the more generations go by to reinforce it for the inheritors of wealth, and even for those who have achieved some wealth only in their own life time. It is possible for the offspring of the wealthy to squander inherited wealth or bring disgrace upon their lineage, but if they do not use their acquired cultural heritage cleverly, for example, by not taking advantage of educational opportunities, or making disdainful career choices, they have not necessarily lost everything, unless their family abandons them. The reproduction of cultural capital, acquired with great difficulty by the lowest fractions, however, is the most difficult to pass on to another generation.[15]

Central to his analysis of the arts in society, Bourdieu develops the idea that, regardless of what else it is, art and its appreciation are used as a form of symbolic capital in the arena (or *champ*) of status. He means by arena a field of contention in which better or worse endowed actors use what capital is appropriate to attain their ends. As with financial capital in the economic arena or power in the political arena, people are endowed with more or less, higher or lower quality of cultural capital. Their ranking in each of these kinds of capital, its volume, and the career pattern of their status are related in a complex manner to particular kinds of aesthetic preferences. For example, Bourdieu notes that those who rank high in cultural and economic capital prefer classical art and music, while those of high cultural, but moderate economic capital, and coming from modest origins, are more likely to prefer modern art and music.

That political acumen or money might be used for competitive purposes is perfectly acceptable to members of modern capitalist societies. The manipulation of art for instrumental aims, however,

15 The important case study by Paul Willis of the failure of working class boys to profit from the common high school education to which they had gained access as a result of educational reforms in England provides support from non-French society for Bourdieu's contention (Willis 1977).

collides with the view that fine art has come to be defined, fundamentally, as a consummatory value, as an end in itself. Supposedly, the capacity and will to use it as an end in itself are allotted only to the few, not the many; the few are considered to be endowed with taste, an innate quality, an ineffable appurtenance designating a natural aristocracy. But as Bourdieu contends, this idea itself is an aspect of the ideological underpinnings of social inequality. An integral aspect of his intellectual project is the exposure of the societal mechanisms that, together, produce our conceptions of art, the artist, the public, and the creation of cultural value through semiautonomous processes and institutions. He points out that among social status groups, the ones most revered for their grasp of cultural capital are those that (happen to) come closest to the Kantian aesthetic style. This is apparent in the contrast he draws between the ways dominant and dominated status groups understand art.[16] The dominant understand art formalistically, abstractly and disinterestedly; the dominated, on the other hand, are either too unschooled to grasp art at all or interpret it "incorrectly," in ways that reveal their lack of "distinction." Instead of having acquired the discourse of art in terms of its formal qualities, their approach is personalized, anecdotal, and sentimental. In some ways they resemble Adorno's "emotional listeners." Not only their tastes in art, but *how* they deal with it reveal only too cruelly their cultural backwardness.

For those who try to overcome their initial disadvantage, the only tool available to them is education. But it seems that as soon as they have attained more education, the rules change, and their tentative gains are washed away.[17] If they try to learn about fine

16 For Bourdieu, the bifurcation of dominant and dominated groups refers to class fractions in the economic sphere with respect to access to and ability to manipulate economic capital, but in cultural spheres, or arenas, cultural capital (the result of family upbringing, education, etc.), and facility in its manipulation are the relevant capital.

17 The recent "discovery" of illiteracy is a case in point. Although rates of literacy are in fact rising, the standard of literacy as a capacity has been raised. Previously, certain groups that would not have had access to schools at all or whose abilities were untested were not required to exercise reading skills because their work did not require them. Now, however, in a service/white-collar dominant society, even though more people are exposed to reading lessons, their performance expectations have been raised.

art, since the public schools teach it little if at all, they have to go outside the schools to other institutions. But those institutions (especially art museums) are even less welcoming to the uninitiated than are public schools. And in any case, if they manage to learn anyway, when they speak of high cultural matters, they sound pretentiously scholarly (Bourdieu and Darbel 1969).

Whether the symbolic codes of art that compose part of cultural capital are as permanent as Bourdieu believes is a matter of debate by those who show that intergenerational mobility is higher than he predicts (Robinson and Garnier 1985). But few argue against his view that, unless active steps are taken to overcome it, social reproduction is for all practical purposes a permanent feature of societies. Although it is often assumed that Bourdieu's work is purely theoretical in his concerns,[18] this is hardly the case. Aside from his own active involvement as critic of and adviser to the French government (Collège de France 1985), much of his scholarly work has direct implications for social action. This is clear when he notes that those high in cultural capital, but low in economic capital, and who have originated in families of low cultural and economic capital are more dependent upon educational institutions for the transmission of their status to their offspring than are others. His critique of education as the handmaiden of the perpetuation of social inequality is directly informed by the realization that much greater effort must be expended on it because it is, concretely, the mechanism of last resort for the dominated fractions to overcome this domination.

His own proposal for overcoming the forces of reproduction are, superficially, close to those of Herbert Gans, who identifies education as the most important mediator for the lower taste cultures and argues that there should be greater access to it. But because Gans treats culture as a matter of consumer choice and object of pleasurable use, he pays no attention to the symbolic uses that

18 Bennet Berger, for example, in his extremely perceptive review of Bourdieu's *Distinction,* concludes in the following terms: "Because the findings of *Distinction* are reasonably close to those of Gans, it may be instructive to ask how the two books differ. Gans is practical, Bourdieu theoretical; Gans's style is plain, Bourdieu's elegant; Gans offers plans and policies, Bourdieu is apparently *au-dessus de la mélée* – although not entirely because, as he says, there is no way out of the culture game' (Berger 1986, 1453)

individuals and groups make of their cultural practices, and the independent consequences their tastes may have for their overall social standing. Bourdieu goes beyond Gans's formulation by taking account of the importance of habitus that may distort the educational acquisition, so that mere knowledge of art, and which kind to admit to liking, are devalued. In those terms, what counts is not how many years of education are made available, but the nature of curriculum and the manner of teaching it. Passive education in the form of transmitting authority is, not only of little help in overcoming the hegemonic character of learning, but may actually reinforce it by convincing recipients of its value, and not providing them the means of using it as symbolic cultural capital. Instead, a reformed educational program teaching critical thinking and the in-depth *socioanalysis* that is the sociological equivalent of psycho-analysis can help to overcome part of the burden of habitus that Bourdieu perceives.

The tests of a taxonomic categorization are its validity and use-fulness. In the case of some of these typologies it might be argued that even if they are useful, their validity is questionable because by the nature of their depictions, as snapshots, they all suffer from fixity – as frozen moments in time. In and of themselves, as is generally the case for still pictures, the art forms do not reveal the reasons for which they change; the trajectory of their rise and fall; the mechanisms of the transformations of "art scenes" in which they occur. Even Bourdieu's analysis, so powerful at explaining how social status is reproduced, and the role of taste in art as a mechanism in that process, only scratches the surface in accounting for the changes in art. It is to this subject that we turn now.

7. How the arts change and why

The present period is one of unprecedented cultural pluralism in which a wide variety of general and specialized worldviews coexist. The art world reflects in its pluralism the cultural fragmentation of its time and is criticized in some quarters for not providing a means of synthesizing these conflicting viewpoints.

> Diana Crane, *The Transformation of the Avant-Garde: The New York Art World, 1940–85* (1987): 142

New styles and techniques, schools and movements, programs and philosophies, have succeeded one another with bewildering rapidity. And the old has not, as a rule, been displaced by the new. Earlier movements have persisted side by side with later ones, producing a profusion of alternative styles and schools – each with its attendant aesthetic outlook and theory. . . . A culture which includes James Bond and Robbe-Grillet, the Beatles and Milton Babbitt, Coca-Cola ads and action painting is indeed pluralistic and perplexing.

> Leonard B. Meyer, *Music, the Arts, and Ideas: Patterns and Predictions in 20th-Century Culture* (1967): 88–9

T HE COEXISTENCE of a multiplicity of art forms, styles, and genres is the predominant characteristic of contemporary society. Some interpret this positively as "progress" (the democratization and popularization of culture and the recognition of previously marginalized culture, that of women and racial minorities); others as decay (the loss of standards of quality to unthinking cultural relativism and the commodification of the arts, including even the fine arts).[1] In contrast to the idea

1 Leonard B. Meyer provides a useful summary of some theories of stylistic change, including A. L. Kroeber's view that certain civilizations are marked by extremely long periods when art styles remained virtually static, specifically, ancient Egyptian art (Meyer 1967, 105). In contrast to stability, Meyer points to the drive for variety in modern Western societies but notes that even in (chronologically) modern time, change and variety are not valued in all cultures. For example, citing Benjamin Lee Whorf, he shows that the Hopi view

that modern society is characterized by progressive change and
the abandonment of traditional forms, the condition in which the
new and the revived coexist is generally referred to as "postmod-
ernism." Since this term encapsulates a radically different epochal
significance from previous ideas of artistic change, it is necessary
to reconsider how change in art takes place. What conditions are
conducive to change as opposed to stability? Is artistic change
cumulative or revolutionary; evolutionary or punctuated? What is
the direction of change – or does it have a direction? Do all art
forms follow similar trajectories, or do they differ in onset and
timing? Is change desirable or a sign of social pathology; significant
and deep, or superficial, manipulated, and ultimately illusory?
Finally, are understandings of past processes of change applicable
to contemporary change?

In this chapter I deal only with a limited set of the possible
questions to which I have alluded. Some serve as antimodels of
questions to which sociology usually can give no answer because
they are too deeply embedded in value judgments; nearly all may
be answered differently because the meaning of art in the historical
and social contexts within which it has existed have changed.
Although the statements cited in the epigraph by Diana Crane, a
sociologist who has studied the effects of market forces on modern
art (Chapter 3), and those of Leonard Meyer, a musicologist who
has analyzed changes in aesthetic ideas in the post-Renaissance,
converge as appreciations of the situation of the arts in contemporary
society, they bring different understandings of how artistic change
takes place. Whereas, as I have shown earlier, humanists emphasize
developments internal to cultural forms, sociologists are more
concerned with sources of influence external to them. They are
more attentive to changing institutional spheres in the context of
economic growth and politics than to change attributable to purely
aesthetic consideration. These approaches, I believe, are comple-
mentary rather than mutually exclusive, because together they
offer promise for greater understanding of aesthetic change, ac-
counting for structural features of art forms, some of which are

repetition in a favorable light, because of its supposed efficacy in religious
ritual (Ibid., 52). This is an example of the anthropological, holistic view of
cultures in which the arts are embedded in other institutions, such as religion
and healing.

more permissive of change than others, in the context within which art forms arise. Context includes changing institutional support structures under different historical conditions.

The theoretical formulations of aesthetic transformation that I examine first range from revolutionary theories to theories of cumulative or evolutionary processes. In different ways, artists engage in career strategies vis-à-vis markets and political institutions. After evaluating these interpretations, I return to the question of the origins, depth, and importance of current patterns of artistic change, in light of the debate about postmodernism. First, however, I consider more generally some of the difficulties involved in studying change in the arts.

Problems in the study of artistic change

The sociology of artistic change includes a well-stocked toolkit of available approaches and frameworks of analysis. Even though sociologists and humanists are likely to emphasize one or the other side of these outlooks, for the most part they rarely insist upon a monocausal, unidirectional explanation. This does not mean, however, that a consensus exists in each set of disciplines concerning processes of change, or that there is agreement as to whether change is marked by a direction, goal, purpose, or *telos*.

Generally, as Wilbert Moore shows, change may be presented as directional, depicted as unilinear or multilinear, progressive or regressive, rising or declining, fluctuating or in stages (1963, 38).[2] Moore's pragmatic view is that the utility of each hypothesized curve or line depends upon how well it fits particular types or fields of data trends, demographic processes, and civilizational developments, as measured in terms of the incidence of different artifacts (inventions, citations, kilowatt hours of electrical consumption). Moore's formulation is useful as far as it goes. In the case of art, however, to begin to understand patterns or directions of change scholars need to specify, not raw counts of objects, but the nature of the origins of *stylistic features;* how they are to be interpreted – as a "natural outgrowth" of their society, its reflection; as an imposition by conquest or dominance of one people over

2 He sees Sorokin's cyclical mode as directionless (Moore 1963, 42).

another; or a mere survival, through accident, whereas other equally prominent stylistic features may have been lost because the art form in which they were located was undervalued or made of unstable materials.

Although it is not difficult to carry out the analysis of content by counting the incidence of certain *kinds of objects* in art works as Diana Crane does (Crane 1987), or by making use of stylistic meanings as detailed by artists themselves, on the whole, because of the multiple readings of art works over time (Chapter 4), these are far from exhausting their significance. Stylistic features are difficult to define and measure because their qualitative nature requires not mere enumeration of objects but sensitive interpretation of these shifting meanings. Subtle aspects of stylistic content are difficult to categorize because, as is apparent in analyses such as that of Pitirim Sorokin, as I show, pre-existing assumptions and biases weaken the force of the argument (Sorokin 1937, 369–506). This is true of most of these works which, consequently, serve as warnings rather than models to build on.

Because, as I have argued, the arts are social constructs emergent from processes of negotiation rather than fixed entities, in order to understand artistic change it is important to consider, not only forces that promote change, but impediments to change as well. Neglecting them makes it easy to fall into the trap of "presentism," or uncritically interpreting the past by current conditions. The configuration of the arts at any given moment is composed of the arts, styles, and forms that have lasted. One of the commonplace ideas is that what has lasted is great art whereas what has disappeared was unworthy anyway. This kind of thinking underlies many sweeping, macrohistorical, cultural studies with pretensions to total understanding of aesthetic change.

Macrosociological universal considerations

The massive work of Pitirim Sorokin, a humanist scholar with pretensions to universal breadth, encompasses 2500 years of civilizations, mostly Western, with nods to virtually all others. In this early attempt to gather data about stylistic change in the arts, Sorokin was hampered by the lack of modern computer technology, making analysis cumbersome. Nevertheless, he leaped ahead boldly,

characterizing his research as a "logico-phenomenological" analysis of culture and the arts. He propounds a general theory of social and cultural change that is suggestive, but problematic because among other things, the categories he employed are inconsistent and marred by conscious or unconscious bias (Sorokin 1937).

Sorokin differentiates "ideational culture" from either "sensate" or "idealistic cultures." In ideational culture the emphasis is on the spiritual as opposed to the material; to sensate culture corresponds an ethos in which the sense organs and their satisfaction have primacy. Not concealing his admiration for the ideational because of its high moral tone, Sorokin seems, nevertheless, to prefer the mixture of ideational and sensate characteristics that he represents by the category he terms the "idealistic." Whereas ideational art is static, religious, and otherworldly in orientation, and sensate is inherently dynamic, materialistic, self-indulgent, and this-worldly (Ibid., 684), the balance of the two in the idealistic state combines what he considers the best features of each. It avoids the extremes of art for its own sake on the one hand, and art devoted so completely to spirit that its austerity provides no sensuous compensation, as Sorokin asserts is the case of plain-chant and Byzantine painting or psalter illustrations. The chief purpose of these works was to be spiritual rather than pleasing. As part of ideational culture, these forms were in the domain of priests, whereas sensate culture composes that of mercenary interest, which in modern times are characterized by bourgeois or populist vulgarity. He takes for granted emphasis on fine art or the art forms related to elites rather than others; expresses his own preferences for certain art styles of the past, and against most modern art styles. Bias is not the only flaw of his work. Even a supporter of Sorokin's ideas, the sociologist John Manfredi, admits that his data and categories were weak, his knowledge of art history and "command of technical epistemological questions necessary to deal with" philosophy lacking in the extreme (Manfredi 1982, 185). Moreover, his work is tainted by probable inaccuracies in the data themselves (Manfredi 1982, 118–19).[3]

3 Sorokin undertook to overthrow what he took to be the increasingly dominant scientistic and functionalist social science that he perceived to be triumphant in American universities. In retrospect his scornful critiques and dismissal of mainstream sociology and functionalist anthropology, largely on the grounds that they were imbued with teleological fallacies, seem more justified than was the case at the time.

According to Sorokin's interpretation of his data, they reveal that art styles fluctuate in a cyclical pattern over time. Assuming an internalist view of art, he characterizes change as analogous to organismic growth: a cycle of birth, growth, ripening, exhaustion, and death of each stylistic category. The cycle is repeated across time, though not in identical patterns. Although he points to differences in the speed of change in different art forms (painting and sculpture, music, literature, architecture), and increased speed in recent times, he is not clear as to why certain forms become dominant and (seemingly) drag the rest along behind them.

Equally broad in scope but from an externalist Marxian perspective, *The Social History of Art* by Arnold Hauser tells a different story, one emphasizing a dialectical process of interaction among socioeconomic forces and artists with diverse aesthetic outcomes (1951). In opposition to Sorokin's culturalist theoretical assumptions Hauser's approach is a materialistic analysis of artistic work that applies an explanatory framework for artistic creation and change on the bases of social relations of production. As different as it is, his work suffers for some of the same flaws as Sorokin's. He too engages in leaps of faith in interpreting little known and inaccessible behaviors, such as the social status relations, work practices, and aesthetic goals of prehistoric cave artists. Moreover, he shares an insufficiently examined unfavorable view of recent avant-garde art. Nevertheless, Hauser's emphasis on the structural contexts of artistic creativity opens the way to further research at middle-level institutional processes and structures that promote, impede, and direct artistic change.

The large data base that Sorokin and his assistants gathered and his theoretical formulation have had little impact on recent sociologists of culture, with the exception of Vytautis Kavolis. On the basis of Sorokin's data Kavolis has attempted to account for periods of artistic efflorescences – moments of great creativity and innovativeness in history (1972). Paradoxically, in light of Sorokin's critique of Parsons, Kavolis adopted a framework suggested by the small group studies of Robert F. Bales, itself based in Parsonian functionalist analysis. Kavolis blew up Bales's small-group perspective to a vast historical and civilizational panorama.

For Sorokin's view of art as a reflection of the spirit of an age, Kavolis substitutes the Freudian-leaning functionalism of Parsons, conceiving of art as functioning to meet the integrative needs of

society and individual needs of individuals for tension reduction. His functionalism leads him to argue that the arts connect people with their disordered systemic environments, helping to overcome alienation. But under modern conditions of overly ordered, bureaucratized conditions, artistic disorder may actually come as a relief (Ibid., 164). Whereas Sorokin tries to characterize entire civilizations, Kavolis alludes to the coexistence of different groups within societies, each having divergent needs or interests. As a rule, however, in his adherence to the Parsonian assumptions of the systemic nature of societies, and his reductive psychologism, Kavolis does not develop these ideas.[4]

At the macrosocietal level he showed that although efflorescences are more likely to occur in times of prosperity, economic forces alone are not enough to explain their appearance. Kavolis finds that efflorescences do not occur in periods characterized by the primacy of goal-directedness (political activism), or of integrativeness (the settling down of a system), nor when a new equilibrium is well established and taken for granted. Rather it is in moments of what he takes to be systemic disequilibrium that efflorescences are likely.

Almost regardless of their disciplinary commitment and the current availability of computational capacity, in recent times almost no scholars have attempted the broad, universalistic project of a Sorokin or Kavolis. Instead, sociologists have turned their attention to more limited studies, perhaps implicitly acknowledging that at a high enough level of generality, almost any thesis can be made to conform to a curve (Moore 1963, 44). As I show later, this does not mean that all social scientists have given up the macrosocietal level of analysis, but they are less likely to found their theories on the illusion of having "hard" data from the past, when in all likelihood

4 The attempt to explain major changes by psychological causes raises serious problems of reductionism. It may rest on the assumption that macrostructures, whether political or economic, and secular trends have no autonomous effects on the rise and decline of nations. For example, Kavolis takes as fact David McLelland's hypothesis that particularly dynamic historical periods in certain societies are *caused by* the presence in them of people with high achievement needs (Kavolis 1972, 119). By McLelland's reasoning, need for achievement adequately explains why certain historical societies, such as Spain of the Golden Age, became dominant, and why it subsequently declined.

they have only obtained the data they have chosen to acknowledge as worthwhile.

Rather than focus on the structure of art forms from an internalist perspective as do aestheticians, or from an externalist view that reduces art to ideological signs, my own approach is to view the arts in relation to the social context, but with attention to the various aesthetic structures (of art forms) and different forms of social structure of art: production, dissemination, and reception. These are viewed as interdependent forces in setting limits on change or permitting change under certain conditions.

Aesthetic structure: internal–external limits to change

Art forms have structural properties some of which are chiefly social or external in their implications, and others mainly formal/aesthetic, or intrinsic. These traits, combined, form a structure more or less likely to impel change under specified conditions (Zolberg 1980). Numerous studies have shown that the most common motors of change in artistic practice stem from three interrelated sources: the advent of new audiences (White and White 1965); political transformations (Goldfarb 1980); and professional pressure (Crane 1976). It follows, therefore, that structural features germane to promoting or impeding access of art works to these external forces are critical in permitting or limiting change. Some kinds of art works, because of their intrinsic structural features, are more amenable to the impact of these forces than others. In other words, makers of works that are readily seen or heard, shown or sold, or otherwise made available to others are more likely to be moved to introduce changes in art styles or to conform to demands external to their own spontaneous impulses than those making works for their own use.

The plastic arts of painting and sculpture are generally detachable from their surroundings. This renders them capable of becoming saleable commodities and collectibles. In fact, the development of easel painting, as opposed to the relative immobility of frescos or other types of wall paintings, may be seen as contributing to the shaping of the artist's role as autonomous actor in a market. Because they are inherently *alienable* art forms that may be sold and resold, they take on the characteristics of other commodities that may

gain or lose in value. This permitted artists, even before the emer-
gence of major art markets, to make paintings and sculptural works
either as commissioned objects for special purposes (for various
kinds of patrons), or for a more or less anonymous market, generally
through the mediation of a dealer or agent. Part of their value, as
I indicated in Chapter 4, has come to be based on their genuineness.
A copy of a work is no longer seen as equivalent to an original
and has little monetary value compared to one that was made by
a much appreciated artist.[5] In fact, the high value attached to the
work of certain artists has been a factor in the rise of an industry
in art forgeries. This has rarely happened in the case of music, an
indication that the work itself is differently structured.[6] Music too
is capable of being bought and sold, but it is not a potentially
collectible object except in the most limited way, as a manuscript,
an early or rare edition or recently, as a rare recorded work.[7]

Beyond marketability, visual and plastic art works of different
styles are capable of being exhibited simultaneously in museums,
thereby potentially appealing to several different taste-cultures.
Live music, on the other hand, requires performance in a concert

5 This may be changing somewhat, as the market in handmade copies grows,
 and as artists undertake to create art works as duplicates of famous works,
 arguing that they are original in concept.
6 As is the case with literary works, ownership of rights to music revolves on
 copyright and plagiarism. This becomes an issue especially when a literary
 or musical work is highly profitable, as in recent suits brought against successful
 artists such as Mick Jagger and Alex Haley.
7 Although the marketability of art works may be seen as a liberating mechanism
 for artists, the reverse is also conceivable. This is the view of Jean Gimpel,
 for example (1970), who considers the detachability of stone sculpture in
 cathedral building in relation to stone carvers. Once statuary and stone blocks
 could be cut to proper size and shaped by stoneworkers near their home base,
 the workers would be freed from having to spend long periods of time on
 the building site, usually a long distance from their home, but could arrive
 when the parts were ready for assembling, and when sufficient funds were
 available to pay them. The opposite may occur by ideological choice, as
 attested by the manifesto of Mexican painters and art workers in the 1920s.
 Because they opposed transforming art works into commodities, they rejected
 the role of the artist as purveyor of art works to a market. Reversing Gimpel's
 reasoning, they viewed mural painting as a means of liberation from the
 dominance of dealers and market forces, in effect rejecting the autonomous
 status of art and artist in favor of their social and political functions (Chipp
 [1968], 1973, 462).

hall, for example, that can only make sense in a temporal-linear format. One consequence of this feature of the art form is that whereas access to original art works in museums for a varied public is facilitated, live music performance can appeal to only one public at a time. In practice this involves a more selective and apparently more conservative public, if symphonic repertoires are any indication (Zolberg 1980; Menger 1983).

Aside from the fact that music patrons are not as likely to be materially affected by a performance that they dislike than they would be if they had purchased a fake painting, the "genuineness" of music is usually not an issue, except to experts such as musicologists (and Adorno's "serious" listeners). From the listeners' and scholars' standpoint, the musical equivalent to the genuineness of a painting consists in, for example, whether or not the pieces conventionally attributed to Vivaldi are actually by Bach; whether Alfano did justice to Puccini when he completed and orchestrated the last part of the unfinished opera, *Turandot;* how the recently released last scene of Alban Berg's opera, *Lulu* affects our understanding of the composer's intention; whether the Rimski-Korsakov orchestration of Moussourgsky's *Boris Godunov* captures that composer's artistic intention better than reversion to Moussourgsky's incomplete score. But because performance art is almost certain to be rethought and redone, it is taken for granted that on each succeeding occasion the work may be interpreted differently.

Performed works and art works by long-dead artists are similar in structure to publishable literary works. Except for original manuscripts or early editions, the works themselves exist socially only when produced or reproduced. That is, whereas works that are complete in themselves, such as paintings and original sculpture, are not expected to be changed, each new edition or new performance differs more or less substantially from previous ones. In fact, if a new edition tries to capture the original intention of the artist or writer, it may become from the public's viewpoint a new work.[8]

Writers and composers may react differently to modifications of their works than do their publics. Samuel Beckett, for example, has been adamant in demanding oversight of how his plays are

8 The recent debate concerning a new edition of Joyce's *Ulysses* supports this point in that those who are incensed by what is claimed to be a distortion of the author's intention are other literary scholars and Joyce specialists.

performed. He allows no major deviation from his directions, and since he holds the copyright on his works, he is able to influence or thwart their production if he disapproves of it. His position conflicts with that of directors, who wish to exercise their own artistry in interpreting his plays. Once a writer or composer is dead or the works have entered the public domain, there are few barriers except for the market and local or national laws of a moral and political nature to enforce particular performance styles. Although the creator's heirs may prevent a work from being adapted, it is not always the case that an artist's descendants attempt to preserve the performance style of the era in which the works were created. The organizers of the Bayreuth Festival of Wagner's opera deliberately engage whomever they take to be the most exciting artistic director of the moment for new productions. At times this policy has been criticized, especially by conservative Wagnerites, but despite the quasi-sacred aura surrounding the event, it seems to be assumed that whatever the production, the works cannot be fundamentally harmed, and their stature only enhanced.[9]

The modalities of promoting or impeding change are embedded in modern times within the legal frameworks that increasingly govern the rights of creative artists, and even help decide *who* are the artists. Assignment to the social role of artist or owner of rights to an art work is potentially valuable, materially and symbolically. Materially, for example, individuals who are able to gain official recognition as artists may be entitled to receive transfer payments (social security, unemployment insurance, medical coverage) or earn the right to live in certain locations, such as in industrial loft neighborhoods in New York (Moulin 1981; Simpson

9 The playwright's intention is rarely taken as sacrosanct, though some performances tend to adhere more closely to it than others. For example, for many decades the Comédie Française was dedicated to producing a supposedly authentic replication of classical French drama. In recent years, much more leeway for originality is permitted, with the result of attracting larger audiences, albeit with more controversy. Official policy in Greece, where classical drama used to be performed in the classical language, is to increase access to culture. Plays in the ancient theater at Epidaurus, against conservative opinion, are now performed in literate but contemporary Greek language. This innovation was put into effect with the intention of attracting a broader-based audience than the tiny minority of Greeks with sufficient knowledge of classical Greek.

1981). In light of competing claims as to what limits are to be placed on changes in art works themselves and how innovations are to be treated, these questions are problematic in relation to performed works, "mechanically reproduced works," and art works generally, in the legal-technological context of advanced industrial-capitalist societies.

In a number of European countries (especially France) under the principle of *droit moral,* art works are not considered to be mere commodities, but are lent a higher, more humanistic stature. The integrity and dignity of the work take priority over the whims of the owner. Even after it has been sold or given away, the creator and his or her heirs or descendants retain a "moral right" to influence the work's disposition. For example, the descendants of the painter Georges Rouault, a number of whose works had been left to the National Museum of Art in Paris, resisted for several years the wish of the government to remove them to the museum's new location in the architecturally unconventional Centre Beaubourg. The family considered the art center demeaning to the works and to the dignity of the artist. Although the case is different, because it was an official agency of the State against which the family acted, in a sense they were asserting an objection similar to that of those shocked by Duchamp when he painted a moustache on the Mona Lisa, that a sacred work had been defiled. According to French law, in theory, if Leonardo da Vinci had had lineal descendants in France, Duchamp might have had to cease and desist.[10] This may be going too far since, of course, Duchamp did not deface the *original* painting, but only a reproduction.

The reason that industrial-capitalist countries do not treat these questions in the same way is because they do not share the same legal-traditional heritage with respect for the arts. Although the

10 *Droit moral* in France includes, not only the aesthetic integrity of a work, which may prevent a dealer from hanging a painting in a demeaning manner (upside-down, for example), or stop an art buyer from destroying a work (as Clementine Churchill did the portrait of the late Sir Winston Churchill because Churchill had disliked the work), but it overlaps with the tradition of family rights as well. For example, when Peter Weiss's play *Marat-Sade* was scheduled to be performed in France, the Marquis de Sade's descendants brought an injunction against it for the harm his portrayal did the descendants. As a result, in France the title of the play was changed to *Marat-X.*

French tradition has been foreign to the United States and some other countries, increasingly, under pressure by artists and collectors, certain American states are beginning to pass laws protecting the art work's integrity.

With the increase in reproduction technologies, the assignment of newer forms of work, such as commercially produced products, to the domain of art is constantly being renegotiated. Although aesthetic aims may coincide with commerce, at times the pressure to "innovate" by transforming a work comes in response to commercial pressures that conflict with aesthetics. This is clear when the technology of colorization, the adding of color to black-and-white movies by computer technology, became commercially advantageous. With the aim of appealing to a new public accustomed to viewing color movies, and supposedly unwilling to watch black-and-white films, the American media tycoon Ted Turner has been colorizing his stock of black-and-white movies for showing on his television network. Movie makers, actors, directors, and many fans see this as a threat to the aesthetic integrity of films. In the United States their legal actions have failed to end the practice because the courts do not consider commercial movies (and even noncommercial ones) to be art works. Furthermore, even if they judged them to be art, it is unclear whether American law would stop the holder of rights to the work from doing what he wanted with them, because they are inanimate. But when Turner tried to have the same colorized movies shown on French commercial television, he was successfully sued under French law by the children of the movies' director, John Huston. Turner contended that a commercial movie is *not* a work of art, but a *multiple,* and that he is not colorizing all existing copies, thus leaving many untouched. French courts have, nonetheless, applied the criteria of *droit moral* to the case. The Huston heirs were supported by the French Movie Directors' Association and the Ministry of Culture. For many years these official bodies have treated certain films as art works without, in any case, drawing as sharp a distinction between the commercial and noncommercial realms in its policies as does American public cultural practice (*Le Monde,* June 25, 1988, 21; *New York Times,* December 4, 1988, 30E).

This case illustrates the importance of considering that stability and change in art forms depend heavily on the social structure of

support, reward, and control on which artists and writers are dependent. They encompass market forces that transform high art into commodities, patronage structures based in government, church, and private individuals that may sacralize them. At least as important is the cultural tradition of meaning and value assigned to art. Historically, specific institutions, such as academies have played an important role in setting the conditions of art making (Pevsner 1940; Boime 1971). The degree of dependence of artists on one or the other support structure, the availability of more than one source of support, and the strength of political authority combine to constrain them differentially to abide by their rules. Most important, however, is the prestige that art works so patronized may gain.

Changing support structures, changing arts

Guild and church

During the better part of the Middle Ages, European art creation had been virtually isomorphic with craft production, a significant indicator of the fact that art was not autonomous either as profession or object. Guilds (or corporations) were the principal structures of training, certification, and organization of artistic work. The apprenticeship system for artists differed little in structure from that of other trades, and was actually combined with them. Graduating as journeymen and in some cases, achieving the status of masters, artists derived a good part of their income from commissions by the Church or its monastic orders, and to a lesser degree, particularly in the later Middle Ages, from noblemen or wealthy merchants and municipalities.

Both guild control and church patronage entailed considerable oversight and restriction on the form and content of art work. Guilds set standards of quality, thereby effectively restricting their members' freedom to use certain materials, compete freely with other artists, or transgress media boundaries by importing into their practice unapproved materials. Artistic freedom was not greater under church authority, though churchly commissions might be prestigious. Through custom, and ratified by official Conciliar regulations, the Church established a canon governing the depiction

of religious subjects. In particular, members of the Holy Family, saints, and other important figures were to be presented in dignified poses, and eventually covered in extremes of modesty (Steinberg 1983). Although it did not remain as confining in the Roman Catholic Church as it did under the Eastern Rite or the Orthodox Church, the canon was fairly restrictive at various times, depending upon what kinds of factions controlled the granting of commissions and dominated the interpretation of Conciliar regulations.

Competition from other patronage sources played an important part in loosening control. In Italy churchly regulations were crosscut by rivalry for cultural (and other material) dominance among city states and led to the development of centers and peripheries as outcomes based, not necessarily on inherent artistic quality and innovativeness, but as the result of competitive struggle. Later, when these support sources were increasingly supplemented and broadened by the patronage of monarchs of nascent nation states, some rules were ignored and others added. In itself, the fact of having *plural* sources of support permitted artists to exercise a certain degree of autonomy by soliciting commissions from one patron or another, rather than being dependent upon, and at the mercy of, a single support source.

Private patronage

Although private patronage of the arts is potentially prestigious both for the artist who receives it and the patron who dispenses it, and at times has been one of the few sources of support available, it has nearly always coexisted with other support structures. At its best, from the artist's standpoint, it supplied not only security but intimacy between artist and patron. However, only relatively few artists benefited from individual patronage of this sort and from regular pensions that some patrons provided. Most were treated as ordinary domestics who were subjected to arbitrariness by their master.

Patronage at its best is virtually synonymous with the rise of the great families of the Italian Renaissance, in particular the Medicis, the Estes, and their epigones. Modeling their entourages on what they conceived to be those of classical antiquity, a number of their members created courtlike settings in which intellectuals and artists

founded "academies." In these centers of intellectual discussion, the patronized artists and writers oriented their creations to flatter, or at least, not offend their patron. These academies provided inspiration for, though they are not to be confused with, the new institution, whose prototype was the French Academy, created to advance the national project of monarchs in the land where the absolutist state first reached a developed form.

Academy and academies of art[11]

As an administrative structure encompassing educational institutions, structures of competition, and rewards for talent, the French Academy became the major institution for commissioning art for public purposes, as well as making the reputations of artists so that they became sought after by private patrons. Created at the urging of artists themselves, the French Academy and its imitators in other emergent, more or less absolutist states, were intended to educate; foster creativity; establish and maintain standards of quality; provide legitimation for new art forms, subject matter, and styles on the basis of rationales derived from humanistic classical scholarship, to the end of symbolizing the glory of the monarch and the state.

Its major innovation was to incorporate theoretical, philosophical, and literary foundations into the craft skills associated with guild training, to transform art into a humanistic profession. This entailed institutionalizing art by elevating certain forms to hierarchical superiority over others, thus establishing the "great culture" that redefined art itself. By implication, excluded art forms became unofficial art and were thereby consigned to the relative oblivion of separate development as "little cultures" or to a weakened, marginalized position, which was the fate of the Church in the realm of artistic innovation. In contrast to the parochialism of local or regional cultural traditions, the sacred universalism of the Church, or the necessity of flattering homely or untalented patrons, academic culture embraced (and helped to create) a newly defined national content, under the protection of and with the support of the monarch.

11 I use the term "academy" to avoid having to deal with the complexities of its changing organizational structure. Actually, it encompassed drama, fine arts, architecture, music and science, though literature was its most prominent subject (Clark 1987, 46).

Now that it has become conventional to consider the academic system an extremely rigid, retrograde institutional arrangement in which artists were virtually enslaved and against which they became embittered, or from which they were excluded and alienated, it is important to remember that although later on it established its own restrictions and limited its canon to a narrow range of possibilities, this is not how it started (Pelles 1963; White and White 1965). Retrospective thinking of twentieth-century connoisseurs who sympathize with nineteenth century antiacademic art movements should not obscure the fact that it was in the artist's interest to be freed from guild oversight, church censorship, and patron capriciousness. For whereas it is true that those aspiring to enter the system had to learn the official content and style of painting (or other art form), and accept the hierarchy of subject matter that became an important feature of its canon for over two centuries, limited and limiting as it was, the academy provided alternative avenues of advantageous career advancement. Because it soon became the dominant cultural agency of the state, however, the academy virtually monopolized official art under the control of a tiny minority of artists.[12] Unlike certain of the academy's scientific institutional components that sought to be in the forefront of modernity, when it came to art the academy took its cues from the past, as a reinterpretation of classical ideas, especially in relation to the depiction of its noblest subject matter, designated as "history painting" (Heinich 1987).[13] This category included subjects of classical mythology, biblical anecdotes, or depictions of selected monarchs and saints in events made significant in order to construct the idea of the national state. The predictable outcome was, as Diana Crane has implied, that few new ideas emerged in a system that kept innovators at arms' length from control over rewards (Crane 1976, 58).

12 It is important to note that in the seventeenth century the membership in the Academy of Painting and Sculpture (founded 1648) included only about 8 percent (178 painters) of all those known to be painters in France in the half century (Heinich 1987, 51).

13 In the famous "*querelle des anciens et des modernes,*" by the 1680s, according to Nathalie Heinich, a consensus seemed to have been reached that whereas the moderns by far surpassed the ancients in science, the reverse was true for the plastic arts (Heinich 1987, 51).

Dissolved along with many ancien régime institutions, then re-created after the Great Revolution in a modernized form, the academic system continued to play the role of principal cultural institution of the nation state, with or without a monarch, throughout most of the nineteenth century. The academic salons had been open only to French members and their students until 1793, when artists of all nations were invited to show their works (Holt 1979, 2). As the academic system grew in size and prestige in tandem with the nation state itself, artists associated with it seem to have gained more in symbolic and material compensation than they lost by having to conform to its restrictions. In the Napoleonic tradition it was intended to provide a career open to talents based on objective criteria of achievement, but it never lost a strongly patrimonial character in which favoritism and mentorship played an important part in the success of artists associated with it, and which increased as the structures were swamped by aspirants (White and White 1965). Patrimonialism colored internal academic politics, reflecting to a certain extent the political world in which it functioned, especially by its competitions for stipends and prizes, exhibitions, and commissions. Nevertheless, despite inertial force of the institution, reinforced by the dependence of lowly entrants upon the conservative established faculty members and salon jurors, the conventional view of academic rigidity and its success in throttling innovation are not entirely justified. Even the hierarchy of subject matter was eventually transformed, as landscapes, previously treated as a minor art form, gained in esteem (Blunt and Lockspeiser 1974, 25–35). In fact the academic art style underwent major changes ranging over the (rather different) cool classicism of David or Ingres, through the churning romanticism of Delacroix, the hieratic symbolism of Puvis de Chavannes, and ending with the syrupy semipornography of Bouguereau, Meissonnier, and Gérôme.

Although the academic structures of France were widely imitated in other countries, by the middle of the nineteenth century, if not earlier, their monopoly over the arts and artistic careers began to be challenged successfully, in part as a result of their own success. The potential public of buyers expanded, but as the art schools turned out increasing numbers of artists, the academic institution was swamped. Although academies and patronage from private or public sources persisted in France and elsewhere, merchants of

art supplies or stationery, antiquities, and bric-a-brac turned themselves into fulltime art dealers or agents, soon constituting a marketing system that rivaled the official salon.

The art market

External to both the academic system and what was left of the guilds, though interacting with these institutions, the art market became the most important support structure for artistic creation and distribution. Organized by dealers who acted as intermediaries between artists, whom they urged to specialize in particular genres, and a more or less anonymous clientele of buyers or consumers, the market came to consist of a highly complex set of commercial activities, guided by entrepreneurship, but sometimes mixed with highmindedness.[14]

A market in art had existed in parts of Europe in the past, in Holland from at least the seventeenth century, as well as in Rome (Alsop 1982; Montias 1982). Specialized dealers had catered as intermediaries between artists and a clientele of noblemen, wealthy commoners, or institutions such as churches. On the whole, market growth coincided roughly with the rise of new classes and status groups, including the prominent families of Florence, Protestant and Jewish entrepreneurs in England and Holland, and Catholic capitalists of the Southern Netherlands. The academic art world was as closely intertwined with political trends, whether of state or nation formation, religious conflict, imperial expansion, or a combination of these as was the art market, but the market seems to have reacted more rapidly to the impact of these forces than did the academic system. In the Netherlands, for example, visual artists, facing diminished church support because of Calvinist distaste for imagery, were increasingly obliged, often with the help of agents, to seek commissions and sell completed works to private buyers, secular associations and municipalities. In response to market

14 For detailed study of the intricacies of the French art market, the rise of a London market, and attempts by other cities, such as Vienna and Berlin, to compete, see respectively: Moulin [1967] 1987; Taylor and Brooke 1969; Paret 1980.

demand they turned away from religious subjects in favor of por-
traits, landscapes, and genre works.

The market became pervasive in many art forms, providing
new entrepreneurial roles. Dealers channeled and promoted the
works of painters; impresarios organized musical and theatrical
performances; printers and stationers expanded their businesses
into publishing houses.[15] Publishing became an industry important
not only to literature or popular writings, but also, directly and
indirectly, to the plastic arts. Fine art coexisted with a nearly mass-
produced art for modest people seeking affordable decorations (the
equivalent of Currier and Ives prints) from at least the mid-nineteenth
century; or of anonymously produced paintings sold at fairs or by
artists on the streets and increasingly marketed through specialized
dealers or, later, in department stores.[16]

Related to the fine art market were art books, periodicals, and
catalogues that eventually became an important subsector in a field
that was becoming increasingly specialized. Nevertheless, analyt-
ically, it is difficult to disaggregate the marketing and consumption
of art from the consumption of furniture, bibelots, and clothing
because some dealers had an interest in several of these simultaneously
(Faith 1985). Although certain merchants had become specialists
in art works alone, they used technological advances in printing
to launch art journals in which they carried critics' (or public
relations hirelings') reviews, and borrowed merchandising inno-
vations from department stores for the more exclusive clienteles
they cultivated or created (Zolberg 1983). In other words, the
modern market for mass marketing and mass consumption came

15 Not only the visual or plastic arts, but print media as well came to be included
in the marketing of cultural creations. The markets in publishing and pictures
filled the breach in certain countries where patronage was, for various reasons,
declining but without necessarily developing a powerful official academy.
This was the case in England, where a commercial publishing world became
the principal support structure for writers (Miller 1959).

16 Already in the seventeenth century, as Montias shows, the bulk of art works
noted in Delft notarial records are untitled, unsigned works (1982), and to
this day the market in chromos, or pleasantly colored pictures sold to tourists
and unsophisticated publics in color tones to match their upholstery, constitute
the part of the art market sociologists tend not to bother with (Moulin 1987).

into existence approximately at the same time as the modern art market in Western Europe and in the United States.

American variants in support of the arts

Compared to Europe, the relationships among state, market, society, and the arts developed differently in the United States. As a new nation peripheral to Europe, and even though heir to many European institutions and ideas, Americans did not adopt them all wholesale. The tradition of and kinds of support structures that had been established in Europe, as shown in Chapter 2, were absent. For practical purposes there was no established aristocracy. Until well into the twentieth century, the state was relatively weak, and there existed no single religious institution as prominent as the Roman Catholic Church on the European continent.[17] On the whole, what public sources of support there were tended to be allocated for cultural institutions such as museums, and came from municipalities and states, controlled by local elites.

The upshot of this lack of a patronage tradition meant that artists had to make do with whatever other resources came to hand, including exercising a fair amount of entrepreneurship and self-publicizing, even if it meant crossing the boundary between disinterested art and trade. This was the case both in musical performance, where entrepreneurial musicians organized orchestras and concert series and persuaded local elites to bankroll them, and for plastic artists, who founded art schools, lotteries for merchandising their art works, and exhibitions. Nearly all artists had to rely on commercial activities, either through selling their paintings through dealers (few of whom were interested in American artists), or through being engaged to perform by theatrical or musical groups. As communications and reproductive media developed in the twentieth century, new opportunities arose, but they involved art worlds very different from those of the fine arts.

17 Quite to the contrary, throughout the nineteenth century, following traditional English prejudices, further enhanced by nativist political interests in reaction against growing immigration of Catholics from Ireland and other parts of Europe throughout the nineteenth century, Americans considered the Catholic Church dangerous, and established American elites usually treated the religion as a pariah faith.

Certain fine art forms were adapted to mass diffusion while others were created from the beginning as mass-produced for a middle-class and lower middle-class, relatively undiscriminating public. It is difficult to disaggregate these two worlds of art. The rise of the modern novel, for example, is closely entwined with developments in printing, particularly in the nineteenth century; the emergence of reproductions of fine art with the technology of color processes; the composition of classical music with the musical instrument and publishing industry. The rise of color lithography in magazines and posters, along with the development of the advertising industry, the recording industry, radio, film, and television, opened up fields of the arts that had never existed, both to disseminate existing forms and to promote the creation of new genres.

The implications of some of these trends were foreseen by critics such as Walter Benjamin who believed that the inventions of "mechanical reproduction" have changed the very nature of art (Benjamin 1969). Rather than assume that technological innovations in themselves account for artistic change, other scholars contend that the impetus for change is more likely to precede than be explained by technological innovations. This is the thesis of Michael Schudson, in analyzing the development of the newspaper (Schudson 1978).[18] But these analyses need to be placed in the broader realm of support structures, including the government, foundations, and corporations.

Until the United States began to develop a strong state and become a major world power, national government support for culture was minimal. With the exception of design commissions for public buildings, stamps, currency, and national museums, and with a tradition of considering the arts a private matter, the government had little incentive to enlarge its role. With the advent of the Great Depression, however, among the many emergency

18 In looking at the expansion of the American newspaper from the nineteenth through early twentieth centuries he shows its heavy dependence upon the technological breakthroughs in paper, ink, energy, and printing production. But Schudson concludes as follows: "The modern mass-circulation newspaper would be unimaginable without the technical developments of the early nineteenth century. Technological change was not autonomous and itself begs explanation. . . . Further, while the technological argument relates to the low cost and high circulation of the penny papers, it says nothing at all about their distinctive content" (Schudson 1978, 33–5).

programs designed to deal with the crisis (public works projects, dam building, rural electrification, major landscaping projects) were a number of agencies employing artists, writers, musicians, and performers. They commissioned creative work, as well as setting up educational programs in which artists and musicians taught children or adults their skills. Although the onset of World War II ended those programs, the United States emerged as the leading power of the West. Its new international standing is said to have created a climate supportive of the fine arts to achieve regime goals.

The main proponent of this view is Serge Guilbaut, who contends that cold war competition with the Soviet Union helps to explain why, from a periphery to Europe, the United States turned itself into an artistic leader. He believes that the emergence of the New York school of abstract expressionist painting was used as a propaganda tool to promote the stature of the United States as a land where, unlike authoritarian regimes, the artist was free to follow his own imagination (Guilbaut 1983). Simultaneously, pressure from culturally interested groups who lobbied Congress for aid resulted in the beginnings of regular national government support for the arts. In addition to the national government, the postwar period witnessed the massive entry of foundations into cultural philanthropy, as well as corporate firms, which both collect art works and provide support for cultural activities as a form of public relations (Martorella 1986).

Change in science and art compared

Establishing the changing general context of support that permits or impedes artistic change is a beginning for understanding how change comes about. This understanding is further specified by considering artistic change in relation to other aspects of culture. In comparing science and art, for example, Rémi Clignet explores the variations in the nature of change for these two cultural forms. Even though science and art share some structural features (creation in colleague-centered communities, recognition of exemplars, and development of paradigms) science and art do not have the same relationship to nature; and whereas startling changes in one scientific field have an impact on science in general, transformations in one

art form or in certain stylistic elements do not necessarily have any consequences for others.[19]

Following the analysis of what Thomas Kuhn called scientific revolutions, Clignet finds that in science, revolutionary change tends to be all-encompassing (taking place simultaneously at the level of phenomenal definition and tools of analysis). Especially in "big science" (that which is modern, based in large laboratories, and bureaucratized research organizations, entailing huge financial support), revolutions have measurable progressive consequences characterized by logistical growth. But it is not possible to speak of growth and progress in art (Clignet 1985, 82). For whereas scientific revolutions lead to purification of fields, artistic revolutions lead simply to more paradigms (Ibid., 217). The scientific community, based primarily in the relationship of the scientist and colleagues, has a major impact on change, through its control over the evaluation of scientific innovations. In the arts, through the mediation of market forces on the one hand, and cultural institutions such as museums on the other, the public plays a greater role (Ibid., 5, 216).

The contrast that Clignet presents underestimates certain persistent ambiguities about sociological analysis of science, and the nature of modern science itself. By deriving his orientation from Thomas Kuhn's studies, he implicitly equates all science with modern physics at a particular historical moment, neglecting other scientific fields that may share some of the features of art such as biology or mathematics. Even in physics, however, at the beginnings of major scientific changes when uncertainty is great and new conceptions are coming into being, the behavior of scientists and their colleagues resembles that of artists, even to the use of a vocabulary and concepts of aesthetics, such as "charm" or "color." When he looks at science he stays at a theoretical level into which the lay public rarely intrudes, but he looks at art much more broadly. For this reason he does not attribute enough importance to the impact of political, community, or religious pressures against unbridled sci-

19 Unlike the sociology of science, which has over the past twenty years or more accumulated a rich data and conceptual foundation (Ben-David 1971; Crane 1972; Price 1986), the changing landscape of the sociology of art is only beginning to be similarly revealed.

entific practice, thereby underplaying the importance of dissensus concerning the nature of what science is as a category or ethical questions of the kind that recur in the arts, as in controversies about pornography.[20]

Both in science and art, revolutionary changes in paradigms are rare events. As Michael J. Mulkay has shown, Kuhn's conception of paradigmatic revolutions assumes a closed intellectual field appropriate for physics at a particular moment of its development, in which innovations were almost by default attacks on existing paradigms. But just as other sciences, such as biology, did not conform to that pattern, neither were the worlds of art, even at the height of the French Academy, so closed and monopolized by one institution. As an important specification of Kuhn's theory, Mulkay introduces the alternative form of innovation that he terms "intellectual migration" (1972, 34). Less spectacular than a paradigmatic shift, it may take the form of "modified application of existing techniques and theories within a different area," such as an area of relative ignorance (Ibid., 46). Those most likely to engage in innovative action are individuals marginal to their institutional setting (because of youth or low status), especially in a relatively crowded field (Ibid., 52). This interpretation, relevant to the development of studies in the sociology of art (Chapter 3,), is equally applicable to the innovation of new genres and styles in the arts under conditions of relative political freedom, in particular when market forces predominate.

20 Apart from historical examples such as the case of Galileo, the strictures against dissection of corpses, and the terror represented in the perennially appealing myth of Frankenstein, I list a few recent examples to suggest a surprising level of uncertainty: fundamentalist religious restrictions on the teaching of biological evolution in certain states; debate about the efficacy of holistic medicine, herbalistic treatment, accupuncture, psychosomatically-based medical conditions; the impact of Lysenkoism in Soviet biology; and the current debate among scientists of France and England concerning the purportedly permanent "traces" left by physical events in space. The point is that even among scientists there is not necessarily complete agreement about what is science and what is quackery. Moreover, especially in the era of "big science," support is more available for certain kinds of science than others, with space, military, cancer, and heart disease receiving disproportionate government funding, as opposed to research in public health.

While it is more common in American experience for the commercial markets in art to dominate the support structure for fine artists, both those with high cultural pretensions and those of a more routine tendency (Crane 1987), this is increasingly happening in European art worlds as well. Even though the colorization controversy shows that traditions of value may serve as braking forces against complete commodification of art, pressures for stability *or* change emanate from noncommercial sources, including religious as well as political institutions, if they have a strong commitment to enforcing particular ideological rationales. In authoritarian regimes, where market forces have been suppressed, the state and its institutions have been the chief agencies of support and control. This control was nearly total in Hitler's Nazi Germany, and in Stalin's Soviet Union, including in their purview both fine and popular art forms.

Considering support structures in the context of bounded entities, such as single countries, is becoming increasingly problematic. Change in the arts cannot be studied within the confines of a single society or civilization because the arts are increasingly international in scope. This has been the rule among compatible nations, especially with the regard to commercial relations as well as symbolic exchanges. In the post-Stalinist Soviet Union a general loosening, punctuated by a major "thaw" under the leadership of Nikita Khruschev and, after a retrogression, an even greater opening up under Mikhail Gorbachev, suggests that artistic expressions may circulate more freely. Among the increasing number of cultural exchanges between the Soviet Union and the United States as part of glasnost, one of the most striking is the first auction of works by Soviet contemporary artists, organized by the world's leading art auction house, Sotheby's, under the auspices of the Soviet Ministry of Culture. Aside from the artists, Sotheby's and the Ministry share a percentage of the profits (*New York Times,* July 8, 1988, C17).[21]

21 Recently certain sociologists are directing attention at constraints on artistic creativity and careers as a result of political repression or commercial pressure (Goldfarb 1982; Rueschemeyer, Glomshtock et al., 1985), a subject to which I return in the concluding section of the book (Chapter 8).

Simultaneity of styles: modernism and postmodernism

Contemporary critics frequently complain that the faddishness of modern art represents degeneration into the same kind of modishness pervading clothing fashions. Deploring the loss of what they take to be permanent values, they perceive the line between fashion and art particularly smudged since World War II, largely in response to the expansion of the art market. This trend is an ominous development because it suggests a loss of aesthetic distinctiveness and artistic autonomy, not only in the world of industrially produced art (Adorno 1976), but even in the domain of "serious" or autonomous art. On the face of it, their observations are accurate, as shown by growth in the sales of fine art paintings (Faith 1985), as well as the arts of unlikely or marginal creators, such as the mentally ill, primitives and naïfs, or children. Moreover, faddishness is found not only in the world of contemporary art, but in art rediscoveries as well. The sociological study of fads is usually assigned to scholars concerned with explaining collective behavior. Among its assumptions is that a good part of this class of social behaviors is irrational.

This is not the place to contest this orientation, but with respect to the arts and to taste more generally, other less mysterious factors need to be considered. As Francis Haskell shows in his analysis of taste in the nineteenth century (1976), historically an important element of the process is the simple availability of works to be observed. For example, as the result of political vicissitudes undergone by their collectors: emigrés from France's ancien régime fortunate enough to have been able to take with them some of their possessions, were obliged to sell many paintings in order to live abroad for what turned out to be a very long time. Many of those works were purchased by more stable monarchs, foreign noblemen, and magnates, eager to snatch up acknowledged masterworks that might not otherwise have become available. That the works had acquired prestigious connections, the aura of being owned by esteemed families, increased their value. Even older works that had little reputation at the time, such as Vermeer's paintings, or the preRenaissance Italian primitives, were eventually (though not always easily) successfully promoted by entrepreneurial critics and dealers or their advisers.

The coexistence of many art forms and styles is even more prominent in the twentieth century. Yet Howard Becker is largely correct in noting that art worlds tend to be separate from one another (1982). This is especially true for naïf artists and integrated professionals and even in the smaller subset consisting of the world of serious music, as between avant-garde musicians and those involved with conservative symphonic music. Nevertheless, it is important to distinguish the community of artists and their *social interactions* from their *aesthetic behavior*. Because the weight of Becker's analysis rests on separation of art worlds from one another and the practice of art as working, rather than the art works themselves, his approach misses out on violations of art world (and art work) boundaries. Yet he is clearly aware of the fact that the actual practice of artists, writers, and musicians consists in *crossing over* art world barriers. Commonly transgressed is the line dividing "popular" and "serious," as, for example, when classically trained musicians become jazz players and composers, or when "fine" artists create works intended for commercial purposes, and vice versa (Andy Warhol; Keith Haring; Alexander Calder, among others).[22]

Diverging from the segregation of art forms and styles that had become clear in the nineteenth century (DiMaggio 1982), now nearly all possible sources of sound and vision have become fair game. To some it may seem that deriving ideas and inspiration from reproved art is a form of behavior akin to the grasping for a forbidden fruit. Although this may be the feeling of certain artists, it does not explain the phenomenon in its entirety. It is understandable if we combine the aesthetic structure of art works with the historical, cultural, and social context in which art worlds

22 The most prominent recent example of this phenomenon is Wynton Marsalis, the trumpet player, who seems equally at home playing baroque music or jazz. Less well known nationally is a group of principal players from the Chicago Symphony Orchestra who have, not surprisingly, formed their own smaller chamber ensemble. What is more unexpected is that some of them also have formed a jazz combo. Given the fact that, as Adorno, along with such composers as Virgil Thomson, rightfully complained, major symphony orchestras play an extraordinarily limited repertoire of pieces (Zolberg 1980), these superbly qualified musicians are likely to seek somewhat more expansive outlets for their untapped abilities.

exist. It is necessary to go beyond consideration of particular art forms or genres as the unit of analysis and look at features of music and painting as they compose its aesthetic structure. Melody, tonality, rhythm, whether in toto or in fragments are capable of being appropriated and incorporated into the musical compositions of other composers or musicians; art media, techniques for coloring, drawing and constructing in order to achieve particular ends may be "borrowed" and recombined in other contexts, and for other ends. This happens repeatedly with folk music, which has been a source of ideas for, among many others, the works of Schubert, Beethoven, Dvorak, Mahler, Bartok; elements of jazz have been taken into the "serious" compositions of Ravel, Stravinsky, Weill.[23] The direction may be reversed as well, since certain "classical" works have come to be incorporated into "pops" repertoires (of such institutions as the Boston Pops Orchestra), used as the starting point for popular commercial songs (Rachmaninoff's Second Piano Concerto among many others); or worked into the original jazz works of such composer-musicians as McCoy Tyner.

Crossing boundaries of genre, style, forms and their associated social classes, status groups, and regional cultural patterns may be the most common characteristic of art developments, but transgressing the barrier is illusory *if there is no noticeable barrier between art forms*. Originally the creation of official art and the separation of certain forms into noble and non-noble forms generally entailed an exclusionary process. Now the reverse seems to be the case, as the French assimilation of commercial movies into the canon of officially recognized art indicates. The amount, variety, and promiscuity of importation, borrowing, or plagiarizing since at least the middle of the nineteenth century has never heretofore been surpassed. Academicians and institutional gatekeepers may rail, but they cannot completely control the diffusion of artistic ideas even by the use of force. Except under the most rigorously au-

23 The adoption of ethnic or folk elements in music and painting has probably always gone on to some extent, but it became more prominent, especially during the nineteenth century, in the course of the search for national roots. These forms are increasingly granted official status in nearly all modern countries, regardless of ideological differences. This suggests that the structural boundaries between the arts imposed by participants in art worlds are permeable and provisional.

thoritarian political regimes, such as that of Stalin or Hitler, no art world can be viewed as impervious to or safe from the depredations, conscious or unconscious, deliberate or accidental, of artists or their agents in search of ideas. Even under extremely authoritarian conditions efforts to insulate artists and art inside these art worlds, prohibiting (or protecting) them from adopting reproved artistic ideas are likely to fail.

The history of artistic change has been written from the Renaissance and romantic perspectives that emphasize revolutionary and progressive themes. In those traditions artists act within a broad set of values and expectations that have become attached to the modern worlds of art, the most salient of which emphasize innovativeness and variety. Despite attempts to explain artistic change from developments internal to art forms or genres, because art forms and styles are increasingly diffused from other sources that are not necessarily aesthetic, aesthetic change has to be viewed in their context. Akin to the sweeping transformations of clothing styles promoted by fashion marketing, a succession of new styles in the fine arts has become the norm especially during the post–World War II era (Crane 1987). Social and professional structures and levels of technological developments provide the parameters within which artists and associated actors function. The structure of the modern world is largely to blame for the contemporary heterogeneity of styles, media, art forms, and their relatively easy transmission to remote regions of the planet. In that sense, the current situation fulfills the visionary ideas of Marshall McLuhan, who on the basis of electronic innovations foresaw the emergence of a global village based on instantaneous transmission of cultural elements. To the despair of purists, the rapid succession of artistic fashions and the accumulation of previous innovations break chronological barriers and juxtapose genres and styles thus constituting current postmodernism.

8. Where does the sociology of art stand, and where is it going?

CONCLUDING THIS BOOK does not mean resolving the debates and dissensus that pervade the arts, the sociology of the arts, and sociology in general. Lack of resolution, however, should not be a matter of regret, since intellectual uncertainty has the potential value of alerting scholars and intellectuals more generally to inadequate theorizing or gaps in their data. My goal was not to achieve closure, an impossible aim in the study of society, but to provide tentative solutions to internecine intellectual conflicts involving art versus sociology, internalist versus externalist analysis, and sociology versus sociology. This chapter serves to synthesize these themes, highlighting recent trends in sociology and in society more generally that offer promise for research and, perhaps, deeper and more complex understanding of the relationships of the arts and society.

At the present time researchers who study the place of the arts in society face two major tasks. The first concerns the meaning of context and contextualization. The second has to do with the problem of value and evaluation of the arts. Contextualizing the arts is a necessary strategy if we are to understand how certain activities and objects come to be defined as art, if, and on what basis they are hierarchically ordered, and how some art comes to be judged as better than others. On the other hand, uncritical contextualization runs the risk of losing sight of the art object itself, trivializing art in general, and prematurely closes off the possibility (and legitimacy) of evaluating art works or genres. With respect to the question of aesthetic judgment, as far as most sociologists are concerned, this is not a legitimate project. They have usually been reluctant to permit evaluations to enter their studies, a position they share with scholars in other fields. Even aesthetic or humanist specialists, including critics, prefer to sidestep making aesthetic judgments. For both scholarly and ethical reasons this is understandable, but the extremity of their stance can be

problematic. As a response to the danger of obliterating the art object or prematurely excluding evaluation as a legitimate project, it is important to foster the study of aesthetics and the arts as special fields and for scholars in each, humanists and social scientists, to learn from one another. What this implies is that it is just as legitimate for specialists to direct their attention to art qua art, as to its contextualization.

The sociology of the arts, yesterday and today

Among the impediments to the social study of the arts that I pointed to in Chapter 1 is the lack of clearly bounded conceptual categories in the arts themselves. This state of the arts is viewed as a threat or problem by conservative critics such as Edward Banfield (Banfield 1984). They argue that ambiguities of definition and genre boundaries, with which modern visual art is rife, reflect decline of standards of quality. I contend that, on the contrary, unclear boundaries challenge the public, artists, humanist scholars and critics, but above all, sociologists. Specifically, they allow sociologists who choose to study the arts no alternative but to examine the conceptions and formulations of its subject matter. The result has been that some of the most important insights into the socially constructed nature of art have come from sociologists who have chosen to or have had to focus on the boundaries between art forms and on what grounds they are established (Bourdieu 1965; Moulin 1978; Becker 1982). For whereas social scientists studying other subjects may be lulled into thinking that they can accept uncritically the categories constructed and used by the actors in their field of study, even in more developed areas such as the sociology of science and technology this has turned out to be an unwarranted assumption (Latour 1987).

Sociologists of the arts and science have a great deal to learn from one another. Of the fields composing the sociology of culture, sociologists of science have made important contributions to clarifying the nature of the world of science. They have revealed gaps between ethos and practice, and delineated the effects on scientific discoveries of types of institutions, distance from major scientific centers, and other social contextual factors on the development of that ethos and scientific practice (Ben-David 1971; Crane 1972;

Zuckerman and Merton 1973; Kuhn 1977; Price 1986). Most of the studies in this field, however, assume the consensus on the nature of science itself as nonproblematical, a situation that was surely not the case until recently, and in some fields is not factually based even today (Clignet 1982; Dumont 1984; Proctor 1988). The illusion of consensus as to what science is had diverted social scientists from some of the fundamental questions about how a field of scholarship is constructed, a study that is both provocative and revelatory of how cultural meaning is created and legitimated. Aside from questions raised about certain fields of thought dismissed by "normal" scientists as "quackery" or "flakiness," such as the metaphysical probings of some of the countercultural physicists that Max Heirich discusses in his essay on cultural breakthroughs (1976, 23–40), it is still possible for accepted conceptualizations to be challenged within science itself, and in the interface between science and "the community."[1]

In the social study of the arts, by contrast, nearly endemic to the domain is the problematic nature of art because of the state of the arts in modern society. As a result, definition and redefinition of what may be excluded and included in the category of art

1. An example of one of the internal battles is the current debate about "the memory of matter," in which the publication of the data of the French research scientist Jacques Benveniste has provoked international scientific furor. Benveniste's research, showing remarkable cellular effects of histamines that support homeopathic theories of medicine, if supported by his results would require major revision of physical principles. Published by the respected British journal *Nature*, the results were immediately attacked by American scientists at the National Institutes of Health, and by other scientific journals, including *The New England Journal of Medicine*, as having arisen as artifacts of the methods used and not replicable by other research teams. Moreover, opponents point out that Benveniste's research was financed by a pharmaceutical firm with interests in homeopathic medicine, as opposed to the dominant allopathic approach (Nau 1988, 7). To this debate should be added the tension and rivalry concerning priority in the discoveries on the AIDS virus between American and French researchers. Although at one level this is an argument internal to the scientific domain, it is clear that the interests involved are external to science for its own sake. The embeddedness of scientific theories in the social-historical and political matrix of society is even more transparent when it comes to the recurrent debate in the United States between fundamentalist religious institutions and the attempt to teach Darwinian theory in public schools where they have influence (Nelkin 1982).

compose a good part of art world debates. These issues come to a head in the face of the conventional distinction between "great art" and the rest; between "fine art" and "popular" or "mass" art; between art that transcends time and place and ephemeral, unpretentiously commodified art, made to fulfill some social function other than "the aesthetic for its own sake." For sociologists and sociologically oriented humanist scholars, they reveal tensions between social engagement and aesthetic choice; between commitment to value-free social science as opposed to commited social analysis.

The qualitative humanistic character of the arts, as I contended in Chapter 2, was out of keeping with the scientistic orientation in sociology in its drive to associate itself to the prestige and gravity of the physical sciences. This disciplinary tendency was congruent with the ambiguity surrounding the fine arts in American political culture. In opposition to its populist strain, the arts had come to be viewed as signifier of elite status. The combined effect of these tendencies was to marginalize the study of the arts, along with certain qualitative sociological orientations.

These themes underlie my analyses of the cases cited in Chapters 3 and 4, in which I distinguished between two general orientation in the social study of various art forms. In general, unlike conventional aestheticians, sociologists explicitly incorporate in their analysis the social context of the art or music they examine. They range over a more catholic variety of music, paintings, etchings, literary, and dramatic works than have most aestheticians, and devote more attention to the institutional and commercial constraints on the art form under consideration (Chapter 3).[2]

Although an art work may serve to illuminate societal and cultural processes in unexpected ways, its analysis by sociologists is far outweighed by emphasis on its context (Chapter 4). Taking art as revelatory or merely reflective of the political and socioeconomic trends in the societies at large is only the beginning of sociological analysis. Sociologists now emphasize the complexity of reflection, incorporating, as the case may be, historical processes of change in how art works were reinterpreted over time (Akrich 1986), the negotiations by competing groups to establish their meaning (Lang

2. They include among numerous others, the study of opera (Martorella 1982), the content of television (Cantor 1980), the symphony orchestra (Arian 1971).

and Lang 1988), and slippages resulting from the artists' inability to control reception behavior of publics, either immediately at their creation, or later (Wagner-Pacifici and Schwartz 1987).

Despite significant differences between the approaches, these analyses highlight a feature common in intellectual orientations of many sociologists: the singular modesty of the artist's presence in the subject of study. Even when works of art are at center stage, as I indicated in Chapter 5, their creators are relatively unsung. This is even more likely when the artists are nearly lost in the sociohistorical re-readings (Bourdieu 1987) and reeditings (Becker 1982) that make up the body of some research. One way of understanding this relative absence is to take it as a sign of the power of structuralist thinking (Bourdieu and Passeron 1967), or as an aspect of the idea developed by literary theorists of the "death of the author." Useful and even valid as these ideas may be for some purposes, carried too far they produce a gap in thinking by refusing to incorporate agency into their analysis. Although the idea of the spontaneous genius may be implausible, and at best an exceedingly rare event, it is equally implausible to think that art works make themselves. That the vast majoity of artists are not geniuses, and most good artists are, as Becker suggests, simply people who work at their art more assiduously than most, does not make the phenomenon of individual greatness trivial.

Even though sociologists would be in error to adopt the conventionally popular adulatory view of the artist as romantic genius (at least not unless this category is germane to their subject), most cannot (and, in fact, do not) leave out the creator of art works altogether. Instead of ignoring or avoiding understandings of the individual artist proposed by aestheticians and cognitive or social psychologists or psychoanalysts as part of an assumed division of labor in the human sciences, I maintain that it is important to reinsert them into the analysis of social realities of society and artistic practice. This would show the awareness by sociologists of the fact that artists emerge from the interaction of initial propensities for talent and personality characteristics within the constraints of historically grounded opportunity structures, through changing processes and mechanisms of discovery, recruitment, and socialization.

This does not mean, however, that humans are necessarily as manipulable as chess pieces in the changing contexts of the board.

In human society the "pieces" are not fixed in their attributes or abilities, nor are their roles completely predetermined. Rather, they change over time in relation to their successive contexts. As convincingly argued by theorists such as Anthony Giddens (1982) and William Sewell, Jr. (1987), these individual characteristics themselves should be seen as being socially constituted and recognized.

Becker's analysis of the process of collective creation (or production) of art works (1982) provides a basis for my contention that the talents, personality, or cognitive skills of artists are far more varied than the idea of the spontaneous, innovative genius implies. My emphases on diverse talents, rather than talent in the singular, as an essential aspect of the artist is an advance in the demystification of artistic creation. To the extent that artistic creation is likely to be a "team effort," then a variety of art-producing roles exist, calling for individual actors of considerably different abilities. Although some may act as initiators (the conventional creative artist), there is room for others to act as coordinators and administrators, as synthesizers of existing ideas, or as interpreters.[3]

Since the institutional and social context must dominate in any understanding of the character of artists and the arts, as I show in Chapter 6, the interrelations of art and its audience have become a major structure for analysis. Just as the individual artist may be viewed as a social construction, this is the case for audiences as well (Crow 1985). As an important aspect of the modern support structure for the arts, the public, particularly from the nineteenth century on, is emergent from a complex of socioeconomic and political developments. Audiences and the public in some theoretical formulations are seen as manipulated by powerful political and economic interests, and subdivided for the purpose of the marketing of goods and services to the ultimate benefit of those interests. In those terms, the arts are merely another commodity, or mechanism of social control. Against this simplistic view, I argued that audiences change in character and composition, as do the arts, that their

3. Becker's idea of the collective nature of artistic production is not to be confused with the critique of capitalism and its tendency to produce alienation in creative artists. When Becker applies the collective action idea to the fine arts, he is removing them from their pedestal; when Adorno does so, he is arguing the hopelessness of autonomous art under commercial constraints.

interrelationships are extremely complex and cannot be assumed to function in such a reductive manner.

The interrelationships between art and the character of cultural support structures and publics stand out when we consider processes of artistic change. As I suggested in Chapter 7, theories of how and why the arts become transformed range over the sweeping macrohistorical to microscopic, evolutionary, or revolutionary conceptions. Research has dealt with the arts as a whole or has differentiated them according to peculiarities of specific types of art and the structures and processes of their creation and dissemination (Zolberg 1980). On the whole, these approaches are most convincing when anchored to particular historical circumstances, as well as general social trends, institutional change, and patterned group behavior. By combining institutional levels with the macroprocesses of sweeping historical trends, and enlarging the microanalytic frameworks of social psychological and interactionist behaviors, they reveal the possibilities for, as well as the limits to change.

The study of aesthetic change highlights a theme that pervades the entire book, the social embeddedness of aesthetic value, and the problematic nature of evaluation for the social sciences more generally. With few exceptions, modern sociologists avoid considering the quality of art itself as a legitimate subject of inquiry. In light of sociological study that has attempted to incorporate considerations of value into research, I turn next to this issue.

Sociology and value hierarchies in the arts

In Herbert Gans's challenging book *Popular Culture and High Culture,* he remarks that "popular culture is not studied much these days," attributing this pattern of neglect to "the anti-commercial bias with which many scholars look at culture" (Gans 1974). His recognition of this presumed lack of coverage leads him to the subtle analysis that has served as the basis for much debate in the domains of sociology of the arts and of social inequality ever since. It needs to be said, however, that although in 1974 when his book was published it may have seemed a rare event for a sociologist to deal with pop or mass culture[4] "high culture" was not much better

4. Gans was, of course, aware of the critiques of popular culture by Adorno, Lukács, and others, because he incorporates and criticizes their approaches

served. Indeed, at approximately the time that Gans's book was being published, it was at least as rare to find studies published by American sociologists on the fine arts!

I undertook to explain that lacuna on grounds as convincing as Gans's, but largely from the opposite side. In American society although commercialism may have been or become an object of scorn, high art was also repellent because of its elitist connotations. Because regardless of their professional commitment, sociologists themselves are part of that society, it is not surprising to find in them a certain ambivalence toward the study of the fine arts. This may be more problematic for sociologists than other scholars, since the arts, whether popular or elite, suffer from a reputation for triviality, by comparison with more obviously material disciplinary concerns, such as social organization, social stratification, urban sociology, race and ethnicity, or criminality.[5]

Adverting to the high culture versus low culture debate does not mean that this issue is necessarily the one most central to research currently under way, though it appears in various guises,

in his analysis. In addition (although their emphasis was less on the art objects themselves than on their reception and their analysis as indicators of collective behavior), he is cognizant of literature in the field of collective behavior that produced such classics as studies of the popular impact of Orson Welles's radio production of "The War of the Worlds" or the U.S. War Bond Drive of Kate Smith. Even though the popular arts were usually considered as social problems rather than as art forms in their own right by the Frankfurt theorists who rejected them as ideological manipulation, their analysis has often been a source of illumination of social understandings. Two older collections of writings on the subject of popular culture contain statements on the subject by thoughtful scholars from a variety of fields (Rosenberg and White 1957; Jacobs 1959).

5. When H.D. Duncan did a literature count of books and articles in *Current Sociology* and UNESCO's *International Bibliography of Sociology*, he found that from 1965 to 1969, of between 4,700 to 5,700 items listed each year, not more than 22 to 30 dealt with works on the sociology of art or music. Moreover, of those listed, more than half had been done outside the United States, and about one-sixth were merely repeats from previous years. Expanding on those findings, I found that in recent years, although the bulk of sociological publications is still in fields remote from the arts, nevertheless, the proportions have shifted somewhat. Whereas in the late 1960s the arts never attained as much as 1 percent of all publications, currently they hover around 2 percent, and although the literature coverage in those compendia is far from complete, at least repeats of entries have been eliminated (UNESCO 1984, 1985, 1986).

and the questions raised in that framework are far from settled. Controversy underlies studies, such as those by Bourdieu, dealing with the influence of cultural capital on social reproduction. In his work the uses of the arts by different class fractions are taken to be indicative of differential access to the symbolic capital of learned cultural codes. Although not formulated in the same ways, the development of cultural indicators and survey of leisure practices (Robinson 1977, 1985) and large scale analyses of aggregate data on cultural behavior (Blau 1988) provide a descriptive empirical basis for penetrating questions raised by those theorists, or for understanding the structural effects of social organization more generally. These approaches and findings constitute a growing body of data for societal critiques of increasing sophistication.[6]

An issue related to the distinctions between popular and high arts is the question of differential evaluation of art, whether among different genres or worlds, or within the same category. If anything, the validity of such a project is even more contested among a broad range of sociologists. For example, from a conflict-oriented, neo-Marxian perspective, Janet Wolff is just as reluctant as Becker to include the subject of aesthetic quality as part of her task, arguing that it is outside of the legitimate concern of sociology to do so. As she puts it, rather than fall into the unresolvable squabble between those who end up "collapsing artistic merit into political correctness" or assume some "univeral, timeless, aesthetic quality which it is difficult to defend," it is better to admit to not knowing the answer to problems of "beauty" or "artistic merit" (Wolff 1984, 7). Interestingly, her rejection of the possibilities for an aesthetic role for sociologists seems a change from the hopes she had expressed in an earlier book (Wolff 1983), in which she indicates promising convergences between sociology and aesthetic writings.[7] The approaches of both Wolff and Becker are criticized by Eugene

6. Beside Peterson's cultural choice studies (1983), updates of Gans's taste cultures study (Gans 1985), and increasingly large sets of data gathered and analyzed (Blau and Hall, 1986) have been a number of reanalyses of Bourdieu's ideas of class reproduction (Robinson and Garnier 1985; DiMaggio and Mohr 1985).

7. Her remark about "political correctness" refers to the protracted debate among Marxian sociologists and Communist ideologues, in particular during the 1930s (Bloch et al. [1977] 1986; Chipp, 1973 [1968], 456–501).

Rochberg-Halton, who sees them creating a sociology of the arts limited to externals. For Rochberg-Halton, Becker is a "conventionalist" and Wolff a "conceptualist," each in some way omitting the consideration of "the human capacity to transmute felt experience through communicative forms whose substance can convey feeling itself." As a result they produce "a 'formalism' in relation to symbols from which meaning and value are absent" (Rochberg-Halton 1986, 40).

Beyond studying the attitudes and judgments of the subjects of their study, the reluctance of most sociologists to incorporate aesthetic judgment explicitly into their paradigms is based on laudable prudence. Those sociologists who have not shielded themselves in this way have inevitably aroused the ire of others for whom a value-free stance is absolute, or who do not share their tastes.[8] On the one hand, their rejection of aesthetic judgment may be considered a legitimate boundary-drawing strategy for their discipline; on the other, however, they may be accused of taking the easy way out, abdicating a responsibility which is both intellectual and ethical, as has been separately contended by Judith Balfe (1985) and Jeffrey Goldfarb (1988).

Despite these criticisms I believe that the goal of a value-free science, itself not fully accepted by all social scientists as a legitimate part of their ethos, is consistent and necessary, even if not always achieved. Yet it should be pointed out that by excluding evaluative judgment explicitly, they run the risk of having it slip in inadvertently. For example, Gans calls for more equality in the provision of access to art forms of a kind that people of particular statures wish to have, even though he thinks that they should have access to the same kinds of art that those with more education and wealth have. By this he implicitly acknowledges that some art forms are richer and more fulfilling than others (1985, 20), but without specifying in what ways they are better. Becker, on the other hand rejects the idea that some art works are intrinsically great whereas

8. The case of Theodor Adorno, as I showed in Chapter 3, is a good example of one who freely vented his scorn for certain kinds of musical works and art forms, and rejected all but the most limited sector of the arts in modern times. His belittlement of jazz, among other "commercial" music, which he considered a marginal ethnic form, won him the epithet of elitist.

others are not, except as the result of establishment of conventions emergent through the influence of certain groups in imposing and maintaining that ordering.[9] However, by not bringing aesthetic value to the forefront of his work, his approach cannot account for why certain art forms come to be more highly valued than others. It cannot explain why more powerful groups co-opt certain art forms, except perhaps through individual spontaneity or unexplained drift.

The problem of aesthetic judgment is one that has baffled not only social scientists but art specialists as well. Unlike earlier generations, now even many humanistically oriented critics and aestheticians hesitate to put forth aesthetic judgments, preferring to avoid dealing with such matters though for reasons different from those common to sociologists. Consideration of their disavowal of judging suggests a similar scientization of their humanistic discipline.

Problems in criticism and aesthetic evaluation

A profound transformation has taken place in the content of art criticism since at least the mid-nineteenth century. Whereas until recently it was replete with polemical writing (Lethève 1959; Goodrich 1963; Zolberg 1987), that is considerably rarer today. This may be explained by changes in institutions and the market, as the academic systems lost their credence. For even though the academic system was based on a variety of changing philosophical premises (Venturi [1936] 1964), it had provided establishment critics with a relatively firm foundation on which to elaborate their judgments. At the same time, because of its centralized and monopolistic

9. Becker does not deny the conflictual nature of the relationships among art worlds but chooses not to address such issues directly. Lower social standing relative to that of "integrated professional" and successful "mavericks" is the fate of certain kinds of artists, incipient mavericks, folk artists, naïfs, and women. Although he is aware of the treatment and lower regard for marginal artists as at least in part the outcome of exclusionary tactics by art world actors, he seems to take them as inevitable facts of social life.

nature, it became a clear-cut target for antiestablishment critics (Boime 1981).[10]

By the middle of the nineteenth century, along with growth in artistic creation both in music and the visual arts, in interaction with a burgeoning publishing world, possibilities for literary and art criticism in a journalistic form expanded greatly. Although criticism continued to grow slowly in certain universities and persisted as an independent scholarly activity, the criticism that became most prominent was largely a freelance activity. As player of a new social role, the art critic flourished in the context of expanding print media, in tandem with the emergent fine art market (White and White 1965). In this opportunity structure, the critic became a professional of the literary and intellectual world whose leaders included stars such as Théophile Gautier, Charles Baudelaire, and others who wrote on nearly every subject (Graña 1964; Frisby 1987). Since critical articles were at times a vehicle for launching new cultural ideas, art criticism came to be as much a public relations device as an evaluation or the expression of an opinion. The critic, acting as advocate for innovative art styles, came to dominate (Lethève 1959). Rather than expressing judgment in terms of the establishment canon, antiestablishment critics used their columns to outline new canons, creating discourses that came to be adopted not only by specialists and lay publics but even by the artists for whom they illuminated the meanings of their innovations.

From the point of view of the public, critics became guides in the formation of taste for both new and revived art that did not conform to known styles. However, the unreliability of critics as objective guides was a fairly open secret because many of them had connections with particular artists, dealers, and publishers. Not until the recognition of modern art as a subject worthy of

10. As Lionello Venturi shows in his book on the history of art criticism, many of the academic critics did not start from the same philosophical premises and interpreted realism and sensibility in very different ways (Venturi 1964). It is also clear, however, that throughout the nineteenth century when the French academic structure was at its most powerful, the art produced under its aegis, at its best, was far from devoid of variety, innovativeness, and talent (Boime 1971).

study by the developing art history field and related university disciplines, did a relatively objective and respectable set of voices that might be considered fairly trustworthy develop outside of the market-dominated world.

Scholarship in the emergent cultural institutions in which art historians, aestheticians, and curators worked were by no means completely insulated from the fine art market.[11] Still, compared to art critics, who might reach a broader audience but whose motives were questionable, they were certified experts. By the mid-twentieth century scholars are supposed to be professionals ethically divorced from commercial activities, not direct beneficiaries of market processes but rather holders of an education that confers on them the credibility needed to be arbiters of aesthetic value. Even aside from the consideration of commercial and institutional pressures on their expertise, however, art historians have tended to avoid the critic's role. Whether as narrators of and collators of art works, influences, origins of national schools of art, or among some "new" art historians, as contextualizers of art works who may criticize the social uses of art and styles, they generally eschew judgment of quality, leaving that to critics, whether academic or journalistic, although they have been taken to task for such a choice (Venturi [1936] 1964, 344).

11. A connoisseur such as Bernard Berenson was more closely involved with the dealer Duveen than either admitted during their lifetime. But Berenson was employed neither by a university nor a museum. It has become unethical for museum curators to be directly involved with dealers, in the sense of accepting a fee for their support for works that the dealer wishes to have bought by or accepted as a gift by the museum. Yet in general, museum curators must have become aware quite early that the presence of art works in museum collections lent them a cachet that they would not otherwise have (Zolberg 1974; Zolberg 1986). When it comes to university-based scholars, who usually are not barred from accepting honoraria for acting as consultants, their choice of subject on which to focus their research and publications, or to which to guide their students, is capable of being oriented by other than intellectual concerns. Art historians have been more concerned with attributions, iconographic analysis, tracing of influences of certain schools of art, preferably of acknowledged masters, but of minor artists as well. Whatever the reasons for such choices, the results could influence the market value of the works (Lang and Lang 1988).

Scholarly curators and museum directors have made themselves the bulwark and guarantor of artistic quality for museums. Scholars have long been employed or consulted to corroborate the genuineness of old art works (Taylor and Brooke 1969).[12] Nevertheless, choices of contemporary art even by well-established curators are likely to be contested since expertise, or at least the right to an opinion about modern art, is claimed by many outsiders as well. The public nature of such attestations of quality and the possibility of contestation from outsiders conflict with the equally powerful motives of discovering new artists, acquiring their works for collections, and winning over donors for the institution.

Given the pressures on scholarly art specialists from one side to make judgments (Faith 1985) and from another to avoid doing that, it may seem surprising that sociologists would want to enter upon such an undertaking. Yet although few American sociologists are currently dealing with that issue, a number of them have raised it, arguing that they are under an obligation to address what they consider core issues of the discipline (Balfe 1985, 2), a question to which I turn next.

Sociology and aesthetic judgment

Despite its taken-for-granted nature, the idea of a value-free approach in sociology has had a rocky career, existing more as a hope than an achievement, according to some critics. From an extreme logical positivist standpoint, value and fact should be strictly separated. But strict construction of this rule would make the behavioral or human sciences virtually impossible, or limited at best to superficial events. Among scholars holding to ideological or political positions as divergent as those of C. Wright Mills, Dennis Wrong, Erving Goffman, or Theodor Adorno, most are in accord in rejecting a scientistic model of sociology, grounded in what they viewed as a specious or trivializing empiricism, emphasizing process and

12. By now they have much to say about certifying the relative importance of modern art, as these works have, willy-nilly, been admitted into museum collections. This is a matter of great importance to many parties, since, by implication, when a work enters a museum collection, its standing and that of other works by the same artist are enhanced.

methodological techniques rather than substantive issues. Not all methodologies were their bêtes noires, but principally those using quantification uncritically, based on frameworks derived from the analogy of the human sciences to natural sciences. Until recently, qualitative methods and quality of life matters resided in new or cross-disciplinary rather than most mainstream sociology journals.[13]

In light of this background Jeffrey Goldfarb and Judith Balfe are exceptional in reopening the question of evaluation, and Goldfarb in taking it on as a central problem. It is interesting that both come to this position through concern for democracy. From Balfe's point of view neglecting aesthetic quality is inexcusable, not only because the subject was excluded with virtually no discussion, but because in a substantive field in which quality is always at issue, far from being on the margins it should have been central. Balfe points out that the recurrent question raised, first by Arnold Foster (Balfe 1985, 7) in the early 1970s, was whether "the sociology of art should (or even could) consider aesthetic quality." As she reminds us, Foster cautioned sociologists not to conflate an art work's quality with the aura lent it by its supporters' social class. Dealing with the related question of "whether the traditional distinction between popular art and high art . . . was sociologically or ethically warranted," he proposed distinguishing between the aesthetic and political functions of art, recognizing that superior quality (or its opposite) may be discerned either in elite or popular art (Ibid., 8).

Even among sociologists calling for analysis of quality, the question of how to define superior or inferior quality is rarely broached. In fact, the matter was not much discussed by American sociologists at all until over a decade later, when the arts were gaining public recognition from expanding governmental agencies at national, state, and social levels. Nearly simultaneous with expanding public subsidies, support from foundations and especially corporations also grew dramatically (Zolberg 1983; Martorella 1986). Balfe suggests that interest in including judgments about aesthetic criteria

13. Among these are such journals as *Qualitative Sociology, Telos, Theory and Society; Media Culture and Society; Theory, Culture and Society; International Journal of Politics, Culture and Society.* Most of them are either published abroad, or have a strongly European representation among their editors and contributors.

has revived because of the need to advise policymakers whose decisions have an impact upon audiences (Balfe 1985, 11). Her view is supported by Margaret Wyszomirski (1985, 54–6), who shows that in policy terms questions of aesthetic quality always come down to "quality versus equality," or the cleavage between quality versus democracy.

The problem with the ideas that Balfe, Wyszomirski, and Foster raise, however, is that they offer no basis for defining aesthetic quality except in terms of socially evaluated judgment (Balfe 1985, 15). This leads to tautologous reasoning by which quality becomes something like a consensus of class or status-related preferences, and quality deriving from the art object and its formal structure is left to be worked out by aestheticians. The matter is not resolved in the collection that Balfe and Wyszomirski edited (1985), where the only paper whose author makes a clear statement about aesthetic quality is, ironically, Herbert Gans. Looking back on his study of high and popular culture, he considers his categories in light of changes in aspects of American class structure. In a footnote he admits that he continues "to feel that the higher taste cultures are better than the lower in the same way that more money and schooling are better than less." This leaves the matter of a sociological conception of quality just as embedded in class and status considerations as before, with no separate view of aesthetic quality (Gans 1985, 20). It is this point to which Goldfarb makes his contribution.

Goldfarb's problematic derives from the Tocquevillian dilemma as to whether it is possible for a democratic culture of high quality to exist, and if so, by what criteria quality may be defined, and what form it may take (Chapter 2). Consistent with Frankfurt critical theory, he charges that conventional sociology avoids the serious issues, preferring to divert it into a technical specialty devoid of content, in the service of commerce in the West, and of political control in the East (Goldfarb 1982, 153). Yet the possibility of cultural freedom and autonomous art is a goal that needs to be pursued. Ironically, whereas Western intellectuals and artists have more degrees of freedom than those of the East, as Goldfarb shows, certain intellectuals and artists from Eastern state socialist countries have managed to transcend those limits. Although to do so under the worst conditions of modern tyranny – totalitarianism, whether in Nazi Germany or under Stalinism was virtually impossible,

because repressed with terror – under the "soft" totalitarianism of today, in countries such as Poland, Hungary, and Czechoslovakia, the possibility of "living in truth" is being embraced by an increasing number (Goldfarb 1988). "Softness" does not mean that is it a simple matter to refuse to allow oneself to be co-opted by the system, to remain an inmate of the "velvet prison," in the words of the Hungarian writer, Miklos Haraszti (1987). Repression is far less dramatic under "softness" but the systemic processes are more insidious. Soft totalitarianism has some of the same character as the hegemonic features of commercial control of Western capitalism. Under either of those conditions, according to Goldfarb, art cannot achieve excellence because it is not autonomous.

Although in certain respects Goldfarb raises issues similar to those that Adorno and others of the Frankfurt school dealt with, where he diverges from them is by refusing Adorno's narrow elitism and personal animosities. Instead, Goldfarb includes in the category of serious art, not only classical or "serious" academic music or fine art, but certain of the popular arts as well. He points to those of sufficient depth and richness to transcend even commercial and functional usage, providing the basis for a continuing conversation rather than a fleeting moment's entertainment. In that way, the dilemma of democratic quality that seemed oxymoronic to Tocqueville has a chance to be resolved.

Implied in his project, though not spelled out, is the necessity for the public's capacity for grasping quality to be expanded and deepened. Without that, there is little likelihood for the "conversation" among art, artist, and public on which he predicates the achievement of cultural excellence. But whether the ongoing conversation can be achieved without creating a new elite culture, as is increasingly the case for certain forms of jazz, is an open queston. Goldfarb's proposals may be challenged from these standpoints, yet they cannot be dismissed without accepting the trivialization of the arts.

Sociology of art: today and tomorrow

This overview of problems in the sociology of the arts reviews some of the disagreements that divide sociologists. Some have embraced the positivist approach, particularly for approximately

two decades, during the 1950s and 1960s, when it was the orientation most acceptable among American sociologists. At the opposite pole are interpretive approaches employing a variety of qualitative methods, such as ethnography or symbolic interactionism and literary approaches including symbol analysis or semiotics. Cross-cutting these orientations are historical and ideological analyses. These approaches by themselves have shortcomings and need to be combined with others to enhance understanding of society in general, especially in the sociology of the arts.

At their most positivistic, sociologists take the natural sciences and their logic of causality as developed from Newtonian and Baconian thought as the appropriate model for their frameworks of thinking, making their discipline an extension of such exact sciences as physics. In their view science is a universal set of operations that can be applied to virtually any set of events, including human ones. A variant of this extreme scientism, by analogy with biology, implies that the goal of social theory is to explain the functioning of society as a quasi-organic entity, assuming its equilibrium and persistence. This view is congruent with certain evolutionary ideas, underlying a tendency to view the world in a developmental manner, in which a particular conception of the process of industrialization, for example, is taken to be the source of modernization (Giddens 1982, Chapter 1). Proponents of this view, including Talcott Parsons and others, embraced conceptualizations consistent with what has been called the "consensus" model of society.[14]

In contrast to this orientation with its vision of gradual reform, predicated on the increase of goods and services, quality of life, and liberal consensus in society, Marxist-oriented social theorists emphasized the image of a world based on inequality, in which conflict was endemic, and societal equilibrium at best unstable. Along with theorists who were not necessarily Marxist but who also perceived the world to be based on scarcity and inequality, they attacked the consensus framework, denying validity to the nonconflictual metaphor of society which this vision entailed (Blau, 1964; Coser, 1959). In fact, however, in their conception of the

14. Predicated on the notion that society is made up of interacting individuals who share a common set of values, their ideas dominated the discipline in the post–World War II period (Turner 1978, 143).

social world, certain Marxian sociologists did not really differ from "mainstream" thinkers, such as Talcott Parsons and Paul Lazarsfeld, among many others. They too shared the common scientific goal, or viewed society as a functional entity. The major difference between them was that Marxian-oriented sociologists were more likely to consider culture, the arts, science, values, and ideas in general to be outcomes of the social relations of production, as mediated through social formations of class. Non-Marxians, by contrast, considered that these cultural products shared a certain autonomy.

Methodologically, both explain the relationship of art to society by similar scientific reasoning. They formulate hypotheses on the basis of which to gather appropriate data, which they analyze according to the logic of science. Nevertheless, regardless of whether they lean toward a consensus or a conflict direction, positivistically oriented sociologists are likely to use similar procedures, even if their respective orientations lead each to ask different kinds of questions and to accept different sorts of explanations of their findings. Thus the logic of a consensus orientation may make them emphasize how use, dissemination, and evaluation of the arts provide individual solace and social concord. In contrast, the conflict approach may focus instead on the denial of art, a scarce good, to deprived social groups (along with other valued goods, such as material comfort, health services, or education); the alienation of artists as their creative products are transformed into commodities; the use of the arts, along with religion and pseudoscience, as a means of mystification, and propaganda, to create "false consciousness."

In an altogether different vein, other scholars seek to develop a conception of social theory based on the antipositivism of interpretive or hermeneutic analysis. Instead of viewing the social world as an extension of the natural, it focuses on the elucidation and elaboration of symbolic meaning of cultural creations. This orientation causes them to question the indispensability of rigid adherence to rules of verification based on Newtonian ideas, logical analysis, development, and testing of hypotheses. Such an approach, they contend, is predicated upon a mechanistic conception of the world derived from an oversimplified reading of positivism or scientism. Instead, their own goal is not "scientific" proof, but interpretation in order to understand social events, processes, and phenomena. The pro-

ponents of these approaches vary as greatly politically as those preferring a scientific approach. They include Marxists such as Benjamin, critical theorists deriving from neo-Marxism such as Adorno, and Weberians such as Elias.

Much of the debate among sociologists since the decade of the 1960's has revolved around questions having to do with the relative merits of these two groups of outlooks. It has been suggested that because of positivist dominance, certain subjects that did not lend themselves to methods congruent with its scientistic style have been neglected or rejected (Pollak 1979, 51). As I showed in Chapter 2, although not without foundation, this interpretation has been somewhat exaggerated, since there are additional explanatory conditions that must be taken into consideration to account for why scholars make particular methodological and substantive choices. Nonetheless, for many the quest for scientific validity precludes studying certain aspects of social life because of their supposed inaptness for objective analysis. Not only did they reject the validity of their study by others, but they too quickly assumed that their own choices, typologies, frameworks of analysis, and other paraphernalia made them immune to the danger that subjective biases might invade their studies. As it happens, critical evaluation of their work reveals that subjective bias is as much a danger for scientistic methodologies as it is for sociologies based on qualitative interpretation and research.

In recent years a number of sociologists have turned their attention to subjects and methods that diverge from the mainstream by creating and using qualitative methods, focusing on historical phenomena rather than contemporary events, elaborating ethnographic studies of everyday life, or doing "text" analysis (of literature, drama, painting, popular or mass culture, and of the emotions). Borrowing approaches from literary criticism, they embrace subjects that are not easily subsumed under frameworks of analysis appropriate to statistical data collection and manipulation. The intellectual choices of those who diverge from the mainstream merit study as much as those who follow it.

The works of Michael Mulkay on the sciences or Victor Karady on the Humanities in French higher education indicate that those who "choose" to enter marginal or new domains do not do so randomly (Mulkay 1972; Karady 1976). In studying their behavior

as a force of innovation, Mulkay suggests that scientific innovators are likely to stem from those who are in a tenuous position within their institutional structure. Karady shows that their social status places them at a disadvantage in achieving entry and success in the more prized domains. Since they have little to lose and stand to gain a great deal, it is worth their while to make risky choices.[15]

Because of innovations in sociology, much more is now known about the microprocesses of production of culture, including the institutions of the arts; processes of discovery, selection, dissemination, and consecration of the arts; the personnel most involved in carrying out these processes, and their career strategies. Sociologists have studied artistic professions, including the recruitment, training, and career trajectories of artists and "supporting players" (Becker 1982) in cultural institutions and art worlds. They have begun to incorporate ideas about artistic reception, support structures for artistic creation, and the various social pressures which these institutions and agencies bring to bear on the creative process.

The recent resurgence of interest by American sociologists in subjects and approaches that had become marginal to the field, of which the sociology of the arts is one of the most striking, has taken the form of treating the arts as something to write around rather than to place in the center of analysis. There is a danger that by neglecting to incorporate the art object itself into their analytic frameworks the discipline may suffer from a dangerous reductionism. Focusing on art is, in a sense, the most problematic aspect of the sociological study of the arts because this brings the scholar to the brink of making value judgments about the subject and, consequently, showing bias. An antidote for bias is a "reflexive"

15. Sociology is a case in point, as Karady's analysis shows. One of its features, both in the United States and in France, is that it is the academic field that attracts students relatively poorly prepared for university level work compared to other disciplines. In the United States, for example, whereas in 1965 sociology, political science, and psychology majors ranked approximately equally on GRE social science scores (between 550–560), by 1982 students in sociology had fallen to 440, political science to 480, while psychology stayed constant. Sociology majors stood 20th in LSAT scores; 17th in GMAT; 19th on GRE/Verbal; and 22nd on GRE/Quantitative (Baker and Rau 1988). The trend is similar in France because most other fields are viewed as more prestigious, better rewarded administratively, and lead to higher professional standing (Bourdieu 1984).

approach (Gouldner 1970), by which scholars undertake constant self-examination, perusing their choice of subject, formulation of questions, procedures, and findings. Not only is it important for sociologists to be aware of preconceived notions that cause members of society to reject uncritically the cultural output of certain segments of society, such as popular or mass culture, but they must be equally alert to falling into the opposite trap – of sentimentalizing the arts of certain groups or permitting nostalgia to obfuscate their thinking. Reflexivity in this sense should, of course, undergird the work of all sociologists, as well as of scholars in general, regardless of methodological approach.

Common to sociologists of art, as well as to social analysts generally, are certain recurrent dilemmas. These include the problem of reconciling approaches so broad that they are capable of meaning anything whatever with others so narrowly focused that they verge on the anecdotal and are of transitory interest. At one extreme microanalytic studies, however rich in texture, may result in de-contextualized cases that teach us little about society.[16] At the other, too much breadth may reduce explanation to assertions about macrostructural phenomena that cry for greater attention to linkages with middle levels of societal structures. To a certain degree this is the case of explanations based on such factors as capitalism at a particular moment in time, but with unclear periodization (Jameson 1984). It has occurred as well where aesthetic outcomes are attributed to "establishment" conspiracies, with inadequate explanations as to why certain conspiratorial behaviors succeed whereas others fail (Guilbaut 1953). Even Veblen's otherwise invaluable insights concerning the symbolic uses of consumption are flawed because he does not sufficiently specify the historical conditions under which these behaviors are likely to occur, but takes them as virtually instinctual. All of these types of research would benefit from a sociologically and historically grounded study of meaning or quality.

16. This is a failing of Judith Adler's analysis of artists in bureaucracies and works like it (Adler 1978). Her study omits so much of the context and focuses so closely on the interaction of artists and officials that the structural features of the institution and the scarcity of resources become secondary. To some degree, as I indicate, the lack of historical and structural context detracts from Howard Becker's art world analysis as well.

As I have argued, merely assuming that the arts reflect their society is a virtual cliché that provides little illumination of the complex relationship between culture and society. Contextualization has to be interpreted richly and in depth. This entails paying attention to micro and macro-levels of society; considering structure and agency; encompassing cultural values as well as material interests. Only then can production, dissemination, and reception of the arts be fruitfully observed over time and across societal boundaries.

Despite the continuing presence of structural or substantive barriers in university worlds, and reticence of art world participants outside of the university to its probing, the sociology of art has grown considerably in recent years. From where it stands today the sub-discipline is gaining recognition from the field of sociology as a whole, indicative of a promising, though not entirely secure future.[17] Equally striking is the fact that ideas about the relationships of society and the arts are becoming normal elements of nonsociologists' toolkits as well, albeit perhaps to the detriment of sociologists' hopes for unquestioned control of an intellectual sphere of their own. Thus historians, art historians, musicologists, aestheticians, critics, and philosophers are increasingly reorienting their disciplinary perspectives to the language and frameworks of sociology, psychology, economics, or political science.[18]

17. Growth in the social study of the arts has benefited from trends of the mid-1960s through the 1970s in American society generally, and in sociology in particular. Especially with the enactment of national government support for the arts and humanities from about 1964 on, there has been a sporadic but apparently growing commitment to the legitimacy of supporting the arts and research in the arts, and the recognition of access to expression and reception of the arts as a right of citizenship. Although sociologists tend to this day to devote themselves to the persistently more marketable subfields of organizational analysis or materially important applied fields such as medical sociology, the American Sociological Association has recently recognized a research section on the sociology of culture. The culture section has shown a membership growth of from barely two hundred in 1986 to over five hundred in 1988.

18. The works of Michael Baxandall, Francis Haskell, T. J. Clark, Arthur Danto, Edward Said, John Berger, Svetlana Alpers, and innumerable others join those of previous scholarly generations including Nicolaus Pevsner, Harold Rosenberg, and John Dewey. This "crossover" phenomenon, of course, is not confined to the study of the arts alone, as Georg Simmel noted, but pervades culture studies in general.

One of the themes of this book is that the sociology of art cannot be insulated from art and art worlds. This is in keeping with the forceful argument by Anthony Giddens that the world of social theory cannot be insulated from the subject of its analysis (Giddens 1982, 13). Unlike specialists in esoteric fields, sociologists of art are not alone in the presence of the arts, nor can they lay claim to a monopoly of knowledge. To the extent that they do this, they reduce the arts to nothing but social variables and their functioning. In spite of their greater expertise, and the desire that some of them may entertain, not even humanists and scholars in related fields have ever been able to monopolize understanding of the arts. Yet sociologists have something to learn from humanists, as have humanists from sociologists. At their best, the two fields have incorporated ideas and approaches from each other's domain, and continue to do so. But it would be a mistake to force social scientists and humanists into a factitious harmony because each might give up too much of their own fields' contributions. Instead, sociologists and humanists would do well to strive to achieve an interpretative framework that admits to partial closure and tentative synthesis. Admitting their interdependence is an important step in that direction.

References

Adams, Charles Francis, editor. *Letters of John Adams Add, to His Wife,* vol. II, letter 78 [1780]. Boston: Little, Brown, 1840.

Adler, Judith. *Artists in Offices.* New Brunswick, N.J.: Transaction, 1979.

Adorno, Theodor. *Introduction to the Sociology of Music.* New York: Seabury Press, 1976 [1962].

Adorno, Theodor, et al. *The Authoritarian Personality.* New York: W. W. Norton, 1969 [1950].

Akrich, Madeleine, a. "Le jugement dernier: Une sociologie de la beauté." *L'Année Sociologique* (1986): 241–77).

———, b. "Le polyptyque de Beaune: La construction locale d'un universel." In *Sociologie de l'Art,* edited by Raymonde Moulin. Paris: La Documentation Française, 1986.

Albrecht, M. C., Barnett, J. H., and Griff, M. *The Sociology of Art and Literature: A Reader.* New York: Praeger, 1970.

Alpers, Svetlana. "Is Art History?" *Daedalus* 1 (Summer 1977): 1–13.

———. *The Art of Describing: Dutch Art in the 17th Century.* Chicago: University of Chicago Press, 1983.

Alsop, Joseph. *The Rare Art Traditions: The History of Art Collecting and Its Linked Phenomena Wherever They Have Appeared.* New York: Harper and Row, 1982.

Altick, Richard D. *The Shows of London.* Cambridge: Harvard University Press, 1978.

Amsterdamska, Olga. "Institutions and Schools of Thought: The New Grammarians." *American Journal of Sociology* 91 (September 1985): 332–58.

Anderson, Perry. *Considerations on Western Marxism.* London: New Left Books, 1976.

Arato, Andrew, and Gebhardt, Eike, eds. *The Essential Frankfurt School Reader.* New York: Oxford University Press, 1978.

Arendt, Hannah. "Society and Culture." In *Culture for the Millions?,* edited by Norman Jacobs. Boston: Beacon Press, 1965.

Arian, Edward. *Bach, Beethoven and Bureaucracy.* Oxford, Ala.: University of Alabama Press, 1971.

Arnheim, Rudolph. *Toward a Psychology of Art.* Berkeley: University of California Press, 1966.

Attali, Jacques. *Noise: The Political Economy of Music.* Minneapolis: University of Minnesota Press, 1985 [French edition 1977].

Baker, Paul J., and Rau, William. "The Cultural Contradictions of Teaching Sociology." Paper presented at Thematic Session on Sociology and Its Constituents, American Sociological Association Meeting, Atlanta, 1988.

Bakhtin, Mikhail. *Rabelais and His World.* Cambridge: MIT Press, 1968 [1940].

Balfe, Judith H. "Moving Toward a New Paradigm on Social Sciences and the Arts: Some Reflections on Conference Presentations." In *Social Science and the Arts, 1984,* edited by J. P. Robinson. New York: University Press of America, 1985.

Balfe, Judith H., and Wyszomirski, Margaret Jane, eds., *Art, Ideology and Politics.* New York: Praeger, 1985.

———. "Public Art and Public Policy." *Journal of Arts Management and Law* 15 (Winter 1986): 5–29.

Banfield, Edward C. *The Democratic Muse: Visual Arts and the Public Interest.* New York: Basic Books, 1984.

Barasch, Moshe. *Theories of Art: From Plato to Winckelmann.* New York: New York University Press, 1985.

Barnett, Antony. "Breaking Through and Falling Off." *Times Literary Supplement* (August 5–11, 1988): 547–8.

Barrett, Michèle, et al., eds. *Ideology and Cultural Production.* London: Croom Helm, 1979.

Barthes, Roland. "The Death of the Author." In *Image-Music-Text,* Glasgow: Fontana/Collins, 1977 [1968].

Baxandall, Michael. *Painting and Experience in Fifteenth-Century Italy,* Oxford: Oxford University Press, 1972.

Becker, Howard S. *Art Worlds.* Berkeley: University of California Press, 1982.

Bellah, Robert N. "Civil Religion in America." In *Beyond Belief.* New York: Harper and Row, 1979 (168–89).

Ben-David, Joseph. *The Scientist's Role in Society: A Comparative Study.* Englewood Cliffs, N.J.: Prentice-Hall, 1971.

Benjamin, Walter. "The Work of Art in the Age of Mechanical Reproduction." In *Illuminations,* edited by Hannah Arendt. New York: Schocken, 1969.

Bennett, Tony. *Formalism and Marxism.* London: Methuen, 1979.

Berger, Bennett M. "Review Essay: Taste and Domination." *American Journal of Sociology* 91 (May 1986): 1445–53.

Berger, John. *Ways of Seeing.* London: Penguin, 1981 [1972].

Blau, Judith R. "Study of the Arts: A Reappraisal." In *Annual Review of Sociology* 14 (1988): 269–92.

Blau, Judith R., and Hall, R. H. "The Supply of Performing Arts in Metropolitan Places." *Urban Affairs Quarterly* 22 (1986): 42–65.

Blau, Peter M. *Exchange and Power in Social Life.* New York: John Wiley, 1964.

Bloch, Ernst, et al. *Aesthetics and Politics,* with an Afterword by Fredric Jameson. London: Verso, 1986 [1977].

Blunt, Anthony, and Lockspeiser, Edward. *French Art and Music Since 1500.* London: Methuen, 1974.

Boime, Albert. "Entrepreneurial Patronage in 19th Century France." In *Enterprise and Entrepreneurs in 19th and 20th Century France,* edited by E. C. Carter II et al. Baltimore: Johns Hopkins University Press, 1976.

_____. *The Academy and French Painting in the 19th Century.* New York: Phaidon, 1971.

Boltanski, Luc. "La constitution du champ de la bande dessinée." *Actes de la Recherche en Sciences Sociales* 1 (Jan. 1975): 37–59.

Bourdieu, Pierre. *Choses Dites.* Paris: Editions de Minuit, 1987.

_____. *Distinction: A Social Critique of the Judgement of Taste.* Cambridge: Harvard University Press, 1984 [1979].

_____. "Habitus, code et codification." *Actes de la Recherche en Sciences Sociales* 64 (September 1986): 40–44.

_____. "L'invention de la vie d'artiste." *Actes de la Recherche en Sciences Sociales* 2 (March 1975): 67–75.

_____. *Questions de Sociologie.* Paris: Editions de Minuit, 1980.

Bourdieu, Pierre, Boltanski, Luc, et al. *Un art moyen: Essai sur les usages sociaux de la photographie.* Paris: Editions de Minuit, 1965.

Bourdieu, Pierre and Darbel, Alain. *L'amour de l'art: Le musée et son public.* Paris: Editions de Minuit, 1969.

Bourdieu, Pierre and Delsaut, Yvette. "Le couturier et sa griffe: Contributions à une théorie de la magie." *Actes de la Recherche en Sciences Sociales* 1 (January 1975): 7–36.

Bourdieu, Pierre and Passeron, J.-C. *The Inheritors, French Students*

and their Relation to Culture. Chicago: University of Chicago Press, 1979 [1964].

———. "Sociology and Philosophy in France Since 1945: Death and Resurrection of a Philosophy Without Subject." *Social Research* 34 (Spring 1967): 162–212.

Bulmer, Martin. *The Chicago School of Sociology: Institutionalization, Diversity, and the Rise of Sociological Research.* Chicago: University of Chicago Press, 1984.

Burke, Peter. *Popular Culture in Early Modern Europe.* New York: New York University Press, 1978.

Cabanne, Pierre. *Le siècle de Picasso.* 4 vols. Paris: Denoël, 1975.

Cantor, Muriel. *Prime-Time Television: Content and Control.* Beverly Hills: Sage, 1980.

Castelnuovo, Enrico, and Guinzburg, Carlo. "Domination symbolique et géographie artistique dans l'histoire de l'art italien." *Actes de la Recherche en Sciences Sociales.* 40 (November 1981): 51–72.

Chamboredon, Jean-Claude. "Rapport de Synthèse" In *Sociologie de l'Art,* edited by Raymonde Moulin. Paris: La Documentation Française, 1986.

Chamboredon, Jean-Claude, and Menger, Pierre-Michel. "Présentation." *Revue Française de Sociologie* 27 (July–September 1986): 363–7.

Chipp, Theodore, *Theories of Modern Art.* Berkeley: University of California, 1973 [1968].

Christie, R., and Jahoda, M., eds. *Studies in the Scope and Methods of the Authoritarian Personality.* Glencoe, Ill.: Free Press, 1954.

Clark, Priscilla Parkhurst. *Literary France: The Making of a Culture.* Berkeley: University of California Press, 1987.

Clark, Terry N. "Emile Durkheim and the Institutionalization of Sociology in the French University System" *Archives Européennes de Sociologie* 9 (1968): 37–71.

Clark, T. J. *The Absolute Bourgeois: Artists and Politics in France 1848–1851.* London: Thomas and Hudson, 1973.

Clifford, James. "On Ethnographic Authority." *Representations* 1 (Spring 1983): 118–46.

Clignet, Rémi. *The Structure of Artistic Revolutions.* Philadelphia: University of Pennsylvania Press, 1985.

Collège de France. *Propositions pour l'enseignement de l'avenir*. Paris: Collège de France, 1985.

Collins, Randall. "Is 1980s Sociology in the Doldrums?" *American Journal of Sociology* 91 (May 1986): 1336–55.

———. "Looking Forward or Looking Back? Reply to Denzin." *The American Journal of Sociology* 93 (July, 1987): 180–84.

Coser, Lewis A., editor. *Georg Simmel* [Makers of Modern Social Science] Englewood Cliffs, N.J.: Prentice-Hall, 1965.

Coser, Lewis A. *Refugee Scholars in America: Their Impact and Experiences*. New Haven: Yale University Press, 1984.

———. "Sociological Theory from the Chicago Dominance to 1965." *Annual Review of Sociology* 2 (1976): 145–60.

———. *The Functions of Social Conflict*. London: The Free Press of Glencoe, 1956.

———. "The Production of Culture." *Social Research* 45 (Summer 1978): 225–6.

Crane, Diana. *Invisible Colleges: Diffusion of Knowledge in Scientific Communities*. Chicago: University of Chicago Press, 1972.

———. "Reward Systems in Art, Science, and Religion." In *The Production of Culture*, edited by Richard A. Peterson. Beverly Hills: Sage, 1976.

———. *The Transformation of the Avant-Garde: The New York Art World 1940–85*. Chicago: University of Chicago Press, 1987.

Crow, Tom. *Painters and Public Life in 18th Century Paris*. New Haven: Yale University Press, 1985.

Csikszentmihalyi, Mihalyi, Getzels, Jacob W., and Kahn, Stephen P. "Talent and Achievement: A Longitudinal Study of Artists." [A Report to the Spencer Foundation and the MacArthur Foundation.] Chicago: University of Chicago, September 1984.

Csikszentmihalyi, Mihalyi, and Robinson, Rick. "Culture, Time and the Development of Talent." In *Conceptions of Giftedness*, edited by Stemberg and Davidson. Cambridge: Cambridge University Press, 1986.

Danto, Arthur C. "De Kooning's Three-Seater." *The Nation* (March 9, 1985): 282–3.

———. *The Philosophical Disenfranchisement of Art*. New York: Columbia University Press, 1986.

Denzin, Norman K. "The Death of Sociology in the 1980s: Com-

ment on Collins." *American Journal of Sociology* 93 (July 1987): 175–9.

Dewey, John. *Art as Experience*. New York: G. P. Putnam, 1985 [1934].

DiMaggio, Paul J. "Classification in Art." *American Sociological Review* 52 (August, 1987): 440–55.

_____. "Cultural Entrepreneurship in 19th Century Boston." *Media, Culture and Society* 4 (1982): 33–50.

DiMaggio, Paul J., and Mohr, John. "Cultural Capital, Educational Attainment, and Marital Selection." *American Sociological Review* 90 (May 1985): 1231–62.

DiMaggio, Paul J., Useem, Michael, and Brown, Paula. *Audience Studies in the Performing Arts and Museums: A Critical Review*. Washington, DC: National Endowment for the Arts, 1978.

Dissanayake, Ellen. "Art as a Human Behavior: Toward an Ethological View of Art." *Journal of Aesthetics and Art Criticism* 39 (Summer 1982): 397–406.

Donoghue, Denis. *The Arts Without Mystery*. Boston: Little, Brown, 1983.

Dornbusch, Sanford. "Content and Method in the Study of the Higher Arts." In *The Arts in Society*, edited by Robert N. Wilson. Englewood Cliffs, New Jersey: Prentice-Hall, 1964.

Douglas, Mary. *Natural Symbols*. New York: Vintage, 1973.

Dumont, Martine. "Le succès mondain d'une fausse science: La physiognomie de Johann Kaspar Lavater." *Actes de la Recherche en Sciences Sociales* 54 (September 1984): 2–30.

Duncan, H. D. *Culture and Democracy*. New York: Bedminster Press, 1955.

_____. *Language and Literature in Society*. Chicago: University of Chicago Press, 1953.

Dupré, Louis. *Marx's Social Critique of Culture*. New Haven: Yale University Press.

Durkheim, Emile. *Suicide: A Study in Sociology*. Glencoe, Illinois: The Free Press, 1951 [first French edition 1897].

_____. "Jugements de valeur et jugements de réalité." In *Sociologie et Philosophie*. Paris: Presses Universitaires de France, 1953.

_____. *The Division of Labor in Society*. New York: Free Press Macmillan, 1965 [first French edition 1893].

_____. *The Elementary Forms of the Religious Life*. New York: The

Free Press, 1965 [first French edition 1912].

Elias, Norbert. *What Is Sociology?* London: Hutchinson, 1978 [1970].

_____. *The History of Manners, The Civilizing Process: Volume I.* New York: Pantheon Books, 1982 [1939].

Elias, Norbert and Dunning, Eric. *Quest for Excitement: Sport and Leisure in the Civilizing Process.* Oxford: Basil Blackwell, 1987.

Endleman, Robert E. *Personality and Social Life.* New York: Random House, 1967.

Etzkorn, K. Peter. *Georg Simmel: The Conflict in Modern Culture* New York: Teachers College Press, 1968.

Faith, Nicholas. *Sold: The Revolution in the Art Market.* London: Hodder and Stoughton, 1987 [1985].

Faulkner, Robert. *Hollywood Studio Musicians.* Chicago: Aldine, 1971.

Feher, Ferenc. "Weber and the Rationalization of Music." *International Journal of Politics, Culture and Society* 1 (Winter 1987): 147–62.

Firth, Raymond. "The Aesthetics of the Exotic." *Times Literary Supplement* (January 15, 1982): 58.

Fischer, Ernest. *Art Against Ideology.* London: Allen Lane, 1969.

Fleming, Donald, and Bailyn, Bernard, eds. *The Intellectual Migration: Europe and America, 1930–1960.* Cambridge: Harvard University Press, 1969.

Foster, Arnold W. "Dominant Themes in Interpreting the Arts: Materials for a Sociological Model." *Archives Européennes de Sociologie* 20 (1979): 301–32.

Foucault, Michel. "What is an Author?" In *Textual Strategies,* edited by J. V. Harari. Ithaca: Cornell University Press, 1979.

Francastel, Pierre. "Art et Histoire: Dimension et mesure des civilisations." *Annales* (March–April 1961): 297–316.

Frankfurt Institute for Social Research. *Aspects of Sociology.* Boston: Beacon Press, 1972 [1956].

Frazer, James. *The Golden Bough.* 3rd ed. 13 vols. London: Macmillan, 1911–15.

Freidson, Eliot. *Professional Powers: A Study of the Institutionalization of Formal Knowledge.* Chicago: University of Chicago Press, 1986.

Freud, Sigmund. "Dostoevsky and Parricide" [1928] *Collected Papers,* Vol. V, edited by James Strachey. London: Hogarth Press, 1950.

Freud, Sigmund. *Leonardo da Vinci: A Study in Psychosexuality.*

New York: Random House, 1947 [1910].

Frisby, David. *Theories of Modernity in the Work of Simmel, Kracauer and Benjamin.* Cambridge: MIT Press, 1986

Gamboni, Dario. "Odilon redon et ses critiques: Une lutte pour la production de la valeur." *Actes de la Recherches en Science Sociales* 66/67 (March 1987): 25–34.

Gans, Herbert J. "American Popular Culture and High Culture in a Changing Class Structure." In *Prospects: An Annual of American Cultural Studies* 10, edited by Jack Salzman. Cambridge: Cambridge University Press, 1985.

———. *More Equality.* New York: Vintage Books, 1973 [1968].

———. *Popular Culture and High Culture: An Analysis and Evaluation of Taste.* New York: Basic Books, 1974.

Gardner, Howard. *The Arts and Human Development: A Psychological Study of the Artistic Process.* New York: John Wiley & Sons, 1973.

———. *Frames of Mind: The Theory of Multiple Intelligences.* New York: Basic Books, 1985.

Geertz, Clifford. *Negara: The Theatre State in 19th-Century Bali.* Princeton: Princeton University Press, 1980.

———. *The Interpretation of Cultures: Selected Essays.* New York: Basic Books, 1973.

———. "Waddling In." *Times Literary Supplement* (June 7, 1985): 623–4.

———. *Works and Lives: The Anthropologist as Author.* Stanford: Stanford University Press, 1988.

Gerth, Hans, and Mills, C. W. *From Max Weber.* New York: Oxford University Press, 1946.

Getzels, Jacob W., and Csikszentmihalyi, M. *The Creative Vision: A Longitudinal Study of Problem Finding in Art.* New York: Wiley, 1976.

Giddens, Anthony. *Profiles and Critiques in Social Theory.* Berkeley: University of California Press, 1982.

Gimpel, Jean. "Freemasons and Sculptors." In *The Sociology of Art and Literature: A Reader,* edited by M. C. Albrecht et al. New York: Praeger, 1970.

———. *The Cult of Art: Against Art and Artists.* New York: Stein and Day, 1969.

Gitlin, Todd. *Inside Prime Time.* New York: Pantheon, 1983.

Goldfarb, Jeffrey C. *Beyond Glasnost.* Chicago: University of Chicago Press, 1989.

_____. *On Cultural Freedom: An Exploration of Public Life in Poland and America*. Chicago: University of Chicago Press, 1982.

_____. *The Persistence of Freedom: The Sociological Implications of Polish Student Theater*. Boulder, Co.: Westview Replica Editions, 1980.

Gombrich, E. H. "The Social History of Art." In *Meditations on a Hobby Horse and Other Essays on the Theory of Art*. New York: Phaidon, 1963 (86–94).

Goodman, Lisl Marlung. *Death and the Creative Life: Conversations with Prominent Artists*. New York: Springer Publications, 1981.

Goodrich, Lloyd. *The Decade of the Armory Show: New Directions in American Art, 1910–1920*. New York: Whitney Museum of American Art, 1963.

Gouldner, Alvin. *The Coming Crisis of Western Sociology*. New York: Basic Books, 1970.

Gramsci, Antonio. *Selections from Cultural Writings*, edited by D. Forgacs and G. N. Smith. Cambridge: Harvard University Press, 1985.

Graña, César. *Bohemian and Bourgeois: French Society and the French Man of Letters in the 19th Century*. New York: Basic Books, 1964.

Greenberg, Clement. "Complaints of an Art Critic." In *Modernism, Criticism, Realism: Alternative Contexts for Art*, edited by C. Harrison and F. Orton. New York: Harper and Row, 1984.

Greenbagh, Michael and McGaw, Vincent. *Art in Society: Studies in Style, Culture and Aesthetics*. New York: St. Martin's Press, 1978.

Griff, Mason. "The Recruitment and Socialization of Artists." In *International Encyclopedia of the Social Sciences*, edited by David L. Sills, New York: Macmillan, 1968.

Griswold, Wendy. *Renaissance Revivals: City Comedy and Revenge Tragedy in the London Theatre, 1576–1980*. Chicago: University of Chicago Press, 1986.

Guilbaut, Serge. *How New York Stole the Idea of Modern Art*. Chicago: University of Chicago Press, 1983.

Haraszti, Miklos. *The Velvet Prison: Artists Under State Socialism*. New York: Basic Books, 1987.

Harris, Neil. *The Artist in American Society: The Formative Years, 1790–1860*. New York: George Braziller, 1966.

Haskell, Francis. *Rediscoveries in Art: Some Aspects of Taste, Fashion and Collecting in England and France*. London: Phaidon, 1976.

Hauser, Arnold. *The Social History of Art* (4 vols.). New York: Vintage Books, 1951.

———. *The Sociology of Art*. Chicago: University of Chicago Press, 1982.

Heinich, Nathalie. "Arts et sciences à l'âge classique: Professions et institutions culturelles." *Actes de la Recherches en Sciences Sociales* 67/68 (March 1987): 47–78.

Heirich, Max. "Cultural Breakthroughs." In *The Production of Culture*, edited by R. A. Peterson. Beverly Hills: Sage, 1976: 23–40.

Held, David. *Introduction to Critical Theory: Horkheimer to Habermas*. Berkeley: University of California Press, 1980.

Hennion, Antoine. *Les professionnels du disque*. Paris: A. M. Métaillé, 1981.

Herskovits, Melville. *Man and His Works*. New York: Knopf, 1948.

Hess, Elizabeth. "A Tale of Two Memorials." *Art in America* (April 1983): 121–4.

Hirsch, Paul M. "Processing Fads and Fashions: An Organization Set Analysis of Cultural Industry Systems." In *American Journal of Sociology* 77 (January 1972): 639–59.

Hoggart, Richard. *The Uses of Literacy: Changing Patterns in English Mass Culture*. Boston: Beacon Press, 1957.

Holt, Elizabeth Gilmore, ed. *The Triumph of Art for the Public, 1785–1848. The Emerging Role of Exhibitions and Critics*. Princeton: Princeton University Press, 1979.

———. *The Art of All Nations: 1850–1873. The Emerging Role of Exhibitions and Critics*. Garden City, N.Y.: Anchor Press/Doubleday, 1981.

Ivins, William M., Jr. *How Prints Look: Photographs with a Commentary*. Boston: Beacon Press, 1960 [1943].

Jacobs, Norman, ed. *Culture for the Millions? Mass Media in Modern Society*. Boston: Beacon Press, 1965 [1959].

Jameson, Fredric. *Marxism and Form*. Princeton: Princeton University Press, 1971.

———. "Postmodernism, or the Cultural Logic of Late Capitalism." *New Left Review* 146 (July-August 1984): 53–92.

Jay, Martin. *Adorno*. Cambridge: Harvard University Press, 1984.

Jencks, Christopher, and Riesman, David. *The Academic Revolution*. Chicago: University of Chicago Press, 1977 [1968].

Jules-Rosette, Bennetta. "Tourist Art and Ethnic Identity in East

Africa." In *Contribution to the Sociology of the Arts,* edited by ISA Research Committee on Sociology of Art. Sofia, Bulgaria: Research Institute for Culture, 1983.

Kadushin, Charles. "Networks and Circles in the Production of Culture." In *The Production of Culture,* edited by R. A. Peterson. Beverly Hills: Sage Publications, 1976.

Karady, Victor. "Durkheim, les sciences sociales et l'université: Bilan d'un demi-échec." *Revue Française de Sociologie* 17 (April–June 1976): 287–312.

Katz, Elihu and Lazarsfeld, Paul. *Personal Influence.* Glencoe, Il.: Free Press, 1955.

Kavolis, Vytautis. *History on Art's Side: Social Dynamics in Artistic Efflorescences.* Ithaca: Cornell University Press, 1972.

Kristeller, P. O. "The Modern System of the Arts." *Journal of the History of Ideas* 12 (1951): 496–527 and 13 (1952): 17–46.

Kroeber, A. L. *Anthropology Today.* Chicago: University of Chicago Press, 1957 [1953].

Kuhn, Thomas. *The Essential Tension.* Chicago: University of Chicago Press, 1977.

———. *The Structure of Scientific Revolutions.* Chicago: University of Chicago Press, 1970.

Laing, Dave. *The Marxist Theory of Art.* Atlantic Highlands, N.J.: Humanities Press, 1978.

Lang, Gladys Engel, and Lang, Kurt. "Recognition and Renown: The Survival of Artistic Reputations." in *American Journal of Sociology* 94 (July 1988): 79–109.

Latour, Bruno. *Science in Action: How to Follow Scientists and Engineers Through Society.* Cambridge: Harvard University Press, 1987.

Lemert, Charles C., ed. *French Sociology: Rupture and Renewal Since 1968.* New York: Columbia University Press, 1981.

Lethève, Jacques. *Impressionnistes et symbolistes devant la presse.* Paris: Armand Colin, 1959.

Levy, Emanuel. *And the Winner Is: The History and Politics of the Oscar Awards,* New York: Harper and Row, 1987.

Liebow, Elliot. *Tally's Corner: A Study of Negro Streetcorner Men.* Boston: Little, Brown, 1967.

Lillienfeld, Robert. "Music and Society in the 20th Century: George Lukács, Ernst Bloch, and Theodor Adorno." *International Journal of Politics, Culture, and Society* 1 (Winter 1987): 120–46.

Lindahl, Mary W., Getzels, J. W. and Csikszentmihalyi, M. "The

Social Construction of Failure: Role Dilemmas of Women Artists."
Presented at American Sociological Association Meeting, New
York, 1986.

Lipset, S. M., and Bendix, R. *Social Mobility in Industrial Society.*
Berkeley: University of California Press, 1959.

Lomax, Alan. "Song Structure and Social Structure." In *The Sociology
of Art and Literature: A Reader,* edited by M. C. Albrecht et al.
New York: Praeger, 1970.

Lukács, Georg. *The Historical Novel.* Boston: Beacon Press, 1968
[1937].

Lynes, Russell. *The Tastemakers: The Shaping of American Popular
Taste.* New York: Dover, 1980 [1949].

_____. *The Art-Makers: An Informal History of Painting, Sculpture
and Architecture in Nineteenth-Century America.* New York: Dover
Publications, 1982 [1970].

_____. *The Lively Audience: A Social History of the Visual and
Performing Arts in America, 1890–1950.* New York: Harper and
Row, 1985.

MacIntire, Alasdair. *Marcuse.* [Modern Masters]. London: Fontana/
Collins, 1970.

Malinowski, B. *Argonauts of the Western Pacific.* London: Routledge
and Kegan Paul, 1922.

Manfredi, John. *The Social Limits of Art.* Amherst: University of
Massachusetts Press, 1982.

Marling, Karal Ann. *Wall-to-Wall America: A Cultural History of
Post Office Murals in the Great Depression.* Minneapolis: University
of Minnesota Press, 1982.

Martorella, Rosanne. "Government and Corporate Ideologies in
Support of the Arts." In *Sociologie de l'Art,* edited by Rayonde
Moulin. Paris: La Documentation Française, 1986.

_____. *The Sociology of Opera.* South Hadley, MA.: J. R. Bergin,
1982.

Marx, Karl. *The Eighteenth Brumaire of Louis Bonaparte.* New York:
International Publishers, 1963 [1869].

_____. *Grundrisse: Foundations of the Critique of Political Economy.*
London: Penguin and New Left Review, 1974 [1939].

Meiss, Millard. *Painting in Florence and Siena After the Black Death:
The Arts, Religion and Society in the Mid-Fourteenth Century.* New
York: Harper and Row, 1951.

Mellers, Wilfred. "Audible Truths." *Times Literary Supplement.* (July 31, 1987): 813.

Menger, Pierre-Michel. *Le paradoxe du musicien: le compositeur, le mélomane et l'Etat dans la société contemporaine.* Paris: Flammarion, 1883.

Merton, Robert K. "Insiders and Outsiders: A Chapter in the Sociology of Knowledge." *American Journal of Sociology* 78 (July 1972): 9–47.

Merton, Robert K., and Zuckerman, Harriet. "Institutionalized Patterns of Evaluation in Science." In *The Sociology of Science: Theoretical and Empirical Investigations,* edited by Robert K. Merton. Chicago: University of Chicago Press, 1973.

Meyer, Leonard B. *Music, The Arts, and Ideas: Patterns and Prediction in Twentieth-Century Culture.* Chicago: University of Chicago Press, 1967.

Michelin. *Bourgogne, Morvan Guide.* Paris: Pneu Michelin, 1977.

Miller, E. H. *The Professional Writer in Elizabethan England, A Study of Nondramatic Literature.* Cambridge: Harvard University Press, 1959.

Miller, Lillian B. *Patrons and Patriotism, The Encouragement of the Fine Arts in the United States, 1790–1860.* Chicago: University of Chicago Press, 1966.

Mills, C. W. *Sociology and Pragmatism: The Higher Learning in America,* Edited by I. L. Horowitz, New York: Oxford University Press, 1964.

————. *The Power Elite.* New York: Oxford University Press, 1956.

Montias, J. M. *Artists and Artisans in Delft: A Socio-economic Study of the 17th Century.* Princeton: Princeton University Press, 1982.

Morgan, H. Wayne. *New Muses: Art in American Culture.* Norman: University of Oklahoma Press, 1978.

Moore, Wilbert E. *Social Change.* Englewood Cliffs, N.J.: Prentice-Hall, 1963.

Morrison, David E. "*Kultur* and Culture: The Case of Theodor W. Adorno and Paul F. Lazarsfeld." *Social Research* 45 (Summer 1978): 331–55.

Moulin, Raymonde. *Guide de l'artiste plasticien* [Collection Etudes Série Secteur Culturel No 4]. Brussels: Commission des Communautés Européennes, 1981.

————. "La genèse de la rareté artistique." *Revue d'Ethnologie Française* 8 (1978): 241–58.

————. *The French Art Market, A Sociological View*. New Brunswick, N.J.: Rutgers University Press, 1987 [abridged from *Le marché de la peinture en France*. Paris: Editions de Minuit, 1967].

Mukerji, Chandra. *From Graven Images: Patterns of Modern Materialism*. New York: Columbia University Press, 1983.

Mulkay, Michael J. *The Social Process of Innovation: A Study in the Sociology of Science*. London: Macmillan, 1972.

Murdock, George Peter. *Social Structure*. New York: The Free Press, 1949.

Nash, Dennison. "Challenge and Response in the American Composer's Career." In *The Sociology of Art and Literature: A Reader,* edited by M. C. Albrecht, J. H. Barnett, and M. Griff. New York: Praeger, 1970.

Nau, Jean-Yves. "Le docteur Benveniste doit répondre à trois séries de critiques," *Le Monde* (9 August 1988): 7.

Nelkin, Dorothy. *The Creation Controversy: Science or Scripture in the Schools*. Boston: Beacon Press, 1982.

Panofsky, Erwin. *Gothic Architecture and Scholasticism*. New York: Meridian Books, 1957.

Paret, Peter. *The Berlin Secession: Modernism and Its Enemies in Imperial Germany*. Cambridge: Harvard University Press, 1980.

Park, Robert E., and Burgess, Ernest W. *Introduction to the Science of Sociology*. Chicago: University of Chicago Press, 1969 [1921].

Parsons, Talcott. "An Outline of the Social System." In *Theories of Society: Foundations of Modern Social Theory*. vol. 1. Edited by Talcott Parsons et al. Glencoe, Il.: Free Press, 1961.

Passeron, J.-C. "Le chassé-croisé des oeuvres de la sociologie." In *Sociologie de l'Art,* edited by Raymonde Moulin. Paris: La Documentation Française, 1986.

Peiss, Kathy. *Cheap Amusements: Working Women and Leisure in Turn-of-the-Century New York*. Philadelphia: Temple University Press, 1986.

Pelles, Geraldine. *Art, Artists and Society: Origins of a Modern Dilemma, Painting in England and France, 1750–1850*. Englewood Cliff, N.J.: Prentice-Hall, 1963.

Peterson, Richard A. "Patterns of Cultural Choice: A Prolego-

menon." *American Behavioral Scientist* 26 (March–April 1983): 422–38.

————, ed. *The Production of Culture.* Beverly Hills: Sage Publications, 1976.

————. "The Role of Formal Accountability in the Shift from Impresario to Arts Administrator." In *Sociologie de l'Art* edited by Raymonde Moulin. Paris: La Documentation Française, 1986.

————. "The Unnatural History of Rock Festivals: An Instance of Media Facilitation." *Popular Music and Society* 2 (Winter 1973): 98–123.

Peterson, R. A., and Berger, D. G. "Cycles in Symbol Production: The Case of Popular Music" *American Sociological Review* 40 (April 1975): 158–73.

Peterson, R. A., and White, H. G. "The Simplex Located in Art Worlds." *Urban Life and Culture* (1979): 411–39.

Pevsner, Nikolaus. *Academies of Art: Past and Present.* Cambridge: Cambridge University Press, 1940.

Poggioli, Renato. *The Theory of the Avant-Garde.* Cambridge: Harvard University Press, 1971.

Pollak, Michael. "Paul F. Lazarsfeld, fondateur d'une multinationale scientifique." *Actes de la Recherche en Sciences Sociales* 25 (Jan. 1979): 45–60.

————. *Vienne, 1900.* Paris: Gallimard/Julliard, 1984.

Price, Derek J. de Solla. *Little Science, Big Science . . . and Beyond.* New York: Columbia University Press, 1986.

Proctor, Robert. *Nazi Medicine.* Chicago: University of Chicago Press, 1988.

Rank, Otto. *Art and Artist: Creative Urge and Personality Development.* New York: Agathon Press, 1968 [1932].

Redfield, Robert. *The Little Community and Peasant Society and Culture.* Chicago: University of Chicago Press, 1965 [1956].

Rees, A. L. and Borzello, F., eds. *The New Art History.* Baltimore: Camden House Press, 1986.

Reich, Charles A. *The Greening of America.* New York: Bantam Books, 1971.

Ritzer, George. *Sociology: A Multiple Paradigm Science.* Revised Edition. Boston: Allyn and Bacon, 1980 [1975].

Robinson, John P. *How Americans Use Time: A Social Psychological*

Analysis of Everyday Behavior. New York: Praeger, 1977.

Robinson, John P., ed. *Social Science and the Arts 1984: A State-of-the-Arts Review from The Tenth Annual Conference on Social Theory, Politics and the Arts.* New York: University Press of America, 1985.

Robinson, Rick E. "A Model for the Development of Ability." Chicago: University of Chicago Press, 1986.

————. "The Cultural Conditions of Creativity: Transforming the Structure of Domains and Fields." Presented at Conference on Social Theory, Politics, and the Arts, SUNY Albany, October 1987.

Robinson, Robert V., and Garnier, Maurice A. "Class Reproduction Among Men and Women in France: Reproduction Theory on Its Home Ground." *American Sociological Review* 91 (Sept. 1985): 250–81.

Rochberg-Halton, Eugene. *Meaning and Modernity in Social Theory.* Chicago: University of Chicago Press, 1986.

Rosenberg, Bernard, and Fliegl, Norris. *The Vanguard Artist: Portrait and Self-Portrait.* New York: Quadrangle Books, 1965.

Rosenberg, Bernard, and White, David Manning, eds. *Mass Culture: The Popular Arts in America.* New York: The Free Press, 1957.

Rosenberg, Harold. *Art on the Edge.* New York: Macmillan, 1975.

————. "The Art Establishment." In *The Sociology of Art and Literature: A Reader,* edited by M. C. Albrecht et al. 1970.

————. *The Tradition of the New* 1970 [1959].

Rosenblum, Barbara. *Photographers at Work.* New York: Holmes and Meiers, 1978.

————. "Style as Social Process." *American Sociological Review* 43 (June 1978): 422–38.

Rueschemeyer, Marilyn, Golomshtok, Igor, and Kennedy, Janet. *Soviet Emigré Artists: Life and Work in the USSR and the US.* Armonk, NY: M. E. Sharpe, 1985.

Rydell, Robert W. *All the World's a Fair: Visions of Empire at American International Expositions, 1876–1916.* Chicago: University of Chicago Press, 1984.

Sahlins, Marshall. *Islands of History.* Chicago: University of Chicago Press, 1985.

Sarfatti-Larson, Magali. *The Rise of Professionalism: A Sociological Perspective.* Berkeley: University of California Press, 1977.

Schudson, Michael. *Advertising, the Uneasy Persuasion: Its Dubious Impact on American Society*. New York: Basic Books, 1984.

———. *Discovering the News: A Social History of American Newspapers*. New York: Basic Books, 1978.

Schuster, J. Mark Davidson. "Tax Incentives as Arts Policy in Western Europe." In *Nonprofit Enterprise in the Arts: Studies in Mission and Constraint,* edited by Paul J. DiMaggio. New York: Oxford University Press, 1986.

Scitovsky, Tibor. *The Joyless Economy: An Inquiry into Human Satisfaction and Consumer Dissatisfaction*. New York: Oxford University Press, 1976.

Sewell, William H., Jr. "Theory of Action, Dialectic, and History: Comment on Coleman." *American Journal of Sociology* 93 (July 1987): 166–71.

Shils, Edward. "Mass Society and Its Culture." In *Culture for the Millions?,* edited by Norman Jacobs. Boston: Beacon Press, 1965 [1959].

Simmel, Georg. *Conflict and the Web of Group-Affiliations*. Glencoe, Il.: The Free Press, 1955.

———. *The Conflict in Modern Culture and Other Essays*. Trans. and ed. by K. Peter Etzkorn. New York: Teachers College Press, 1968.

Simpson, Charles. *Soho: The Artist in the City*. Chicago: University of Chicago Press, 1981.

Smith, Thomas Spence. "Aestheticism and Social Structure: Style and Social Network in Dandy Life." *American Sociological Review*. 39 (October 1974): 725–43.

Solomon, Maynard, ed. *Marxism and Art: Essays Clasic and Contemporary*. Detroit: Wayne State University Press, 1979.

Sorokin, Pitirim A. *Social and Cultural Dynamics*. Vol. 1. *Fluctuations of Forms of Art*. New York: American Book Company, 1937.

Steinberg, Leo. *The Sexuality of Christ in Renaissance Art and in Modern Oblivion*. New York: Pantheon, 1983.

Strauss, Anselm. "The Art School and Its Students: A Study and an Interpretation." In *The Sociology of Art and Literature, A Reader,* edited by M. C. Albrecht, et al., New York: Praeger, 1970.

Taylor, Joshua C. *The Fine Arts in America* [The Chicago History of American Civilization]. Chicago: University of Chicago Press, 1979.

Taylor, J. R., and Brooke, B. *The Art Dealers*. New York: Charles Scribner's Sons, 1969.

Thernstrom, Stephan. *Poverty and Progress, Social Mobility in a Nineteenth-Century City*. New York: Atheneum, 1975 [1964].

Thiesse, Anne-Marie. *Le roman du quotidien: Lecteurs et lecteurs popularies à la belle époque*. Paris: Le Chemin Vert, 1984.

Thomas, W. I., and Znaniecki, F. *The Polish Peasant in Europe and America*. 2 vols. New York: Dover Publications, 1958.

Tilghman, B. R. *But Is It Art? The Value of Art and the Temptation of Theory*. New York: Basil Blackwell, 1984.

Tocqueville, Alexis de, a. *Democracy in America*, Volume I. New York: Vintage, 1955 [first French edition 1835].

————, b. *The Old Regime and the French Revolution*, translated by Stuart Gilbert. Garden City, N. Y.: Doubleday/Anchor, 1955 [first French edition 1856].

Tuchman, Gaye. *Making News: A Study in the Construction of Reality*. New York: Free Press, Macmillan, 1978.

Turner, Jonathan H. *The Structure of Social Theory*. Revised Edition. Homewood, Il.: Dorsey Press, 1978.

Turner, Victor W. *The Forest of Symbols: Aspects of Ndembu Ritual*. Ithaca: Cornell University Press, 1967.

Van den Haag, E. "A Dissent from the Consensual Society." In *Culture for the Millions?*, edited by Norman Jacobs. Boston: Beacon Press, 1964 [1959].

Veblen, Thorstein. *The Theory of the Leisure Class*. New York: Random House, 1934 [1899].

Venturi, Lionello. *History of Art Criticism*. New York: E. P. Dutton, 1964 [1936].

Verdès-Leroux, Jeannine. "L'art de parti: Le parti communiste française et ses peintres (1947–1954)." *Actes de la Recherche en Sciences Sociales* 28 (June 1979): 33–56.

Vidich, Arthur J., and Bensman, Joseph. *Small Town in Mass Society: Class, Power, and Religion in a Rural Community*. Garden City, N.Y.: Doubleday, 1960.

Vidich, Arthur J., and Lyman, Stanford. *American Sociology: Worldly Rejections of Religions and their Directions*. New Haven: Yale University Press, 1986.

Vygotsky, L. S. *The Psychology of Art*. Cambridge: MIT Press, 1971 [c. 1925].

Wagner-Pacifici, Robin and Schwartz, Barry. "The Vietnam Vet-

erans' Memorial: Ambivalence as a Genre Problem." Presented at American Sociological Association Meeting, Chicago, 1987.

Warner, W. Lloyd, and Lunt, Paul S. *The Status System of a Modern Community*, Vol. II [Yankee City series]. New Haven: Yale University Press, 1942.

Warshay, Leon H. *The Current State of Sociological Theory: A Critical Interpretation*. New York: David McKay, 1975.

Weber, Max. *The Rational and Social Foundations of Music*. Carbondale, Il.: Southern Illinois University Press, 1958.

White, Harrison, and White, Cynthia. *Canvases and Careers*. New York: John Wiley, 1965.

Whyte, William Foote, *Street Corner Society*. Chicago: University of Chicago Press, 1943.

Williams, Raymond. *Culture*. Glasgow: Fontana Paperbacks, 1981.

_____. *Keywords: A Vocabulary of Culture and Society*. Glasgow: Fontana/Croom Helm, 1976.

Willis, Paul. *Learning to Labor: How Working Class Kids Get Working Class Jobs*. New York: Columbia University Press, 1977.

Wilson, Robert N. *Experiencing Creativity: On the Social Psychology of Art*. New Brunswick, N.J.: Transaction Books, 1986.

_____, ed. *The Arts in Society*. Englewood Cliffs, N.J.: Prentice-Hall, 1964.

Winkin, Yves. "Entretien avec Erving Goffman." *Actes de la Recherche en Sciences Sociales* 54 (Sept. 1984): 85–7.

Winter, Robert. "A Musicological Offering." *New York Review of Books* (July 18, 1985): 123–6.

Wirth, Louis. *The Ghetto*. Chicago: University of Chicago Press, 1928.

Wittkower, Rudolf, and Wittkower, Margot. *Born Under Saturn, The Character and Conduct of Artists: A Documented History from Antiquity to the French Revolution*. New York: W. W. Norton, 1969 [1963].

Wolff, Janet. *Aesthetics and the Sociology of Art*. London: Allen & Unwin, 1983.

_____. *The Social Production of Art*. New York: New York University Press, 1984.

Wolff, Kurt H. *The Sociology of Georg Simmel*. Glencoe, Il.: The Free Press, 1950.

Wollheim, Richard. "Sociological Explanation of the Arts: Some Distinctions." In *The Sociology of Art and Literature: A Reader*,

edited by M. C. Albrecht, J. H. Barnett, and M. Griff. New York: Praeger, 1970.

Wyszomirski, Margaret Jane. "New Directions in Arts Policy Research." In *Social Science and the Arts 1984,* edited by John P. Robinson. Lanham, Md.: University Press of America, 1985.

Zolberg, Vera L. "The Art Institute of Chicago: The Sociology of a Cultural Organization." University of Chicago, Ph.D. dissertation, 1974.

———. "Betrayal of a Trust? Art Critics in the World of Art." In *The Evolution of Art Criticism in a Changing Society.* Brussels: Belgian Association of Art Critics, 1987.

———. "Changing Patterns of Patronage in the Arts." In *Performers and Performances: The Sociology of Artistic Work,* edited by Jack B. Kamerman and Rosanne Martorella. New York: Praeger, 1983.

———. "Displayed Art and Performed Music: Selective Innovation and the Structure of Artistic Media." *Sociological Quarterly* 21 (Spring 1980.

———. "New Arts – New Patrons: Coincidence or Causality in the 20th-Century Avant-Garde." In *Contributions to the Sociology of the Arts,* edited by ISA Research Committee on Sociology of Art. Sofia, Bulgaria: Research Institute for Culture, 1983.

———. "Postmodernism Previewed: Aesthetic Eclecticism in the 19th Century Art Museum." Presented at the Annual Conference on Social Theory, Politics, and the Arts, Washington, D.C.: October 28–30, 1988.

———. "The Sociology of Art in France. Presented at American Sociological Association Meetings in Toronto: 1980.

———. "Tensions of Mission in American Art Museums." In *Nonprofit Enterprise in the Arts: Studies in Mission and Constraint,* edited by Paul J. DiMaggio. New York: Oxford University Press, 1986.

Zolberg, Aristide R., and Zolberg, Vera L. "The Meanings of May, Paris, 1968." in *Midway* (Winter 1969): 91–109.

———. "The Regimentation of Bourgeois Culture" in *Comparative Education Review* (Sept. 1971): 330–45.

Zuckerman, Harriet A. *The Scientific Elite.* New York: The Free Press, 1977.

Zukin, Sharon. *Loft Living.* New Brunswick, N.J.: Rutgers University Press, 1989.

Index

abstract art, 8, 56, 102

abstract expressionism, 62, 63, 184

academic art, 148–9, 180

academic canon, 8, 21, 143, 178

academic system, 202–3; French, 63–4

academies, 175, 177–80

academy (the), 10; artistic canon of, 178

Academy of Painting and Sculpture, 178n12

access: to art, 201; to valued goods, 125

Addams, Jane, 41

Adler, Judith, 213n16

administration, 134

Adorno, Theodor, 13n10, 37, 47, 54, 56n3, 58, 71–8, 143, 144–5, 151, 153, 155, 159, 171, 189n22, 197n3, 198n4, 201n8, 205, 208, 211; *Authoritarian Personality, The*, 73n11; critical theory as evaluation, 145–8; *Introduction to the Sociology of Music*, 74–5; on music, 5n5, 64, 65

advertising, 5n5, 183

aesthetic analysis/critique, 61, 77, 202–5

aesthetic assumptions: and externalist perspective, 8–11; and internalist perspective, 6–8, 29, 163, 169

aesthetic change, 163–4, 198. *See also* artistic change

aesthetic culture, 152

aesthetic judgment, 36n8, 192–3, 204; changing, 14–15; and institutions, 21; in sociology of art, 200–2, 212–13; state and, 34

aesthetic paradigm, 57

aesthetic preferences, 158

aesthetic quality, 5, 21; capitalism and, 145–6; and democracy, 31–3, 35, 207

aesthetic structure, 169–75

aesthetic taste, 157

aesthetic value, 73–4, 204; challenges to, 24–5; intrinsic to art work, 83; as negotiated process, 174; production of, 125; reproduction and, 87; social embeddedness of, 198; uniqueness in, 82–3

aesthetic violence (Bourdieu), 156–61

aestheticians, 4, 9, 14–15, 192, 204, 214; aesthetic judgment of, 202; arbitrariness in choices of, 155n13; focus on "greatness," 117–18; and social study of artists, 127–9; study of art, 53–4, 55; view of artist, 115

aestheticism, 64

aesthetics, 2, 4, 14, 128; in Adorno, 77; changing definitions of, 2n2; logic of, 36n8; in Marx, 13n9; perspective in, 13, 14; premises of, 81, 82; in social critique, 155; in Weber, 36

African music, 67–8, 69

Akrich, Madeleine, 82, 92–7, 98, 101, 103, 104

Albrecht, M. C., 81n1; and J. H. Barnett and M. Griff: *Sociology of Art and Literature, The*, 50

Alfano, Franco, 171

alienation, 75n14, 112n12, 168; of artist, 115, 118, 122, 197n3, 210

Alpers, Svetlana, 54, 55, 214n18

Alsop, Joseph, 84

American Social Science Association, 42n16

American society: and the arts, 30–5

American Sociological Association, 214n17

American sociology, 36, 37, 39–40, 42–4, 71–2; changes in, 48, 49; context of, 26; development of, 29

Amerindians, 67, 70

André, Carl, 2

Année Sociologique, L' (journal), 38

anthropologists, 15–17, 18, 42, 45, 71

anthropology, 19, 20, 65, 166n3; folkloristic conception of, 68

antiacademicism, 64, 130, 132, 178

antipositivism, 210–11

antiquities, 91

Apollo Belvedere (art work), 15n12

architecture, 132, 134, 167

aristocracy, 32, 33, 182

Arneson, Robert, 154

237

Printed in the United Kingdom
by Lightning Source UK Ltd.
93406